RENAISSANCE SCULPTURE IN SPAIN

RENAISSANCE SCULPTURE IN SPAIN

by

MANUEL GÓMEZ-MORENO

HACKER ART BOOKS

NEW YORK

1971

First published by Pantheon-Casa Editrice
Florence, 1931
Reprinted by Hacker Art Books
New York, 1970

THE TEXT WAS TRANSLATED FROM THE SPANISH
BY BERNARD BEVAN

Library of Congress Catalog Card Number: 76-116354
ISBN: 0-87817-042-1

CONTENTS

LIST OF PLATES

VIII

THE TEXT

INTRODUCTION

THE Renaissance is here understood in the strictest, that is to say the traditionally accepted meaning of the term: a historical phase developed in Italy from classical originals which had never been forgotten in that country, but at this time received new life from the study of Graeco-Roman works. This reaction was natural, and even inevitable from the moment when modern culture in its development sought to possess the intellectual capacity for drawing inspiration from the classical ideals placed before it; and this took place in Italy during the fifteenth century. The other western countries, however, and, especially Spain, saw in this impulse only an exotic fashion, an imported "article de luxe", accepted with reluctance save by the few who had lived in Italy and were in a position to appreciate it. It meant, moreover, the rejection of that northern current of art centred in Burgundy, Flanders and the Rhine valley, which had monopolized popular taste, encouraging the mannerisms of Gothic in its last phase; and it was with these mannerisms that in Spain it had come to fruition with an admirable display of originality.

THE DEVELOPMENT OF SPAIN

In Spain there was to be found at this time an ever-increasing desire for magnificence and ostentation, born as a result of the success of the fortunate enterprises which raised Spain to fame in the last decade of the fifteenth century; such were the capture of Granada and the discovery of America, as well as the alliances with Portugal, England and Flanders. It was a true "Renaissance", entirely her own, faithfully reflected in her art without classical interference, but it strayed from its path owing to the predominance of Spanish political influence in Italy, and later with the conquests of Naples, Lombardy and Navarre. At the beginning of the sixteenth century Spain came to be the richest and most powerful nation in the Christian world. Nevertheless, all things were not in a state of perfection. Spanish credit lay in the hands of Flemish and Genoese bankers, cunning enough to fill to their own advantage the void occasioned by the expulsion of the Jews from the Peninsula. In its turn Italian industry came to impose itself upon that of Flanders and conquered the markets for which, hitherto, the Spaniard, or rather the Morisco, had competed, and in order to fight competition it was necessary to learn to copy the Italian products. So it came to pass that Spain, the conqueror in the lofty sphere of arms and political influence, was forced to become a vassal in matters financial and commercial; the superior Italian culture exercised upon her its inevitable influence, and in the first place it was in the realm of art

I

that Spain was overpowered, as we shall presently see in the course of our study of her sculpture.

But in other ways this conquest proved neither easy nor complete, that is to say decisive, for the Spanish temperament possesses a remarkable energy which can never resign itself to inaction. On previous occasions, when this spirit appears to have lain dormant, Spain was in reality quick to be carried away by her own personal genius, to which everything was subjected. Perhaps there was never a period comparable to this, in which Italy, with Michael Angelo and Titian, imposed her art so firmly upon the whole of Europe; and yet Spain resisted the temptation, marshalling her own powers, firing with enthusiasm the foreign artists working in her midst, and maintaining a religious ideal in the emotional nature of which life and colour were the essential elements, well suited to the taste of the people, from whom its principles were drawn. The Renaissance in Spain does not represent perfect balance, but exaltation of feeling; it lives not through motives of choice, but by sudden impulses; it is not classical but baroque; and its accomplishments are inevitably rooted in this baroque ideal.

FOREIGN SCULPTORS IN SPAIN

THE SITUATION of Spain, between two seas and upon the only trade route of the time, placed her in a position of equal relationship with the two great marts, Flanders and Italy. First Flanders, then in her prime, allowed her art to penetrate into Spain by the Cantabrian shore through ever active districts, till gradually she established her influence over the rest of Castile. Thus assisted, the northern currents of art became nationalized, giving birth to the Isabelline style, elder brother of the Portuguese Manueline, both witnesses to the fertile originality of the country under Gothic inspiration. It was then that the pure Spanish style became crystallized in Castile and, later, the same crystallization took place under the Renaissance, when it was sufficiently vigorous to absorb all foreign influence. At the foot of many works of art foreign names prove whence they come; yet it was Spain that inculcated the spirit which animates them, a fact our remarks will make clear.

The other Spanish zone faced the Mediterranean, and to it three maritime cities, Barcelona, Valencia and Seville, gave access, unrivalled in the whole of Castile for their size and wealth; these bases of oversea communication were, at the time of their prosperity, turbulent, immoral, materialistic, wasteful and without a thought for the spiritual. Everything began and ended in the excitement of fortunate *coups*: the people neither cared for the past nor were pre-occupied with a morrow which, for all they knew, might break the illusion of momentary happiness; and so, holding all to be the best in the best of worlds, they lived from day to day in the enjoyment of the present.

Of these cities, Barcelona reached her zenith in the fourteenth century with a great artistic development, but Gothicism clung so closely that there was scarcely any appreciation for the classical, which came to her principally when decline had already begun. Catalonia, poor by the sixteenth century, continued, longer than any other part of the peninsula, unmindful of the Renaissance in all of its phases. No echo accompanied the rare imported examples of Italian art, and that produced has little local character. It seems as if the Catalan genius rejects the abstract of the Renaissance ideal, with all that it implies in discrimination and rejection, and this circumstance must be taken into account if we wish to put at their true value the later Catalan achievements.

Valencia, and at the same time her little daughter, the Balearics, reached at a later epoch the full bloom of her art: her century is the fifteenth; her Renaissance is characterized by ostentation and colour without stylistic refinements. The Morisco, the Burgundian, the

Flemish, and later the Italian, inspired her affections; and these gave her new ideas, move-ment, the light for which she yearned. Valencia and Palma being open to Italian commerce, it was natural that they should receive artists from Italy. From Naples Alfonso the Magnan-imous encouraged these relations, while the two Borgia popes, Calixtus III and Alex-ander VI, saturated their beloved country with Italianism. The industrial arts and painting rose to distinction in this orgy of ambitious display, but sculpture also played its part, and from a very early date.

JULIAN THE FLORENTINE

At a time when the art of the great Tuscan masters had scarcely built up the formulas upon which the school was founded, a certain "Julià florentí" sculptured in Valencia twelve alabaster reliefs for the "trascoro" of the cathedral, representing complementary scenes from the Old and New Testaments. He was employed upon them from 1418 to 1424, and they survive rearranged in a modern architectural decoration. Their most individual characteristic is the care lavished upon the backgrounds, sometimes landscapes, sometimes architectural. In them the sculptural composition hesitatingly follows the lead given by painting, relinquishing the Gothic formalities which persevered in the Pisan school, and conforming with the Florentine tendency born upon the façade of Orvieto Cathedral and made secure in the baptistery altar-piece at Florence. These bas-reliefs have been compared to Ghiberti's doors in the baptistery in question, the first of which was unfinished when the reliefs were made, and accordingly this work has been attributed to one of the three crafts-men of the name of Giuliano who worked upon the above door. But as a matter of fact we miss all the personal characteristics of Ghiberti in these Valencian bas-reliefs; we are dealing with a parallel work, quite distinct from that of Ghiberti and visibly inferior, parti-cularly in the treatment of the perspective and in certain ugly, mis-shapen heads entirely deprived of elegance and without the least observance of the precepts of Romanism. None the less, a few scenes are well, though simply, composed, for instance, the Coronation of the Virgin; while some of the figures, such as in the Christ in Limbo, the group of Solomon and the Queen of Sheba, and the angels of the Resurrection, are arranged with sober dignity. The type of Christ is always beautiful and the frank charm of the whole work atones for many faults.

Plate 1

IMPORTATIONS IN EASTERN SPAIN

In the eastern districts there are some remarkable works imported from Italy. Gerona Cathedral possesses a metal repoussé plaque showing the Virgin and Child in bas-relief,

Plate 2a

the work of Donatello, known by another, in a bad state of preservation, at Cologne, and by several recastings; but this example at Gerona has hitherto escaped recognition. In Segorbe Cathedral, above a doorway, exists another relief, of marble, likewise of the Virgin with the Child in her arms and two little angels, with an architectural background and a parapet in front; an original and fine work remotely connected with Donatello. The Archaeological Museum of Madrid contains a marble medallion from the monastery of Poblet, which represents in profile the head and shoulders of King Alfonso V of Aragon, with this inscription: "Invictus Alphonsus rex triumphator". It accords perfectly with Pisanello's second medal, signed in 1449, but it is not a copy of this and may perhaps be attributed to Francesco Laurana. To the same artist can be assigned two works at Palma, Majorca, namely a life-size statue of the Virgin, holding the Child in her arms, which stands upon a pedestal decorated with cherubs, and a bas-relief of the Assumption, enclosed within a laurel wreath, which is in the hospital church. Two other figures resembling this, one upon the high altar of the same church, the other in the Diocesan Museum, are apparently by Domenico Gazini, an artist of whom it is recorded that in 1483 he commissioned the sale of three marble images in Catalonia.

Plate 3

Plate 4

Valencia displays over the doorway of the monastery of the Trinity, founded by the wife of Alfonso V, a medallion of glazed earthenware with a border of fruits and a relief of the Virgin clasping the Child Jesus, between two seraphim, a copy with variations of that upon the Strozzi tomb in Santa Maria Novella by Benedetto da Maiano (1491), whose activity extended to this kind of glazed work, in the manner of Andrea della Robbia.

IMPORTATIONS IN ANDALUSIA, ETC.

Seville was not only the great mart for commerce with America, but also possessed many and firm links with Italy, as witness the numerous pieces of sculpture brought from that country. The oldest, of glazed earthenware, come from the workshop of the della Robbias. An undoubted work of Andrea della Robbia is the retablo of Our Lady of the Pomegranate in the cathedral, with a very beautiful group of the Virgin, seated, with the Child, with two angels crowning her and four saints at the sides; in the tympanum is represented Christ leaving the Sepulchre, with half-length figures of Mary and John weeping; from the frieze there remain two cherubs like those reproduced in the course of restoration, and the decoration is completed by two pilasters with coloured leaves and fruits. There is no other colour upon the rest of the work, which is left white except for the sky-blue of the backgrounds and the purple in the eyes. The same cathedral preserves another

Plate 5

work by Andrea, well known as the Virgin of the Cushion, which was brought from the Capuchin convent. At Sanlúcar de Barrameda there existed a medallion of the Virgin and Child standing upright with two angels, similar to another in the Bargello at Florence, but with the typical ornamentation of polychrome garlands; and lastly, in the village of Gines there remain portions of another retablo with rather similar reliefs of the Virgin adoring the Child and cherubs.

Seville herself patronized imitations of this type of art, for there was a Pisan potter named Niculoso Francisco who was at work certainly after 1503 and included as many as seven medallions with reliefs and decoration of fruit in his principal work, the portal of the monastery of Santa Paula, dated 1504. The medallion in the centre, with the Birth of Jesus, is copied from an oft-repeated composition by Andrea della Robbia, first seen in the altar-piece of the Portiuncula at Assisi; but the other medallions with saints we owe to the collaboration of a Gothicist sculptor named Pedro Millán.

Of the Italian works of marble remaining in Andalusia the earliest appear to be two sepulchral slabs, dating from about 1450, with effigies of Pedro de Suazo, gentleman of Cadiz, dressed in full armour with open helm and coat of mail, and his wife Doña María de Espínola, of an illustrious Genoese family. In their relentless naturalism they recall Lombard works and are specially worthy of praise for the masterly modelling of the faces; it is probable that they were made during the lifetime of those they represent, since the epitaphs within the delicate border of laurel and other entwined decoration are lacking. These tombs are in the church of San Francisco at Jerez de la Frontera, removed from their original site and partly covered by boards.

The cathedral of Seville contains another Italian slab which was turned upside-down and used to form another memorial; this slab is now in the courtyard near the chapter-hall. It is that of Íñigo Mendoza, a learned patrician and priest who died in 1497; he is represented in relief beneath an arch upon fluted pilasters, with coats of arms in the spandrels; the sculpture is correct, very simple, of great elegance and finesse, like an echo of Mino da Fiesole.

Closely related to the above work, there followed another, of far greater pretensions, in the same cathedral. This is the tomb of Archbishop Don Diego Hurtado de Mendoza, the cost of which was borne by his brother, the famous Conde de Tendilla; it was executed at Genoa from 1508 to 1510 by the Florentine Domenico Fancelli, or Dominico de Alexandre as he was called in Spain. This tomb forms a great arch surrounded by decoration of fruits, in the della Robbia manner, and possesses two columns delicately ornamented and six little niches with saints between; above are two shields in garlands of

flowers with twisted ribbons; in the tympanum is a relief of the Ascension; while there are also several smaller reliefs and the sarcophagus with its recumbent effigy. All this appears to be an imitation of the tomb of Pope Paul II in Rome, the work of Mino da Fiesole and Giovanni Dalmata, but without the great qualities of these artists and eclipsed later by other works of Fancelli. In fact, following the recommendation of this same Conde de Tendilla, he was commissioned to make the tomb of Prince Juan, which his mother *Plate 6* Queen Isabella ordered to be erected in Santo Tomás at Ávila and which dates from 1511 to 1512; afterwards, from 1514 to 1517, he worked upon that of Ferdinand and Isabella *Plate 7* for their Chapel Royal at Granada, and in 1518 contracted for that of Cardinal Cisneros. This Domenico did not make, as he died shortly afterwards; but we know that it would have been an exact repetition of that of the Sovereigns. This last and that of the prince follow the same general scheme, although in the latter it is less developed. They take the form of a bed or catafalque and are fairly original, although indebted to Italian work, since the resemblance to Pollaiuolo's tomb of Pope Sixtus IV in the Vatican is distant. To analyse these monuments would be a long and not very instructive task, since they are so well known. It is enough to say that Fancelli displayed here, within the strictest bounds of classical taste, the most exquisite decorative *motifs* in the style of those of Andrea Bregno in Rome; but since there is no sign of such ornamentation in the tomb of the Archbishop of Seville it is possible that we owe this to another artisan, a collaborator of Fancelli in his last works. As a sculptor he follows the ideals, already out of fashion, sought by Benedetto da Maiano and Civitale, but he lacks vigour and shows a certain carelessness in design; the head of Ferdinand, perhaps taken from life, does him honour without doubt; the relief of St George upon the same tomb is of exemplary classicism, and another relief of the same subject in the museum at Valencia can also be attributed to Fancelli on account of the resemblance between the two. For Seville Cathedral he made in 1510 certain images, perhaps of clay, which have not been preserved.

This encouragement which Seville gave to the Renaissance, thereby putting an end to the Gothic tradition she had maintained with such pomp in the immense retablo of her cathedral, was further accentuated as a result of the journey to the Holy Land made in 1519 by the first Marquis of Tarifa, Don Fadrique Enríquez de Rivera, who endowed his house with architectural marbles worked at Genoa. Here, in 1520, he ordered likewise two magnificent tombs for his parents, the one by Antonio Maria di Aprile of Carona and the other by Pace Gazini: these are now in the University chapel. It is on record that upon the second tomb Pace was assisted in 1524 by his nephew Bernardino Gazini, and the latter it was who brought them over in the following year. Few tombs

7

are more pretentious than these, but their artistic merit lies no deeper than mere decoration, and in plan they follow that of the triumphal arch already alluded to, with a profusion of carving, reliefs and figures. The best on the tomb of Don Pedro Enríquez are the two weeping children who lean upon extinguished torches, a little like Donatello but of direct classic inspiration; while upon that of Doña Catalina de Rivera, there is a relief of the Last Judgement far superior to the rest. For Seville also, and by the same artists, was carried out between 1526 and 1532 another sumptuous piece of decoration, ordered by the Marquis and Marchioness of Ayamonte, namely, a large retablo and two kneeling effigies, with the epitaphs, of the above-mentioned nobles Don Francisco de Zúñiga and Doña Leonor Manrique, the whole now removed to the church of San Lorenzo at Compostela. This retablo follows the same design as the tombs referred to, but has two orders of four columns; its principal sculptures are a Calvary and reliefs of the Agony in the Garden and the Via Dolorosa.

A younger brother of the already-mentioned Antonio di Aprile, named Giovanni Antonio, and his friend Pier Angelo Bernardini della Scala executed between 1524 and 1526 for the convent of San Juan de la Penitencia at Toledo the tomb of its founder Bishop Fr. Francisco Ruiz, a colleague of Cisneros. An innovation in design is noticeable here, for the tomb consists of a large square niche containing the recumbent figure, with a pair of curtains above held back by four angels; in front are seated three Virtues; at the sides are four little saints and there is a crucifix for a finial, while this does not take into account the parts of whitewashed wood which were added to embellish it still further.

We meet again with the type of monument resembling a triumphal arch in another tomb which rivals or even surpasses in magnificence those at Seville. This is the tomb of Don Ramón de Cardona, Viceroy of Naples, at Bellpuig, a village in Catalonia. It is signed by Giovanni da Nola and had already been erected by 1531. This sculptor, whose surname was Merliano, has left many works in Naples, but none so important and of such original composition as this; moreover, its profane elements and pagan themes, such as the band of Tritons and sea-nymphs who line the sarcophagus, place this tomb in a different category from those before it in the evolution of Italian sculpture; but in Spanish art these elements are almost entirely lacking in precedent.

Still later in date, but not in style when compared with the other works brought to Seville, are the retablo and tomb in the cathedral there of Bishop de Escalas, erected in 1539. Its principal subject is a large composition representing Pentecost, and although the author is unknown, it seems to belong to the style of the Gazini, a prolific family of artists.

Inland at Badajoz, the Italian Renaissance arrived early with two works of the greatest distinction: a marble bas-relief with a half-length figure of the Virgin, clasping the Child *Plate 2b* who stands upright and unclothed before her, and a great sepulchral slab of bronze. The first is an exquisite repetition of a relief in the picture-gallery at Turin, the work of Desiderio da Settignano, but with variations which do not permit us to regard it as the prototype; it is placed in a retablo of a chapel in the cathedral, founded by Lorenzo Suárez de Figueroa, ambassador in Venice of Ferdinand and Isabella, whose stay in Italy lasted from 1494 to 1506, the date of his death, and it is to him and his wife that the already- *Plate 8* mentioned slab belongs, occupying the centre of the chapel. Upon this Lorenzo is represented in relief, not dead nor in the usual rigid attitude, but alive, upright, turned a little in profile and seen in perspective; his bearing is frankly arrogant as he looks heavenwards, with his cap, his loose gown with wide sleeves and broad-toed shoes; in his right hand he listlessly carries a sword, while from his other hand proceeds a scroll or ribbon with an inscription alluding to the two coats of arms, his own and that of his wife, which are seen at the sides; the composition is surrounded by an ornamental border of the greatest delicacy, and below is written his epitaph in minuscule characters and in Castilian, composed with no less facility and naturalness than the effigy. To be compared with this singular piece is another, smaller, also of bronze, with the same shields and this inscription: "Sola salus servire Deo. Sunt cetera fraudes". Doctor Justi attributed this very remarkable and masterly work to Alessandro Leopardi, and it is worthy of his fame; but if we notice the *motifs* of the ornamental border, exactly similar to those upon the pedestal of the "Virgin of the Shoe" in St Mark's, Venice, we must pronounce it a work of Pier Zuanne delle Campane. It was made in Venice about 1503.

Let us now turn our attention to another high personage, in order to enquire into the origin of an exquisite work of art, almost unknown and superior to all the others in parentage. Francisco de los Cobos, secretary to the Emperor, instructed by Hernando de Zafra, the clever secretary to Ferdinand and Isabella, and the successful follower of his policy, founded a sumptuous chapel, like a church, at Úbeda, his birthplace. He saw that it was designed by the best architect of the time in Spain, Diego Silóee; for the retablo he chose the most famous Castilian sculptor, Alonso Berruguete, and there he placed, in addition to rich furnishings, three remarkable works of art: his portrait by Titian; a Pietà painted on slate by Sebastiano del Piombo, and a statue of St John the Baptist, in *Plate 9* marble, a present to Cobos from the Venetian Senate, now placed to the left of the high

altar. The latter represents the Precursor in early youth, clothed in a goatskin fastened round his loins with a belt and clasping a bowl with his left arm; in his right hand he carries the customary cross; he rests upon a rock which rises beneath his left foot, and behind him a tree-trunk serves as support. The face lacks expression, as if in a vision, and a central dot accentuates the pupil of the eyes; the modelling is of irreproachable perfection and of perfect classicism; the technique of the hair and of the goatskin, of the rough stone base, of the tree and of the hands, all point to that group of works by Michael Angelo consisting of the Pietà, the Bacchus, the Cupid and the David, whose dates range between 1497 and 1502. Now we know that when Michael Angelo returned to Florence in 1495 he executed a "San Giovannino" for Lorenzo di Pierfrancesco de' Medici, a lost statue which some have attempted in vain to identify with a figure from Pisa in the Berlin Museum. Undoubtedly, once the Úbeda statue is known, criticism will not hesitate to recognize in it the first work of the period of insensibility to the classical and of affection for childhood through which Buonarroti passed.

Much later, another work reached Spain, believed to be by the same incomparable master: a small crucifix of bronze with four nails which the Italian silversmith Giambattista Franconio brought to Seville in 1597, where it was wastefully melted down. It so happens that other copies of this work are known, in particular two of silver with an incongruous shroud of gilded copper; one of these is in the Royal Palace at Madrid, and is a most beautiful work, 9¾ inches high, the study of the anatomy being admirable and of great sobriety and refinement. Montañés imitated it in the first and most famous of his crucifixes, and from it begins the new fashion of allowing the head and even the whole body to fall to the right, as was repeated later by Pacheco, Zurbarán and Velázquez.

But these influences came too late for us to take them into account at present. Since the fourteenth century Seville had possessed her own entirely distinct school of painters, and with the advent of the Renaissance she could boast of her own distinguished sons, the forerunners of the splendid masters of the seventeenth century, but, on the other hand, she was lacking in native sculptors during the whole of the sixteenth. Desiring the most pretentious, she was content with importations from abroad, and further with the work of strangers whoever they might be; strangers who did not open workshops and consequently did not teach sculpture to the young men of the country. Thus, when at the end of the century a school was formed, foreigners still led the way. Likewise in Valencia; but here there arose a distinguished sculptor, who, far from his native town, managed at Saragossa to revolutionize the sculpture of the eastern provinces. This confirms the theory that in Spain the inland cities were those which stimulated the arts both of sculpture and

of architecture. Where economic stability was assured, it was possible to work collectively, plenty of employment and good wages ensuring a livelihood free from worry; in poor districts, the masters had to manage their own affairs and train their own pupils. This fact tended to create rivalry, and later these pupils were forced to seek their fortunes wherever the demand for artists was most pressing and wherever they could find their own level among other workers in the profession. In the eastern districts the centre of sculptural activity was Saragossa; in Andalusia, Granada; while, in Castile, Toledo, Valladolid and Burgos fought for supremacy, and Cuenca played a by no means insignificant role.

THE RENAISSANCE IN EASTERN SPAIN

AT THE END of the fifteenth century, both for painting and for silver-work came the triumph of Italianism at Valencia. Upon the silver altar of her cathedral the Pisan, Barnaba da Pone, intervened definitively after 1492, although he had already worked upon it ten years before, and in 1506 he finished it with an ordonnance of pilasters in the Roman manner. Here also, another retablo was executed for Queen Isabella from 1488 to 1489 by the Milanese silversmiths Juan Pedro and Francisco Sexto, but of this nothing remains. Of painters we need not speak, those known being so illustrious that a few allusions will suffice. When, from 1511 to 1513, the great organ of the cathedral was constructed, it was a painter who gave to the carvers the designs for its Lombard grotesques. On the other hand, a certain Juan Alemany, image-maker, worked in 1506 in the Lonja or Exchange, and to him we owe the Virgin and Child with two little angels in the doorway. Even at this time there had arisen a family of carpenters and carvers, named Forment, who, in 1503, collaborated on the retablo of the Purification in the convent of Santa Clara, now in the museum. Before 1501 they had also constructed the retablo still existing in the colle-giate church at Gandía, while at Molinos, a village near Teruel, there is another, resem-bling this last and evidently a production of the same workshop, but older, as it is entirely Gothic except for the painting. That at Gandía shows a decoration of Corinthian orna-mented pilasters in the central niche, in which is placed a figure of the Virgin with Jesus in her arms. The retablo of the Purification, though also containing panels painted in the Italian style, gives more ample space to sculpture both in the border framing the tabernacle, adorned with angels and seraphim, and in the eight little saints which decorate the pillars and others at the base of the framing borders, such as are repeated in all three retablos, a veritable signature which persists in successive works. These sculptures, so alike, might pass for Gothic, like those which were made at the same time in Toledo, as if their author had learnt from the magnificent series of images which people the convent of San Juan de los Reyes. Nevertheless, this resemblance is not enough to suggest a direct relationship.

There can be no doubt who was the sculptor. Amongst the Forments, Pablo, the fa-ther, with his sons Damián and Onofre, there stands out Damián Forment, who executed some figures between 1504 and 1509 at Valencia which have not been preserved. It will be remembered that in 1506 Barnaba da Pone completed the silver altar in the cathedral, and that in 1507 the celebrated painters Fernando Yáñez and Fernando de los Llanos,

disciples of Leonardo da Vinci, collaborated upon its doors; in addition, Forment's re-tablo at Gandía was painted by the Lombard Paolo da San Leocadio. Damían thus possessed the means of identifying himself with the Renaissance before leaving Valencia.

AT SARAGOSSA

It is without doubt surprising to find Forment at Saragossa in 1509, suddenly entrusted with the completion of the great altar-piece in Nuestra Señora del Pilar, begun in 1484 by Miguel Gilbert, who had died shortly afterwards. This was no labour in wood, such as he had made in his own country, but a work in alabaster with colossal figures, made to surpass the high altar in La Seo, composed after the models of the German Gothic style and finished amidst general applause in 1477 by a Master Ans, from Gmünd in Swabia.

Plates 10, 11a

His disciple Gil Morlans, a Biscayan, had undertaken in 1506 another similar, though small, retablo, for the monastery of Montearagón, which is now in the sacristy of Huesca Cathedral. Its novelty consists in the base, which shows ornamentation of Roman type and columns which are not precisely Gothic. This is not strange when we consider that the same artist placed "fullas a la romana" in another alabaster retablo finished in or be-fore the year 1502. Moreover, the sculpture of that at Montearagón, except for the three lar-gest groups, deplorable and trivial in composition, follows the same route, both in the well-organized background of classical architecture and in the Roman military trappings, despite the fondness shown in the rest of the work for modern costumes. There are also two bas-reliefs, a form of sculpture gone out of use in Aragon, where such ornamentation is generally placed in the foreground and carved in high relief. Of surpassing beauty are the group of the Adoration of the Kings and two shields supported by lions and griffins upon the base. In its general aspect it does not differ much from the figure sculpture on the contemporary altar at Brou, although the latter is more Italianate, and this resemblance recalls to mind the fact that Morlans, in 1492, made a partnership agreement for twenty years with the Flemish sculptor Pedro Danvers, that is to say "from Antwerp", though this is all we know concerning him.

The same Gil Morlans, the elder, undertook about the year 1512 the great portal of the monastery of Santa Engracia at Saragossa, discarding in it all Gothicism, though we do not know whether or not this was owing to the initiative of his son, of the same name, who obtained the deed of contract in 1515 because of the great age and infirmity of his father, who died before two years were over. The son, it is said, had been in Italy and per-haps to him belongs the entire work, in which the Lombard style wholly dominates,

without any especial beauty but possessing an originality of design and simplicity not often found at the time. As for the statuary, it is unlikely that we owe this to the young Morlans, for he was usually associated with works of stone-cutting in preparation for the sculptors, as we shall see later. The central group represents the Virgin and Child and recalls a well-known type by the della Robbias, as do the seraphim of the arch and the pilasters laden with fruit; the frieze with scallop-shells is a common Florentine *motif* borrowed from Donatello, and the medallions, each within a laurel wreath with ribbons, are an interesting innovation.

FORMENT AND HIS SCHOOL

During this time Damián Forment was engaged at El Pilar and upon many other retablos, his activities developing with unceasing vigour; he was assisted by pupils and contracted with foreign workmen, especially Frenchmen, Germans and perhaps occasionally Italians. To these we owe the architectural carving, which is for the most part Gothic, now Flemish in character, now German, but Italian in the details of the framework and in the whole of the base of the retablo in El Pilar, and also in the niches and base of that at San Pablo, which is of wood and was executed between 1511 and 1517, while that of El Pilar was completed in 1515. The sculpture of both retablos is so closely related that it is certain that Forment had a hand in both, at least in the design and in the direction of the work. Nevertheless, his mastery impressed itself with such force that even the statuary known to be by his collaborators and disciples scarcely differs from his own, whilst in the purely decorative features the style of each is clearly defined. Forment first revealed his genius in the three colossal groups of El Pilar, without our being able to place this work as definitely under the direct influence of any other master; it stands midway between the mediaeval and the Renaissance; is simple and grandiose, sensitive and truly sculpturesque, spontaneous and formal. The figures are massive and firm, but when disengaged from their framing of architecture they gain a grace and elegance which almost brings them to life; he never repeats himself despite the constant repetition of subjects demanded by the narrow, religious, iconographical repertory of his commissions, and so great were his resources that free as he was from plagiarism it would be difficult to find any close resemblance amongst the many hundreds of figures which constitute his work. Nevertheless, Forment at the present day lacks fair criticism; his ancient fame has vanished and the observer is wearied rather than fascinated by the contemplation of his work. It would be necessary to take out one by one the pieces of each retablo in order to enjoy them as they deserve, and this fact applies generally to the Spanish sculptors, so that if a few are now

rescued from oblivion they are precisely those whose works the bad taste of the nineteenth century accumulated in the museums of Valladolid and Seville.

Forment alone boasted of his own merits, in defiance of the modesty which Spanish feeling imposed upon her artists. In the classic epitaph which he consecrated to a pupil he declares himself a rival to Phidias and Praxiteles; and upon the retablo of El Pilar he sculptured his own portrait and that of his wife, both very young, in medallions, his own surrounded with ears of corn, symbolical of his name, Forment, and with the chisel and mallet of his trade; that of his wife within a wreath of poplar, an allusion to her name Arboleda, and with the rosary for a badge; it is not possible to imagine greater freedom of invention than is revealed in this work. Nowhere perhaps is the familiar story of the Birth of the Virgin so vividly represented as in this retablo. Hidden amongst the canopies are enchanting little figures, whose Italianism is astonishing; the seven high reliefs of the base are devoted to gentle, quiet scenes such as the Annunciation and the Adoration of the Shepherds, while emotion and vigour are wanting in that of the Resurrection; Forment at this time did not appreciate the dramatic appeal in art. Upon the lowest stage, all in the Roman manner, are spaced supports on colonnettes resembling candelabra, crowned with fruits, between which are shields supported by little angels and medallions with portraits, all of exquisite workmanship and irreproachable taste; Forment, perhaps ignorant of the principles of Gothic composition, here discloses his predilections, with a tendency towards naturalism in the rendering of flowers and birds recalling Ghiberti and Benedetto Briosco. Did he ever reside in Italy as was thought of old? According to the known records of his life, there was scarcely time for such a journey; but failing this, his determined progress in Italianism remains inexplicable. The retablo of San Pablo does not bring sufficient evidence to outweigh the judgement already formed upon that of El Pilar, and besides this its scenes are unworthy; the work being of less importance and less well paid, the collaboration of his pupils must necessarily have impaired it.

From 1518 to 1519 the presence of Charles V and his court at Saragossa attracted other great artists influenced by the Renaissance, such as Alonso Berruguete, Felipe Bigarny and perhaps Ordóñez, whose example must have affected local talent; in particular a certain development of style in Forment was early ascribed to the influence of the first-named artist. This development is shown in the retablo of the parish church of San Miguel de los Navarros at Saragossa, for which he made a sketch in 1519, wholly in the Roman manner; the design was entirely his, since the supposed participation of Joly has proved illusory. In reality Forment's accomplishment in this retablo was the translation into Corinthian pilasters, arches with scallop-shells and Roman entablatures, of the Gothic

ordonnance of the retablo in San Pablo, while still retaining the frame or ponderous ornamentation necessary to adapt it to the doorways between which, as usual, it is placed. This sudden abandonment of Gothic architecture is a proof that the latter was only continued through the traditional influences of the Church.

As regards the sculpture of this same retablo, the change is less obvious. The disengaged figures are mannered, but the archangel in the centre is remarkable for its elegance and the very Roman style of costume. The scenes represented on the base in high relief, when compared with those at El Pilar, display more expression, and this is particularly noticeable in the Descent from the Cross and the Via Dolorosa. The marked decline in the strength of form and the deep folds of the draperies justify the tradition handed down by Jusepe Martínez that Forment was influenced by Berruguete, an influence which becomes more and more accentuated in his later works.

Afterwards, in 1520-1521, there rose around him a group of collaborators who drove the art of making retablos to seek new models. These were Gil Morlans the younger, already known to us; Gabriel Joly from Picardy, who appears in 1515, when he was nominated provost for his ability as a fencer; the Florentine Juan de Moreto, qualified with the title of "honourable master"; Juan de Salas the younger, a pupil of Forment, who completed his career in Majorca, and lastly, Pedro de Lasaosa and Miguel de Peniaranda, another pupil of Forment. All these, and other less-known artists formed a working brotherhood or union which lasted with remarkable persistence, making it difficult to recognize by which of them each work was produced. Nevertheless, one type of retablo is distinct, differing completely from that in San Miguel, numerous examples being scattered throughout Aragon; these works are generally of wood but some have figures in alabaster. At their head stand the following: — that of St Augustine, originally of St James, in La Seo at Saragossa, the work of Morlans and Joly in 1520; that of St Michael in the cathedral of Jaca, the work of Morlans, Moreto, Salas and Joly, with its magnificent marble doorway which Moreto signed in 1523; and that at Tauste by Morlans, Joly and Salas, of 1521. In this portal, a work of the first order in its class, the Florentine reveals himself as a great decorator, somewhat in the style of Andrea Sansovino, and if the figures also had come from his hand he would be highly esteemed as a sculptor; these, however, are sufficiently within the style and powers of Forment for us to relinquish them to him and, moreover, in several retablos undertaken by the Florentine it is recorded that the making of the statuary was entrusted to other artists, especially to Joly.

During this revival of artistic activity Forment obtained the more important commissions. In 1520 the cathedral of Huesca wished to possess a retablo like that in El Pilar,

and in it Forment returned to the use of Gothic architectural finery, repeating faithfully that which he had made ten years before; only did he vary a little the composition of the base, in order to allow space for the representation of the twelve Apostles above his small scenes, and these last do not in any part of the retablo allude to the Virgin but to the Pas- *Plate 11b* sion of Christ. The dramatic actions of these scenes gave Forment opportunity to carry to the extreme his new outlook, so influenced by Berruguete; in fact, the strong unity of this series of compositions, the more resolute and expressive grouping of the figures, the arrangement of the draperies, leaving portions of the bodies uncovered, the stricter canon of proportions, and certain anatomical details, confirm the statement of Jusepe Martínez, and we can admire the variety of types and attitudes displayed within its permanent ideal of nobility and realism.

From the retablo at Huesca Forment sprang suddenly to that of the monastery of Po- blet, commissioned in 1527, also of alabaster and very large. This spring resulted in a work of absolute Italianism, in which Italian carvers were certainly engaged to execute the grotesques, the draughtsmanship being poor, with scenes and small figures placed so high up that they are scarcely distinguishable, the whole being without light and shade or proportion; it is a veritable blunder for which its author atoned with dissensions and rebukes. At the present day, moreover, it is spoilt by mutilations begun by the Napoleonic soldiery and continued when all the worst elements of nineteenth-century taste met in this edifice. Only in the twelve Apostles, less damaged than the rest, and in the St Sebastian, an important study of the nude, can we appreciate the influence of Berruguete. A certain Italian collaborator, if he was not actually commissioned by Forment, erected about the year 1530 the tomb of Cardinal Don Jaime de Cardona, in Tarragona Cathedral, the only figures being certain winged lions in the corners and children holding the coats of arms within wreaths of fruit, the whole of the work being exactly as at Poblet. Sadly muti- lated also is the tomb of the Viceroy Don Juan de Lanuza, at Alcañiz, executed in the same style by Forment in 1537, and forming an arch upon pairs of columns. The destruc- tion of its statuary is even more unfortunate when it is seen that, in two figures of Virtues placed between the columns of the first stage, Italianism and femininity are accentuated.

Although of less importance, his other works of this period should not be forgotten, such as the relief of the Adoration of the Magi in the upper tabernacle of Huesca Cathe- dral, a part of the high altar and consequently the work of Forment, and one of the most carefully executed and precious examples. In the same cathedral is the little retablo of the chapel of St Anne and a kneeling effigy, dating from about 1523, which have been falsely attributed to Berruguete. This retablo is of wood, with painted alabaster statuary, as are

18

also the retablo of St Nicholas at Velilla de Ebro, signed in 1532, and others in the monastery of Sigena, the most remarkable being that of St Anne. Entirely of wood, unpainted, large and little known, is the retablo at Aniñón, notable for its design, although this is out of keeping with the first stage, while there appears to be no obstacle to its attribution to Forment, although the type of architecture is that imposed by Morlans in 1521, of formal arrangement and superior to other creations which Forment planned on his own.

We now come to his last great work, begun in 1537; the retablo of the cathedral of *Plate 12* Santo Domingo de la Calzada, a town in the Rioja district, which is Castilian territory. In design it is a variation of the above type, conforming to others made at the same time at Teruel by Joly; it is of wood, splendidly gilded and painted in colours, very rich in carving and far superior to all other works in this class, the grotesques of which do not include animal or figure representations except dragons, nor more than a passable medallion and cherubs, whereas here there are angels, nude boys and children, satyrs, centaurs and nymphs, Tritons and Nereids in animated groups, sphinxes and other monsters and, high up, two large figures in the nude representing Adam and Eve. Such a profusion of profane representations, such a riot of paganism, is perhaps not repeated in any other Spanish church, nor can it be explained by the few similar representations upon the tomb of the Viceroy Cardona, by Giovanni da Nola, which Forment might have seen; on the other hand, imitations of Forment's work, more or less suggestive, abound.

The religious statuary of the same retablo carries to an extreme the mark of Berruguete's influence, as shown in the powerful physique of the nudes; the draperies which cling to the flesh; the violent attitudes, all movement and fire; a feminine type of beauty in the treatment of angels and Virtues; children who laugh and gambol, and mournful scenes bordering on the pathetic. Also worthy of attention are the curtains drawn back by little angels, the abundance of garlands, cartouches etc. It is an admirable assemblage of Renaissance fantasies heightened by the gleam of gold and colours, which, besides enriching the whole, give to it veritable miniature-paintings of grotesques wherever the carving leaves room for their display, and even this was executed under the direction of Forment.

Just when he had reached in this work the zenith of his genius and power, he died on the 22nd of December 1540. His pupil, Bernat Lorente, delivered over the finished retablo a few months afterwards, but it is recorded that it was already practically finished in October 1539, when Andrés de Melgar accomplished the gilding and painting. Forment was assisted by the above-mentioned Lorente, by another pupil called Gaspar de Pereda and by several craftsmen, amongst whom were Maestre Cristóbal, Borgoñón, Maestre Francisco and Juan Francés, all these being otherwise unknown.

Nevertheless, the great Valencian master left one posthumous work: the retablo of Barbastro Cathedral, which perhaps would have resembled that of El Pilar, and was likewise of alabaster, but all in the Roman manner. The base was begun with the little statues of St Peter and St Paul, and reliefs of the Presentation and Resurrection, in which the hand of Forment can be recognized; the remainder was the work of his pupil Juan de Liceire, between 1558 and 1560. The upper portions of the retablo are much later and entirely different in style from the older work.

FOLLOWERS OF FORMENT

In comparison with the above, the work produced in the time of Forment by his disciples and imitators offers scanty interest, lacking as it is in emotional power. Juan de Salas worked at Cariñena, executed the base of the retablo of San Mateo in the Maestrazgo, and completed the decoration of the choir in the cathedral of Palma, Majorca, between 1525 and 1536. Gabriel Joly went to Teruel in 1536, executed the retablo of Saints Cosmas and Damian, one of the several altars in the parish church of San Pedro, and died two years afterwards, leaving unfinished the high altar of the cathedral. The important crucifix of Calatorao, perhaps the best of this school, may be from his hand; but not so the high altar of the above-mentioned church of San Pedro, a pendant to that of the cathedral, both having been left unpainted and showing the original colour of the wood. The latter is the work of another artist, perhaps the already-mentioned Juan de Salas, who finished likewise the above-mentioned high altar of the cathedral and made those of San Pedro at Albarracín and the parish church at Cellas, now reduced to fragments. Another Frenchman, Esteban de Obray, a clever decorator who worked a good deal at Tudela, furnishing several churches with retablos, constructed, together with the stone-cutter, Juan de Talavera, the fine portal of Santa María at Calatayud, which dates from 1524 to 1528, and lastly, undertook in Saragossa, in collaboration with our old acquaintance Juan de Moreto and the carver Nicolás de Lobato, the great work of the choir-stalls of El Pilar, in the year 1544. The latter are very rich, of immense size, and possess fifty-nine reliefs, forming the backs of the upper stalls, among them being some which are by no means insignificant.

In this work can be observed the same development in ornamentation as in the retablo at La Calzada, that is to say the predominance of animated subjects in the grotesques, in conformity with the example of the Castilian schools, and persisting among the Aragonese masters of the second half of the century. The principal artists were Pedro de Moreto, son

20

of Juan and brother-in-law of Obray; Bernardo Pérez, probably the son of another sculp-
tor, called Juan Pérez, a Biscayan who assisted Juan de Moreto in his last works, and
Juan de Liceire, already mentioned as a pupil of Forment. They decorated sumptuously
the chapel of St Bernard in La Seo at Saragossa, endowed by Archbishop Don Fernando
de Aragón, between 1550 and 1555, with works in alabaster, including the retablo by
the first-named artist, the tomb of the archbishop by the second, and that of his mother
by the third. All three are very uniform as far as composition and style are concerned, but
Moreto's work is notably superior in correctness, softness of modelling and good taste,
despite a certain affectation, a symptom general at that time, and inevitable at a time when
the theories of Michael Angelo were having a confusing effect upon art outside Spain;
but the group of the Virgin among angels, which represents the vision of the titular saint
of the chapel, is nevertheless admirable in its delicacy.

In this chapel another very illustrative problem is offered by the tympanum of the arch-
bishop's tomb, which represents the Last Judgement. A tradition handed down by Jusepe
Martínez, about 1630, assigns the plan of this chapel to Gil Morlans the younger, although
others may have helped in the completion of the decoration, and relates that this relief of
the Last Judgement is the work of the celebrated Gaspar Becerra, whom Morlans is said
to have entertained as his guest upon his return from Italy. Dates do not help to prove
the matter: over the relief is written the year 1552; Morlans must have died in 1547 and
Becerra did not come before 1556; but the fact remains that this piece of sculpture is greatly
superior to anything else in the chapel. In style it is wholly Italian; it is clever in compo-
sition and technique, while the conception of the scene is original, like a "Sacra Conver-
sazione", unostentatious, yet full of grandeur. We can judge Becerra well by the high
altar of Astorga, and the comparison compels us to deny him the attribution of this work,
which, on the other hand, is closely related to those of Pedro de Moreto, who may perhaps
have executed it following some drawing received from Italy.

Another piece of sculpture, the authorship of which we cannot rescue from oblivion, *Plate 13*
is reserved for us in the beautiful chapel of the trasaltar in Valencia Cathedral. The ala-
baster decoration displays three arches with a balustrade and four small figures above,
the whole being similar to what, for example, Juan de Moreto and Salas accomplished
in Saragossa after 1520; but as regards the figure-sculpture, also of alabaster, which belongs
to this retablo, the resemblances are limited to the great depth of the relief, which allows
the figures of the foreground to stand out disengaged, as in the reliefs of Forment. The
subject is the Resurrection, with the novel feature that Christ does not appear standing
on the sarcophagus, nor in front of it, but among the clouds, surrounded by angelic chil-

21

dren and cherubim; all round, the usual band of soldiers, in Roman costume, is grouped in expressive and carefully studied poses; the scenes at the back are on a small scale and in low relief, with two angels flying, the Marys, the Calvary, and a few buildings and trees. The sarcophagus itself is adorned with a moulding, a lion's head and little angels holding the sheet, almost unique in design. It is a work of the High Renaissance, elegant and of great technical ability, without obvious relationship with anything else in the peninsula, nor can it be easily ascribed to any Italian master. Nevertheless, in it reigns the spirit of Buonarroti; but, disconcerting as it may seem, with a striking and impetuous freedom.

The Old Cathedral of Saragossa possesses another great decorative work belonging to the same epoch, that is to say after the appearance of Forment, and to a famous artist of whom, however, we know little. This is Martín de Tudela, who finished in 1560 the oldest portion of the choir enclosure, which is of stone and encloses the front and one half of the right side with an arrangement of balustered columns, niches with saints and reliefs of episodes alluding to their lives; all very elegant and correct. The reliefs, for example that *Plate 14* of the martyrdom of Saint Lawrence, are finer than usual, and are more accurate in tech-nique than capable of inspiring interest or emotion; the decorative portion is crowded with little nude figures, and two friezes represent the triumphs of Neptune and Amphitrite, the latter depicted with sensual ardour. Upon the altar in the middle of the trascoro stands a Calvary of painted wood, in the same style as the rest, the expressive delicacy and composition of which surpasses the work produced in Aragon during this century, the St John being rather reminiscent of Berruguete.

At the same time, from 1562 to 1564, the trascoro of Barcelona Cathedral was completed by a Saragossan sculptor named Pedro Vilar, with two reliefs of Saint Eulalia, harmoniz-ing with that executed by Bartolomé Ordóñez, of whom we shall speak in the right place. Of white marble, the whole was sculptured in Italy, the part due to Vilar being very in-ferior; nevertheless, it constitutes what little Barcelona can show of the Renaissance. Some-what earlier is the decoration of the porch of San Miguel, with three beautiful statues and decorated pilasters, bearing the signature of René Ducloux, doubtless a Frenchman.

On the other hand, Aragon during the whole century enriched herself with retablos. Somewhat similar to that by Martín de Tudela is one in Huesca Cathedral, of wood and alabaster, painted in colours, in which the principal group represents the Adoration of the Kings. To the same sculptor is attributed that of Saint John the Evangelist in the church of La Magdalena at Tarazona, which seems earlier. The tomb of the abbot of Veruela, Don Lope Marco, who died in 1560, almost rivals, in richness if not in merit, that of his patron, Archbishop Don Fernando de Aragón. Lastly, the monastery of Rueda erected a

22

retablo of alabaster with fine reliefs, which is said to have been made by two unknown masters in 1607, although it appears to be of earlier date. It is now preserved at Escatrón, though placed in a bad position. But the Aragonese school had to give place at last to the Castilian, which burst in from Navarre and the Rioja with tempestuous whirlwinds of baroque, and with that latter school we shall have to study this posthumous phase.

This tardy influx of Castile represents on the one hand the entry of the Basque element into sculptural activity, for hitherto the Basques had but furnished the whole of Spain with hard-working stone-masons; and on the other hand the exhaustion of Aragon, which followed that of Catalonia and Valencia, although Valencia fiercely maintained her independence, but only in the realm of painting, in the seventeenth century.

III

A NOTE ON PORTUGAL

ON THE OTHER side of the Peninsula, in Portugal, is to be found a very interesting pheno-
menon: the Manueline style comes to fruition in decorative architecture; Portuguese paint-
ers, first under Flemish and later under Italian influence, form a brilliant band. Only
sculpture languishes, still in the hands of foreigners: Spaniards, Flemings, Frenchmen, the
latter in the great majority, and all of small account. Although History singles out the
name of a celebrated Italian, Andrea Sansovino, who arrived before the end of the fif-
teenth century, all trace of him in this country has been lost. The character imprinted by
these foreigners on Portuguese sculpture during the first decades of the sixteenth century
did not differ from that of districts in Castile just across the frontier, the least significant
in themselves but important as a whole, such as Salamanca, Zamora, León and Galicia:
the ornamentation is elegant, likewise the sculpture and statuary, but with nothing cha-
racteristic, nothing distinctive. Thus a peninsular branch appears to detach itself, Gali-
cian-Lusitanian-Leonese, indifferent to the classical, yet not averse from its graces, without
discrimination, so that if in the lowlands it was hampered for want of stimulant, the
table-land of León, on the contrary, received a fruitful stimulus from Castile, incorporating
it with her own reconstructive movement which added so much to the value of her art.

As in Spain, the transition from Portuguese Gothic, passing through the Manueline
style, affected sculpture but little, but not so the ornamentation, wherein there is always a
recognizable sign of Renaissance influence awaiting discovery. The royal tombs of the
convent of Santa Cruz at Coimbra are more primitive than the portal of the hospital
at Santiago de Compostela, both being contemporary French works, dating from about
1517 to 1520, as is likewise in its entirety the very rich pulpit in the same convent, dated
1521. However, earlier than this, that is to say after 1517, a master of distinction, the French-
man Nicolau Chanterene makes his appearance at Belem and then at Coimbra, working
till after 1538; to him belong the beautiful and delicate decorations, which, however, lack
inspiration and personal character, so much so that his work is confused with that of
Jean de Rouen, at work at Coimbra from 1531 till 1580, in company with other unknown
artists. This group erected portals, like the "Especiosa" of Coimbra Cathedral, thoroughly
classical in style; arched tombs, like that of Gois, with a kneeling effigy and an exquisite
bas-relief of the Assumption, dated 1531; retablos, like that of alabaster and dark-coloured
marble, in what was the monastery of Cintra, dated 1532, and another similar work which

exists in San Marcos, near Coimbra, earlier than 1530, both the work of Nicolau; likewise the high altar of the church of Guarda, attributed to his school, a notable example of architectural composition; and lastly, figures, such as the group of the Last Supper, made of clay by Hodart or Olarte, a Frenchman, in 1531; and that of the Entombment of Christ, especially worthy of praise for its delicacy, both these being in the museum at Coimbra. In like manner the tomb of Don Juan de Noroña, in San Pedro at Obidos, with, amongst other groups, a Pietà, deserves special mention. What we do not find are local characteristics sufficient to dispel the cold formality of these works, nor indeed are there any discordant tendencies beyond those which might be caused by the effect of Portuguese taste. The national impassiveness entrenched itself more firmly and for longer here than in any other part of the peninsula, and consequently its contributions remain valueless for the history of Spanish sculpture.

THE RENAISSANCE IN CASTILE

FAR FROM the coast, where trade offered a ready channel to the superabundant activity of foreigners, and far also from the quarries of alabaster which fostered imitations of Italian art, the new ideas, contagious as they were, could not easily bring about an artistic revolution. In the heart of Spain, in Castile, the land of easy-going farmers and proud graziers, absorbed in their own affairs, accustomed to the sight of an art already mature and developing by virtue of its own merit, the Renaissance only came into favour if encouraged by the country itself under special circumstances which satisfied its longing for self-dependence and autonomy. The revolt of the "Commons" of Castile in 1520, against the European policy of the Emperor Charles, bears witness to this supreme aspiration, and it is remarkable that its heroine, the widow of Padilla, who defended Toledo, was actually the daughter of the great supporter of the Castilian Renaissance, Don Íñigo López de Mendoza, Conde de Tendilla. It was he who commissioned Domenico Fancelli with the tomb of his brother, the archbishop of Seville, mentioned above; he who presented at Court the same artist, who was there charged with the construction of other tombs; he who probably exerted his influence upon his uncle, the Great Cardinal of Spain, to enamour him of Italian art, on the occasion of the decoration of his college of Santa Cruz at Valladolid during the years 1489 to 1491, and he it was who kept in his employ the architect and sculptor Lorenzo Vázquez for the construction of the church of San Antonio at Mondéjar, in Alcarria, before the year 1509, the first religious building in Spain where the Roman style prevailed.

IN TOLEDO

The posthumous works of Cardinal Mendoza were his mausoleum and the hospital of Santa Cruz in Toledo. The first-named stands in the Capilla Mayor of the cathedral of that city; it is built of Italian marble, with three arches in the lower storey which were to have been left open, but that in the centre was afterwards closed; above is another arch containing the sarcophagus; the tympana are filled with bas-reliefs and, in the niches on each side, upon both façades, are two series of statues. Italian though the design may be, it presents, nevertheless, certain novel features; the sculpture and architectural details show a complete resemblance to the work of Andrea Bregno in Rome and Siena, but its statues are discordant for the most part, revealing an ungainliness both in composition and the

types portrayed which is much more northern than Italian. The monument must have been erected between 1495 and 1503, but we have no knowledge as to its creator. It is on record that in 1500 Andrés Florentín made a statue as a sample for the high-altar of the same cathedral; but although Andrea Sansovino, who returned at that time from Portugal, has been mentioned in this connection, it is actually impossible to ascribe to him any part of the tomb.

In the arch of this monument, closed to form a little chapel, a bas-relief of St Helena with the Cross and the Cardinal adoring it, as well as the surrounding ornaments, all of alabaster, are a curious local adaptation of the Italian style, which we may possibly attri-bute to the master Copín, formerly a follower of the Gothic style. To the same artist be-longs, in the high altar of this cathedral, one half of the figure-sculpture of its lateral por-tions, executed from 1500 to 1503. The other half is the work of Sebastián de Almonacid, more forcible and with greater movement in the draperies, with intelligent heads and the expressions varied to accord with the personages represented, as is seen for example in the four statues of Apostles on the base, at the ends of each side, which are probably his work; nevertheless, he did not give satisfaction to the cathedral chapter, who insisted on certain corrections, nor did he work there again, although it is certain that he was living and esteemed in 1527. Copín was devoted to Lombard ornamentation; his monotonous designs become more and more lacking in interest, and his work in the cathedral lasted until 1517. It seems that he was a Dutchman; on the other hand, the name Almonacid is certainly Toledan, so that the difference of temperament, so strongly marked in the two men, fully vindicates our judgement of the personal force of Castilian sculptors.

The hospital of Santa Cruz in Toledo was building from 1504 to 1514; its archi-tecture is entirely in the Roman or rather Lombard manner, but we have no knowledge of its builders; the portal, however, attains a high degree of sculptural excellence, filled as it is with statues, in which we seem to recognize a French master of the school of Touraine, with a technique not very different from that of Michel Colombe. Even greater is its de-corative value, both on account of the exquisite Italian style of the ornamentation, which gives place, nevertheless, to Gothic vagaries in the finials, consoles and mouldings, and on account of the masterly composition, exuberant and remarkably free.

VASCO DE LA ZARZA

Not long ago there emerged from oblivion an artist of great significance in the history of our Renaissance, Vasco de la Zarza. Educated in the Lombard school of Amadeo, of

the style of the Rodari and Briosco, and partly under the influence of the Lombardi and of Benedetto da Maiano, he brought to Castile as his favourite medium alabaster and stone, and most of his work consisted of tombs and architectural decoration. An unfortunate effect of the artistic *milieu* in which he was brought up is his lack of ambition and the de-sire to improve, his want of symmetry and refinement; nevertheless, he gives us good work here and there: a degree of splendour then little in vogue, seductive feminine types, and atti-tudes of surprising originality; all clever and facile, and all richly, even extravagantly, deco-rated. But Zarza did not come to Spain with the bearing of a conqueror in order to im-pose innovations on the country; Castilian taste regulated itself by its own initiative, and it was he who had to mask his Italian tendency behind a Gothic passion for ornament, like Forment, creating decorative combinations which did not differ from the old style.

His first known works must have been the very rich tomb of Bishop Don Gutierre de la Cueva, in San Francisco at Cuéllar, and the altar-piece of Ávila Cathedral, upon which he was working at any rate after 1499. The tomb is of alabaster; it surpasses in size that of the Infante Don Alfonso in the Cartuja of Miraflores, which is of the same type, and likewise possesses some affinity with the tomb of Archdeacon Diego de Fuen-tepelayo in the cathedral of Burgos, both works of Gil Silóee which perhaps he took for models, giving even more importance at Cuéllar to the cresting of figure-sculpture and finials. The Roman taste is limited in this tomb to the mouldings, a few shells and the groundwork of some of the decorations in bas-relief, some of which are of so decadent a type that we must lay them to the charge of Gothic carvers, indifferent to the Lombard foliations, though skilled enough to execute the thistle crestings which surmount them.

The retablo in Ávila Cathedral is of gilded wood and forms a simple frame for its admirable pictures; its outline is defined by the hard line of the framing borders. It pre-serves traces of Gothicism in the robust setting of the panels, in the open-work decoration and the twisted thistle crestings, and even in certain of the rather modest pillars. But the general columniation, with its low columns and all the carving in low relief, is of Lom-bard character, the latter being modelled drily and with florid angularity.

But Zarza, perhaps before completing this retablo, reached the height of his Renaissance achievements in another magnificent tomb near that of Bishop Don Gutierre and destined for the second wife of Don Beltrán de la Cueva, the patron of the convent. Here every trace of Gothicism disappears, except in minute details in some of the niches, in order to display a sort of triumphal arch, adorned with Corinthian pilasters, two upper stages su-perimposed and crowned with a pediment and candelabra; everything is irregular from the classical point of view, but graceful and original, with ample space to give play to the

decorations and statuary which animate the whole. In the ornamentation, the compositions drawn from nature, lilies, pinks and vines, which alternate with the grotesques, are interesting; in the midst of the sculptures lies the recumbent effigy of the young duchess, Doña Mencía Henríquez de Toledo, a really delightful figure and one in which the frankly naturalistic note reaches its highest pitch. Both tombs, torn from their sites when the church was doomed to destruction, have been sent to New York, where the Hispanic Society preserves them, in fragments, in its museum. A few other fragments remain in the Archaeological Museum of Valladolid.

In Toledo Cathedral there is another great tomb by Zarza, that of the Bishop of Ávila, Don Alonso Carrillo, who died in 1514, and it is the only tomb which this artist signed. It is likewise arched, very fine in design, with decorated columns and, above, the statue of Our Lady with the Child seated on her knees, of very Italian type. Another tomb in this church, that of Don Íñigo López Carrillo, Viceroy of Sardinia and brother of the bishop, is remarkable for the heraldic basrelief of its front. Probably there are more tombs of his in the same cathedral; he gave the design for the panels of the door of the chapterhouse, and decorated a few inside doors of the hospital of Santa Cruz.

The cathedral of Ávila possesses, besides the retablo, a number of works by Zarza, preeminent among them being the embellishments of the trasaltar, or wall between the *Plates 15, 16* Capilla Mayor and the ambulatory, with the tomb of "El Tostado" ("the Tanned") in the middle. It is of alabaster, rather like a retablo, with the statue of the famous and venerable bishop, seated and writing, beneath an architectural composition with columns and an attic storey. The four lateral wall spaces, made of stone, display similar architectural compositions, much decorated, with figures of the Evangelists in the middle, sturdy and of a certain very Spanish ruggedness; on the other hand, the central frieze, with the cavalcade of the Magi, appears to be a reminiscence of Lombardy. The tabernacle of the high altar is also of alabaster, very graceful in composition and with reliefs endowed with an expressive movement exceptional for that time. In the decoration of the baptistery he carried out his usual design of columns, inspired by Roman candelabra, while others are covered with decoration and have a circlet a third of the way up after the Venetian manner of that time; all this and other details date from before 1520. The last works of Zarza were the tombs of Doña María Dávila and of her first husband, the accountant Arnalte; that of the latter, now reduced to fragments, in the church of Santo Tomás, the former, with its very beautiful recumbent effigy, being in the choir of the convent of Las Gordillas; lastly, the altarfront of the oratory, within the sacristy of the cathedral; all these are at Ávila, where Zarza died in 1524. His work grew more and more delicate as he continued

to follow the example of Domenico Fancelli, whose most beautiful tomb was in Santo Tomás at Ávila, and he must have even had the opportunity of knowing Fancelli personally, since the latter came to judge his works in the cathedral in 1518. In a sphere less narrow than that of Ávila, with encouragement and good pay, Zarza would certainly have reached greater heights; but even as it was, his good taste, simplicity and poetic feeling single him out with the marks of a vivid personality in this dawning of the Renaissance.

FELIPE BIGARNY

The Italian influence which so powerfully dominated our painters: the Fernandos in Valencia; Alejo Fernández in Seville; the great Pedro Berruguete and the amiable Juan de Borgoña in Toledo and Ávila, would have ended, with the help of Forment in Aragon and our own Zarza in Castile, with the elimination of colouring from sculpture. The favourite type of monument in Spain, namely the tomb, tended towards such a solution of the problem, but ecclesiastical tradition intervened and polychrome sculpture, fortunately, won the day. Otherwise, the emotional expression of our art would have definitely gone from bad to worse, but our painters took upon themselves to co-operate in the task, completing with their brushes the plastic effect.

The wooden Gothic retablo, entirely gilded and painted in colour, reached its zenith, marvellously ornamented, at Burgos, and when Toledo rebuilt the Capilla Mayor of her cathedral, every effort was concentrated on endowing it with a worthy high altar; this was in 1498, and the choice fell on Gothic. A Frenchman, Peti Juan, and a German, Maestre Rodrigo, undertook the carving, the Gothic character of which only at the last moment was corrupted with a few Roman mouldings. For the sculpture, designs were asked from the already-mentioned Andrés Florentín, Zarza, Maestre Felipe Borgoñón and perhaps from others; in the end it was Copín and Almonacid, as we know, who did the work; but in 1502 the above-mentioned Maestre Felipe began the four central groups, finished in 1504, thus establishing his pre-eminence over all the other sculptors.

At first sight, his share in the magnificent high altar at Toledo is hard to distinguish from the rest; it is even probable that his fellow-workers strove to emulate his style, and in reality there is little variation among them all, since Felipe was inspired from the North, with only a superficial touch of Italian influences, preserving as he did the naturalistic types, the deep folds of the draperies, the naive attitudes, and the pious sincerity of the Gothic masters. A certain anatomical knowledge shown in the Calvary, the Corinthian pilasters in the background of the scenes of the Nativity and of the Assumption, and the

31

Roman appearance of the silver throne of the Virgin, prove that the artist but timidly pur-
sued the new direction in art.

He deserves to be recorded with some tenderness. Felipe Bigarny, better known under
his nickname of "de Borgoña", for he was a native of the diocese of Langres, came in
1498, perhaps as a pilgrim on his way to Santiago, but, passing by Burgos, he undertook
the three great reliefs in the centre of the trasaltar of that cathedral, which turned out even-

Plate 17 tually to be his masterpiece. They represent the Via Dolorosa, the Crucifixion, a Pietà
and the Resurrection, and it is noteworthy that the first, finished in 1499, represents the
Gate of Jerusalem decorated in the Roman style, with certain reliefs showing a taste
for the mythological and, standing at the side, a figure of Eve which might almost be a
Venus by Praxiteles; in the others, all is true to nature, correctly modelled and well grouped
in deep compositions; the dresses are those of the day, the human types distinctive, senti-
ment and beauty unforced; while in the last relief, unfortunately much damaged, with its
two most graceful figures of prophets on each side, emotional feeling rises and interest is
at its highest point. The local surroundings were then making their impression on the
artist, who refines his figures to resemble the Castilian type and accentuates the devotion
in their faces. They stand to witness the artistic apprenticeship which he brought from his
country, and bear a vivid resemblance to the Entombment of Christ at Solesmes, dated
1496, a fact which almost points to Borgoña as author of that group, the most precious
of the period in the region of Touraine, which is equivalent to saying, in all France.

Having finished these works in Burgos and Toledo, Maestre Felipe carved other small
figures of wood for the retablo, also Gothic, of the University of Salamanca, some of them

Plate 18 very beautiful, such as those of the Virgin and Saint Jerome writing. After this the
stone-carver Pedro de Guadalupe gave a decisive impulse to the Romanizing stylistic
tendencies in the high altar at Palencia, making for it, from 1505 to 1507, an archi-
tectural composition of little pilasters in three orders upon bases, some very small columns
in the upper part, cornices and entablatures, all full of Lombard ornamentation, with
constant repetitions; in the centre, scallop-shelled niches contrived for single statues al-
ternate with panels which the celebrated Juan de Flandes painted; all rather paltry and
inferior in the *coup d'œil* to the Gothic retablos, but only thus could the new style come to
fruition for the first time in such surroundings. The sculpture of this retablo shows deca-
dence in its craftsmanship and it is probable that having made sure that his workmen were
actively busy, Maestre Felipe shifted on to his pupils and foremen the execution of the
task, and did not himself do more actually with his own hand than carve the faces of
these figures; on the other hand, as the resources of his imagination were not enough to

32

give sketches and models in great variety, the result was disastrous, as this retablo makes very clear. The inferiority is accentuated in the companion retablo, that of the convent of San Pablo, in the same town; in certain small retablos and the stalls of the cathedral of Burgos; in the portal of Santo Tomás at Haro and that of the convent of La Piedad at Casalarreina, all works of the second decade of the century.

Then, on the 7th of January 1519, Felipe appears in Saragossa, undertaking every kind of work, and for four years he was in partnership with Alonso Berruguete, who had just returned from Italy. It was there that they both obtained important commissions for the Chapel Royal at Granada. We come across them again and again uninterruptedly; Berruguete working on his wall-paintings for the above-mentioned chapel and Felipe carving his great retablo. With them was also associated another artist, Jacopo Florentino, l'Indaco, whom we shall get to know later on.

This retablo contradicts from every point of view the judgement, formulated above, of *Plate 19* the decadence of the Burgundian master. The result is a veritable triumph, although we do not know whether to ascribe its merit to his new companion or to the Florentine, or perhaps to both. In any case it decided once and for all the route which the Spanish retablo should follow: made of gilded wood, stately and of imposing lines; carved in relief deep enough to be enjoyed from a distance; the figures, of large size, richly coloured and painted with all the force of a striking realism, arranged in groups wherein feeling reaches even the pitch of brutality, as in the beheading of the Baptist, and with human types *Plate 20* of immense racial vigour. Architecture is made more refined by the use of balustered columns with finer bases and entablatures, to the great advantage of the sculptural effect of the whole. The Spanish Renaissance, in its religious phase, establishes itself at one stroke in a rank peculiar to itself, superior to the Italian Renaissance, superior to the Aragonese, escaping as it does the danger of losing itself in the empty formulas of classicism, of the mannerism which was never to triumph completely in the peninsula. After that, the victory was complete, as is shown in the high altar of the Constable's Chapel in *Plate 22* the cathedral of Burgos, made jointly by Felipe and Diego Silóee in 1523 and 1524. It is a retablo both original and magnificent, characterized by a life and impetuous movement never before remarked in the Burgundian, which we must attribute to the suggestions of his new partners. When these disappear, the work of Maestre Felipe once more declines, and this time definitively, while art around him was developing progressively, as we shall see, in mastery and representation.

Bigarny, at this stage of his career, indulges in fantastic flights, unsuspected in his work up till then; unbalanced postures, carelessly arranged draperies; disorder without modera-

33

tion; pomp of circumstance without spiritual depth; a false baroquism as if in the face of deficiencies which allowed no other way of escape. Then it was that he executed the alabaster tomb of Canon Lerma, in the cathedral of Burgos, reminiscent perhaps more of French works than of those by Fancelli, with its series of portrait medallions, dated 1524. In 1531 he received a commission for another very rich tomb, that of the founder of the college of San Gregorio in Valladolid, destroyed by the French, but in Toledo Cathedral there still survives the little alabaster retablo of the Descent from the Cross or "Virgin of the Pillar" made in 1527, and it seems impossible that this can be from the same hands as the trasaltar of Burgos, so baroque and slovenly is its execution. The small bas-reliefs, relating to St Ildefonso, very flat like those of the base of the high altar at Granada, which

Plate 21a

represent the entry of the Catholic Sovereigns into the city and the baptism of the Moriscos, exhibit a very interesting manner of Bigarny, wherein he illustrates scenes from life with observant fidelity, and with a technique in the perspective which is more Italian than anything in the rest of his work. They are reminiscent of medals, the art of making which he

Plate 21b

may well have practised, since we possess one of Cisneros, which was perhaps made by Bigarny, for we know that he drew his portrait as well as that of the humanist Lebrija.

Bigarny's reputation in Castile is astonishing; his general culture in all the arts received immediate praise; his reports, projects and instructions, including those which concern architecture, kept him constantly at work, and he was rewarded with honours seldom lavished. His censure of the retablo by Berruguete for San Benito at Valladolid is of a severity which concords ill with the long-standing friendship between the two artists, and the same fickleness is apparent in his dispute with another Frenchman, a sculptor and his own assistant, whom he used to describe earlier as his brother and friend. With the exception of a nucleus of Aragonese sculptors with whom he seems to have got on well, Maestre Felipe formed no school, properly speaking, in Castile; everywhere are to be found works which appear to be inspired by his mastery, but they are all without coherence, vulgar and insipid, while those who could have been his followers, such as Ordóñez, Diego Silóee and Balmaseda, do not imitate him, nor does there appear to have been any friendly intercourse between them. The influence of Bigarny appears to have been due to his relations with the upper classes; he had a brother who was a doctor; of his sons he gave two to the Church; while one who followed in his father's profession was the son-in-law of the architect Covarrubias, and he married one of his daughters to Borgoña, King-of-arms to the Emperor.

Nevertheless, the favour which Maestre Felipe enjoyed in Toledo is proved by the commission he was given in 1538 for the design for the upper stalls of the cathedral choir;

and then, at the beginning of the following year, he was entrusted with the execution of one half of them, being given the preference over Berruguete to whom was entrusted the other half. This was his last work, and it even seems like the reaction of old age towards his customary formulas; in the lofty row of alabaster statues representing biblical figures the vulgarity of his style stands out in sharp contrast to the work of Berruguete which faces them; some being mere puppets dressed up in the Roman fashion, theatrical and with little variety; others simple and less ridiculous figures. The wooden backs, with saints and patriarchs, seem better, partly owing to the influence of Berruguete and partly because we recognize in some of them the hand of Gregorio Pardo, his eldest son, whose later works we shall examine. Bigarny died in 1543, and earned an epitaph in the cathedral itself eulogistic not only of his work but of the manner of his life. As a posthumous work there remains the retablo of the hospital of Santa Cruz at Toledo, ordered in 1541, but which his hand never touched. We may, however, attribute to his better period a group of the Virgin seated with the infant Jesus and John the Baptist, at Barco de Ávila, and perhaps the panel of St Andrew in the choir-stalls of San Benito at Valladolid.

Plate 23

THE FOREIGN GROUP

Of a like artistic type to Bigarny there was another sculptor, perhaps a Frenchman, named Maestre Gil, or Gille de Ronça, as he signed himself, who worked, between 1509 and 1534, at Salamanca, Zamora and Tordesillas. Most of the sculpture in the "Gate of Pardon" of the new cathedral of Salamanca must be his, especially the Calvary and many figures in the archivolts. By comparison we may attribute to him another Calvary, some of the innumerable little saints in the Capilla Dorada of this same cathedral, a third Calvary of wood, and the recumbent effigies of Arias Pérez Maldonado and his wife, in the church of San Benito. Incorrect as sculpture, but curious in the highest degree, are the panels in the balustrade of the staircase in Salamanca University, where are displayed on both sides and between fanciful ornaments in the Lombard taste, bull-fights, tournaments, dances with accompanying musicians, pipers, jugglers, etc., giving us an idea of the amuse-'ments and types of that day.

Plate 24

In Seville a certain Maestre Miguel distinguished himself, executing an ever-increasing number of clay statues for the cathedral between 1517 and 1526, but he was still alive in 1552, although too ill to go on working long before that date. He must have been a foreigner, but not a Florentine, as has been said, confusing him with Domenico Fancelli; to judge by his style, it is more likely that he was a Frenchman, but, like so many others,

he may have completed his training in Lombardy. It is to him that we owe the figure-sculpture of the "Gate of Pardon", with its great relief of Christ casting out the money-changers from the Temple, represented as a building of Italian type; in the group of the Annunciation the angel is depicted clothed in classical fashion, while the Virgin, a lovely and expressive figure, folds her dress in the French manner. In the series of prophets and angels which adorn the portals of the "Campanilla" and the "Palos", the same diverse

Plate 25 tendencies are to be noticed; the tympanum of the latter, which represents the Adoration of the Magi, recalls that of the cathedral of Como depicting the same subject, while the tympanum of the former, depicting the Entry of Christ into Jerusalem, may be compared with that of the church of Neuville-lès-Corbie in Picardy; the views of towns, which form the backgrounds, also seem to be French, while some of the details, such as a palm-tree, camels, turbans and a shield, are inspired by the South. Altogether he is a clever and ingenious craftsman, but without emotion or passion; a few heads modelled from life, here and there a sacred statue like the "Virgin of the Dream", among many other works of his which decorate the top of the trasaltar, are valuable as a proof of the penetration, even in Seville, of that northern eclecticism examples of which we have just examined.

Another Frenchman, Nicolás de León, succeeded Maestre Miguel in the same town, and worked in stone and alabaster, first at Granada, from 1524, and then in Seville from 1531 to 1547. A creditable effort is his St Andrew in the parish church at Granada dedicated to this saint, which is pathetic and touching, as though influenced by the local masters; but his work in Seville is difficult to identify.

Plate 26 Much more importance must be given to a great piece of sculpture in the cathedral of Santiago de Compostela; the group of mourners before the dead Christ, forming a Pietà, with thirteen figures and a town in the background. It recalls in some ways the work of Maestre Miguel and is likewise of clay, but much finer. Compared with the similar groups at Solesmes and Chaource (Aube), which are supreme examples of Burgundian art at the beginning of the century, it is in no way inferior in feeling, naturalness, balance, and even technical exactitude; the rigidity of the Christ, stretched upon the knees of the Virgin, is in admirable contrast to the Magdalen bending at his feet, and all the figures behind express most effectively a devout and restrained sorrow. It dates from about 1522 and it is possible to recognize the author as one Cornielles de Holanda, a Fleming who executed much work here and was still alive in 1545.

After 1513 great decorative schemes were carried out in the cathedral of Sigüenza, beginning with the surpassingly beautiful tomb of Santa Librada, inspired by that of Cardinal Mendoza and with undeniable resemblances to the portal of Santa Cruz

at Toledo. It is adorned with figures in niches and there are others on the adjacent tomb of Bishop Don Fadrique de Portugal, all of them remarkable for their grace, although lacking appeal and monotonously alike. Alonso de Covarrubias, the architect and splendid decorator who began by practising sculpture, was concerned in this work; but most of it is to be attributed to Francisco de Baeza who, in 1514, left in that very place the Virgin "de la Leche" or "del Cepo", a statue of strong individuality, carved in alabaster and painted.

This centre, of Toledan origin, fruitful in beautiful decoration of obviously Italian inspiration, had its counterpart at Burgos with Francisco de Colonia, who, however, is much more extravagant and coarse in sculptural decoration. The Portal of the Furriers in the cathedral there, dating from 1516, a stone retablo and a chapel in the church of San Esteban, as well as the palace of Peñaranda de Duero, may be mentioned as examples. Francisco de Colonia's sculptures are of even less value, and it is surprising that Maestre Felipe should have had so little influence upon them.

JUAN DE BALMASEDA

Returning to the Gothic style, we find in the high altar in the cathedral of Oviedo what is probably a copy of that at Toledo, though it is also closely related to that at Burgos. The sculpture is of interest for its naturalistic and sincere expression. Most of it was executed apparently in the time of Bishop Ordóñez de Villaquirán, between the years 1508 and 1512, but positive information is lacking. His successor Don Diego de Muros went on with the work and then it is that the sculptor Giralte appears as the artist in charge of the retablo, and Juan de Balmaseda as the figure-sculptor, between the years 1516 and 1518. We know for certain that the latter renewed a few of the figures, amongst them three from the scene representing Christ revealing himself to St Thomas, and by comparison we can attribute to him the Crucifixion, the Resurrection and perhaps the Christ at the Column, as well as some of the prophets in the frame borders, leaving it a matter of doubt whether Balmaseda was associated with the first sculptor of this retablo. In addition to the costume of some of the angels, the ornamentation of the tomb in the scene representing the Resurrection and the throne of the Saviour are already under the influence of Romanism.

The later movements of the same artist, as known by documents, show that in 1519 he was completing with a Calvary the retablo executed by Bigarny in Palencia Cathedral; in 1520 he was in Burgos, where also was his friend the great iron-worker or "rejero" Cristóbal de Andino; in 1527 we find him at León and in 1548 again at Palencia, when he declared himself to be fifty years old, more or less; he must certainly have been older.

The above Calvary is surrounded by decoration in Lombard taste, similar to that by Francisco de Colonia and not nearly so fine as that of Bigarny. On account of its identity in style we can assign with certainty to Balmaseda another retablo with a Calvary and *Plate 28* the Evangelists in León Cathedral, as well as the figures in the Lázaro collection of the Virgin and St John weeping, attributed to Berruguete. Certainly also by him is the statuary of the retablo of Villamediana near Palencia; the architecture is almost entirely Gothic save for the ornamentation of the borders; it must be earlier than the Calvary at Palencia and is filled with beautiful figures, original, and, above all, expressive.

Far more interesting is his later development, which appears to reach its zenith in a group of sculptures in the Constable's Chapel in Burgos Cathedral. The lateral retablo in the Gothic style, dedicated to St Anne, must be the last work of Gil Silóee. He was obliged to leave it unfinished, and the additions, including three large figures of St Mary, Martha, and Mary Magdalene, another small figure and the enchanting group of the *Plate 27* Dead Christ supported by two angels, as well as the painted and gilded Italian ornaments, all of which are very different in style to the earlier portion, appear to have been executed by Balmaseda, who thus wins in our eyes an undeniable pre-eminence, unless some document should come to light which contradicts this supposition. In front of this retablo is another, dedicated to Saint Peter, but architecturally in the Roman manner, replete with decoration and arranged in two orders of Doric and Ionic columns, niches with scallop-shells and a canopy forming another order of little balustered columns, with medallions and pinnacles. So long as no contrary evidence is forthcoming, we may attribute it to Diego Silóee, and it must have been executed before 1523, the year in which León Picardo was paid for gilding and painting it. The figure-sculpture, closely related to the above-mentioned parts of the other retablo, is of very unequal excellence; every figure presents a problem of technique and expression and it is impossible to consider separately the figure of Saint Jerome, famous because it has been wrongly attributed to Becerra.

Worthy also of the ardent and rugged imagination of Balmaseda are the panels of the chapel door in the Hospital of the King outside Burgos. Its bas-reliefs represent Adam and Eve penitent, a knight on his knees between Saint James and Saint Michael, and a group of pilgrims, in allusion to the hospital having been built for them. It is a work of brutal realism, in which the hair is represented in corkscrew curls, while there are certain trunks of fantastic trees, anatomical details without reticence and other typical peculiarities.

In retirement later on at Palencia, Balmaseda must have produced much in the more than twenty years of life that remained to him. The retablo of San Cebrián de Campos, full of statuary and reliefs, shows reminiscences of Burgos, both of Diego Silóee's work

38

in that place, and of what is attributed to Balmaseda; the retablo of St Ildefonso, in the cathedral of Palencia, quite certainly belongs to him, although the relief of the Adoration of the Magi is a plagiarism of Berruguete. The same may be said of another little retablo in Santa María de Nieva, and that of Becerril de Campos, the composition and carving of which date it approximately in the middle of the century, while it appears to mark the last stage in our artist's gradual but persistent evolution. His school produced numerous retablos in which the influence of Berruguete walked hand in hand with the impassioned spirit which uplifted Balmaseda from the time of his earliest works, a characteristic due, perhaps, to the Basque origin which can be inferred from his name.

GIRALDO AND RODRÍGUEZ

After Zarza the figure-sculptors Lucas Giraldo and Juan Rodríguez continued his work in Ávila Cathedral, working together upon the alabaster retablo of St Catherine, *Plate 29* the stone trascoro and the wooden choir-stalls. These last they executed in partnership with the carver Cornielis de Holanda, according to all appearances a different person from his namesake of Galicia. Before this, Giraldo was at Saragossa, where in 1516 he appears to have been a creditor of Forment for a large sum; he lived at Ávila from 1524 till 1549. He was probably a Fleming and his work is remarkable for a certain lack of repose in the draperies and poses, with fundamental artistic inaccuracies. To him we may attribute the alabaster group of the "Virgin of the Snows" in a chapel in the same town. Rodríguez worked with more exactness, if without the gift of expression; other works in Ávila belong to him, and above all, the great retablo in the monastery of El Parral outside Segovia, ordered in 1528, and the tombs on each side with their extreme elaboration and their inspiration from Zarza. He died at Ávila in 1544. Amidst all his vast array of work no single statue stands out above the rest.

V

THE EVOLUTION OF CLASSICISM

UNTIL NOW we have seen in Castile only the paving of the way for the classical revival of the sixteenth century: the movement which Michael Angelo led with his enslaving genius. In reality, the style of the masters studied hitherto rests upon a mediaeval, Gothic foundation upon which, little by little, innovations of an Italian type were built up; sometimes it is only the accessories, such as ornaments or architectural details, which define the category of the artist, including or excluding him as a follower of the Renaissance. So it is that Jorge Fernández, in Seville and Granada; Sebastián de Almonacid in Toledo; the author of the retablo of Orense Cathedral, etc., remain aloof, while others, though scarcely differing from them, such as Copín, Gil de Ronza, and even Bigarny himself, pass as disciples of the Renaissance. This condition of affairs reached a crisis about the year 1520 with the appearance of younger artists, whom we are now about to study, although their names have already been mentioned in connection with the influence they exercised upon the sculptors of the older generation. Inversely, the survival of these last, the indolence of their pupils, and later the arrival of straggling artists maintained during many years a state of archaism with carelessness of technique and the monotony of conventionalism, which, in accordance with the conclusions which we have already reached, lasted till a relatively advanced period, though without causing a rupture interrupting the general homogeneity of the style and still less the life-history of the artists.

It is a well-known fact that Tuscany had laboured with classicism for many years, and by this time the style was already far removed from that of the forerunners upon whom was founded the genius of men like Leonardo and Michael Angelo; the conditions, however, were very different in the other countries, inspired with the love for that older Renaissance of the fifteenth century, with its ideal of a life free from conventionalities. Upon such a foundation it was impossible to graft an affection for classical antiquity such as Florence and Rome had experienced by reason of their traditions and the inspiration derived from the sight of their ruins. The sudden change from one ideal to the other — ideals so diametrically opposed — was more than difficult, but there existed one means by which the gap could be bridged, namely the Lombard style, itself midway between the two revivals: old and conventional at heart but clothed in a new garb which, like a thing of fashion, ensured its adoption. In this guise it was able to enter the life of the sixteenth century, not only without stigma but even attracting the attention of those beyond the Alps.

These last mistook the Lombard superficialities for the essence of Romanism, and, assimilating them without difficulty, the schools of the north and likewise Castile evolved in the direction indicated above. But the fault lay in that, trying to adopt a classical appearance, they produced not men, but merely lay-figures. This was the vice of sixteenth-century sculpture not only in the countries of the north but even in Italy, except in the case of Michael Angelo, and except, as we shall see, in Castile; but first we must try to discover the origin of this phenomenon.

Mediaeval art, appreciating the realities of life, sought to understand and to reproduce the impulses of passionate emotion; at one time it laughed, at another it wept; sometimes it sought to express the fundamental in humanity, evolving new types when a transcendent imagination drove it to create them; but all this in its own manner, pleasantly expressed and developing as an enchanting baroque art. From the Rhine to Champagne, a field was ready for the burst of new life represented by the Gothic Renaissance, while France stereotyped her art in the search for graceful and effeminate forms. Both tendencies were anticipated in their turn by Florence with that exquisite delicacy of feeling so peculiarly her own, cherishing at one and the same time the baroque tendencies of Donatello and the classic inspiration of Ghiberti; vitality in the one, perfection and repose in the other. Then came the reproduction of the Graeco-Roman antiques, decadent, cold and mannered, though some of them technically perfect; then Michael Angelo, with his vast creative power, absorbed all that these tendencies had to impart and conceived successively the Captive, the Descent from the Cross, the David and the Saviour. This second classical phase, that of exaggerated though graceful attitudes, that of the anatomically perfect nude, of serene passiveness or intellectual indifference, is the phase, likewise, of apparel draped upon lay-figures cunningly posed; and this is all that Michael Angelo's rivals and imitators succeeded in producing; while the other phase, dynamic and alive, only came to maturity under the chisel of a Bernini. Thus it was that classicism degenerated into mannerism, and spread to France and Germany, countries which had fallen into a spiritual coma as a result of the blows of the Reformation.

In Spain it was otherwise. For a long time Castile had been becoming less and less inclined to work; her tradition of conquests and adventures had decoyed the nobleman, which is as much as saying every man of culture, from wielding a workman's tools; work was considered degrading, and this opened the road to numbers of fortune-seeking foreigners who, with no competition to face, offered their skill for gold. The Moors of Andalusia and the masons of the north rivalled one another in enriching the country with Mudéjar, Romanesque and Gothic monuments; then, with the northern Renaissance,

there arrived sculptors from far and wide, from northern France, Burgundy, Flanders and the Rhine, some of great merit, who left a splendid memorial of their different talents. The inrush continued throughout the sixteenth century and even increased, for the fame of the wealth and extravagant splendour of the religious cult promised more gain in Spain than in any other country. The passion for retablos and portals alone offered enormous possibilities of work.

But the day came when, for the nobleman, proficiency in arms and aristocratic pre-eminence lost their value to a considerable extent. The Castilian was forced to consider how he could save himself from penury by work, and he began to compete with the foreigner in the domain of art. Royal generosity even promised patents of nobility through this channel, although, strictly speaking, there are few examples to confirm this theory. The flood of foreigners continues, but now it is the Spaniards who give the lead, who set the course, and it is the others who have to turn Castilian in order to be successful. we have then, a noble, an aristocratic reaction in favour of the arts in Castile; there are noblemen who, instead of enlisting in the armies to seek their fortune, go to Italy to perfect themselves in art. Pedro Berruguete, triumphant in Italy even among good painters, showed the way by his example, and the result did not disappoint the hopes of that other new generation in which the Fernandos, Pedro Machuca, Alonso Berruguete and Ordóñez rose to pre-eminence.

BARTOLOMÉ ORDÓÑEZ

The school of Burgos, reaching its zenith in Gothic times with the mastery of Gil Silóee, and later, transformed by Maestre Felipe, remained productive and of high quality under three able craftsmen: Juan de Balmaseda, whom we already know, Diego Silóee the son of Maestre Gil, and his illustrious friend Bartolomé Ordóñez. The events of his life so far established occupy but four years. We are completely in the dark as to what he did in Burgos before going to Italy, and when he returned his transformation is such that it is impossible to guess what he had originally learned in Spain; we see only one of his technical peculiarities, the "schiacciato" or flattened relief, in the choir-stalls of Burgos Cathedral, which Maestre Felipe directed between 1507 and 1512; in which there are certain heads and gay little figures so foreign to the taste of Bigarny, that they make one suspect the collaboration of another sculptor, young and full of character.

Ordóñez is first revealed to us as working in Naples in 1517, and here was born to him an illegitimate son named Diego. He contracted for large quantities of marble, and perhaps his work was lost together with the internal decorations of the Castel Nuovo;

however, there is one work known in which he may be supposed to have had a hand. This is the tomb of Galeazzo Pandone in the convent of San Domenico, attributed without foundation to Giovanni da Nola, but which recalls rather the works of Girolamo da Santacroce; and, since the latter knew the works of Ordóñez and learnt from him, the whole problem remains unsolved, except as to the influence which Ordóñez exercised upon the Neapolitan sculptors.

In the year 1518 Ordóñez must have gone over to Barcelona, where he married and had another son. In 1519 new and important commissions, which he obtained from the Emperor Charles and his courtiers, induced him to set up his workshop at Carrara, and there it was that death overtook him at the end of 1520. His known works are the following: in Barcelona, the backs of the choir-stalls in the cathedral, carved in oak with bas-reliefs and architectural decorations of strictly classical design; one half of the trascoro, in marble, that is to say, two reliefs, two statues and the greater part of the surrounding decoration; perhaps also a small relief depicting the Holy Family in the Diocesan Museum. In the Chapel Royal at Granada he executed the monument to the sovereigns Juana and Philip, the Emperor's parents; at Alcalá de Henares, the tomb of Cardinal Cisneros; at Coca, four other tombs belonging to the Fonseca family, and in Zamora Cathedral a group of the Virgin with Jesus and the little St John, all in marble.

Plate 30

Plates 31a, 32
Plate 31b

It is to be noted that at Coca, besides the sarcophagus of Don Juan Rodríguez de Fonseca, Bishop of Burgos, a posthumous work of Ordóñez completed by others, there are three more tombs which may be included amongst his finest known works: they were commissioned by the same bishop, for some time his patron. Of these, two are placed beneath arches; the one, with ornamented pilasters and medallion portraits of Roman emperors in the spandrels, appears to be of Lombard type; the other, richer, has columns of the composite order, decorated a third of the way up, and possessing a scallop-shelled pediment raised above the entablature, with trophies in the angles. As to the sarcophagi, upon which lie the recumbent effigies, all are alike in that they bear coats of arms within wreaths of fruit supported by little angels. It is these details which seem to indicate an apprenticeship with Domenico Fancelli, for the wreaths with their ribbons and the two angels possess an undoubted analogy with the tomb of Ferdinand and Isabella. Apart from this, certain decorative *motifs,* such as the sphinxes which support the tomb of the sovereigns Philip and Juana, are seen in the work of Bregno, from whom also Andrea Sansovino learned their use. The ornamental technique of Ordóñez followed the same course, with bold manifestations of his knowledge of things Roman, but his figure-sculpture remains original, without inclining, even indirectly, towards Michael Angelo, famous

44

by this time; nor is this strange, for the latter's genius, ever masterful and sculpturesque, harmonizes ill with the style of Ordóñez, prone to the sensitive and picturesque. Further, not a single plagiarism can be found, not even evident reminiscences such as those found in the works of Raphael. The comparison, for example, of the thoughtful judge of the trascoro at Barcelona with the Erythræan Sibyl of the Sistine chapel; the little Charity in the choir with the Libyan Sibyl or the Joram in the same chapel; the Baptist of the royal tomb with the Moses; these convince one as being diametrically opposed, while the children of the Sistine chapel, whose series of attitudes are so suggestive, are not continued in the work of the Burgalese sculptor. He adopted special poses and discovered for himself a canon for the human structure, but this was entirely his own.

In the above-mentioned Charity the contortion of the group exceeds the limits of Michael Angelo; on the other hand, the tendency to load the shoulders of the figures, to reduce the size of the heads and flatten the hands, to shirk the nude by covering it with draperies falling in dignified folds, such characteristics are the veritable signature of Ordóñez. But it is in the art of the bas-relief that his talent, long recognized, finds expression, and gains over all his contemporaries. In it are to be noted the gradation of background and foreground, an exquisite sense for the arrangement of the groups, the boldness of the foreshortening, the vehemence and dramatic effect, the good taste and unequalled finesse, a grace in the decorative accessories, especially in the children, and a correctness which scarcely leaves room for a fault. Sometimes, as a result of his naturalness and simplicity, the full-length figures are unsuccessful, but this lack of skill is compensated by features of grandeur and elegance. An austere religious perception, without a taste for the Pagan, inspired his Christ in Limbo, his Burial by the angels, his Road to the Cross, the two large scenes of St Eulalia, the four medallions of the royal tomb, etc., all of them masterpieces, while the decoration, the extravagance of floral ornamentation, enlivened by delicious little figures, monsters, birds, trophies, etc., are also admirable; his architectural compositions are astonishingly correct and their like had never been seen in Spain before: models of classicism, they possess notable peculiarities, such as the decorating of the lower third of the columns, which became the custom with his followers, beginning with those at Naples. All this was accomplished by a youth who had scarcely begun his career when life was taken from him!

Plate 30b

JACOPO L'INDACO

Just at this time there arrived in Spain another master with powers sufficient to eclipse the unfortunate sculptor of Burgos. He was a Florentine and a friend of Michael Angelo,

45

whom he assisted in the painting of the ceiling of the Sistine Chapel, while previously he had worked with Pinturicchio; he executed other works in Rome, but after this we lose sight of him, which makes it impossible for us to adjudge the merit of his work in that city. Vasari, however, praises his drawings. He was called Jacopo l'Indaco, and nick-named the Elder, in order to distinguish him from his younger brother Francesco; but in Spain he was known simply as Jacopo Florentino, and as such he signed himself.

In 1520 he came to Granada, probably in company with Pedro Machuca, and both were perhaps associated with Berruguete. He married the daughter of a carver from Jaén named Juan López Velasco, to whom, with the German, Gutierre Gierero, we owe the beautiful choir-stalls in the cathedral of that city, imitated from those at Burgos. In the very year of his arrival he passed to the work in the Chapel Royal, making designs for the sculp-tors and executing a retablo, carved and with paintings, which has been partly preserved.

Plate 33 It is clear also that the painted stone group representing the Annunciation, over the sacristy door, is from his hand. Although in Italy he is mentioned solely as a painter, here in Spain he not only practised sculpture, but also directed the construction of large and rich build-ings such as the Capilla Mayor of the monastery of San Jerónimo in Granada (up to the level of the cornice), and the lowest storey of the tower of Murcia Cathedral with the por-tal giving entrance to the sacristy. He died early in 1526 at Villena.

Jacopo Florentino and Alonso Berruguete are good examples of the facility and skill with which artists trained in Tuscany were able to generalize their professions, forsaking painting for sculpture, or, like Jacopo again and Machuca, becoming architects. In addi-tion, after examining the Florentine's works, we are astonished at the way in which he adapted himself to the local conditions, and at his typically Spanish outlook, which, in architecture, makes him graft upon the Bramantesque classicism of his native country a lavish display of decorative ornament. This feature was the determining factor in the extra-vagant ideal of the Andalusian Renaissance, and was due in reality to Jacopo, although later Silóee carried it still further. In his repeated plan of ornamenting the uppermost part of the column and fluting the lower (the opposite to Ordóñez) it seems as if he were imitating Andrea Sansovino, but there are no other resemblances between them. As to sculpture, the above-mentioned group of the Annunciation and the portal of Murcia, upon which are found statues of the theological Virtues and two small reliefs of the Evan-gelists, enable us to attribute to him with certainty another work upon a larger scale: the

Plate 34 celebrated Entombment of Christ preserved in the above-mentioned monastery of San Je-rónimo, a group composed of seven life-size figures of wood, exquisitely painted and gilded: the masterpiece among all groups representing this subject.

Nevertheless, if in Ordóñez we could recognize a spirit in harmony with the grandeur and classicism of Michael Angelo, it would seem that Jacopo, on the other hand, although a Florentine and a companion of the sublime master, shuns him. He is revealed to us as a very accurate sculptor, gifted and distinguished, but wrapped in his own ideas, placing emotion, devout and Christian, before the studied rendering of form. We should take him for one of the greatest men of his century, were it not for his simplification of style and the fact that he was addicted to plagiarism. In order to express the keen sorrow of Joseph of Arimathaea and of John, he copied the heads of Laocoön and one of his sons, and in *Plate 35* the same way, the arm of Christ falling upon a cherub perhaps recalls that other in Michael Angelo's Pietà, the difficulty being poorly overcome by a fold in the dress. His nude is admirable in its anatomical perfection and sturdy balance; the head of Nicodemus seems to be taken from life, and as usual the Magdalene is distinguishable by her charms without this preventing her from being absorbed in her grief. The figure of the angel Gabriel is no less surprising in its attitude, full of reverence, and in the stately draperies. The Charity at Murcia appears to dream in Leonardo's manner. A peculiarity of Jacopo are the sleeves with cuffs and ample folds, executed with natural ability, but the satyrs, holding torches, in the spandrels of this same portal, are not a success.

JERÓNIMO GUIJANO

A son of Jacopo, artistically speaking, was his pupil Jerónimo Guijano, who appears at Jaén from 1524 to 1527, working for the cathedral together with López de Velasco, while he succeeded Jacopo upon the work of the tower of Murcia Cathedral and other buildings till the year 1563. His architectural work was very considerable, and as a sculptor he enjoyed a celebrity amongst the best, although only lately have his works become known, nearly all the attributions being conjectures, but apparently well founded. The first, directly inspired by his master, is the great scene of the Calvary in the church of La Magdalena *Plate 36* at Jaén. It is of gilded wood, the relief cleverly graduated in order to make the foreground stand out prominently. It is a little inferior in correction and delicacy to that of Jacopo, but has a young warrior and a Magdalene embracing the cross which are enchanting. After 1527 he executed in the cathedral of Murcia the very rich sacristy chest, especially the bas-relief of the Pietà, with many figures in a daring and lively composition, but the features of the background, rendered to excess, are confusing. In the same place, in a chapel entirely decorated by Jerónimo, there is another Annunciation, inspired by that of Jacopo, of gilded wood, with its very fine stone retablo. At Santiago de Villena he made another

retablo of wood, dedicated to Our Lady of Hope, a beautiful image, as are his others of St Peter and St Paul, and several reliefs, carved with an air of placid intimacy, save for an angel Gabriel which denotes the same spirit of advance as that of Murcia.

PIETRO TORRIGIANO

If the presence in Spain of Jacopo l'Indaco the elder is a discovery unsuspected till within the last few years, on the contrary the coming to Spain of Michael Angelo's celebrated rival and his unfortunate death form one of the commonest tales in the history of art. Concerning Pietro Torrigiano's sojourn in Spain we only possess, in addition to what is related by Vasari, Francisco de Holanda's statement that he made a portrait in clay of the Empress Isabella, a fact which confirms the date of the artist's death, given by Milanesi as 1528, which, as is well known, took place in the prison of the Inquisition at Seville. His stay in England lasted at least till 1522, and since the Emperor's marriage was celebrated in Seville in 1525, it is probable that Torrigiano was there at that time. His clay crucifixes to which Vasari alludes no longer exist: we have only the St Jerome and the Virgin, which belonged to the monastery of Buenavista and are now in the museum, and another similar Virgin, likewise of clay and painted, in the University, which is attributed to him. The hand known as the "mano de la teta", of which a plaster cast was made for the studies of artists about fifty years ago, was slim, of poor modelling and unlike those of the above images; it appears less improbable that the one now in the University is that commissioned by the Duke of Arcos, certainly very much restored but not unworthy of the Florentine.

Plate 37 The St Jerome exercised an irresistible influence on the Sevillian artists of the end of that century; not only do copies of it abound, but from it they all learned anatomy. It seems, in fact, to be more an anatomical study than a representation of the warm-hearted Christian hermit: it impresses by the force of its naturalism, accentuated by the painting, while in correctness it perhaps admits of no reproach. It is possible to establish analogies with the Moses of his rival, and the manner in which the dress and hair are executed justifies the accusation of plagiarism. The Virgin does not yield to that of Bruges in coldness; everything in this group is foreign to the idea of maternal affection, and the artist seems to be engrossed by no other consideration than the display of a learned conventionalism in the folds of the dress. In the other example of his work in the University he gives a certain amount of attention to the Mother's face and a little liveliness to that of the Child, but the restorations make it difficult to estimate the extent of the change. All this proves

that Torrigiano remained on the borders of the religious ideal; he did not feel it. Per-chance it was true that the preliminary atmosphere of the Reformation had overtaken him, and that the Inquisition made no mistake in its attacks against him. As an artist, at Se-ville, he was a great virtuoso, so far as technique is concerned, but nothing more.

DIEGO SILÓEE

Let us now return to Castile, to Burgos, the home of Ordóñez, in order to meet Diego Silóee, the companion of his youth and son of the foremost Gothic decorative architect of the fifteenth century. Perhaps he was not old enough to receive instruction from his father Maestre Gil, who disappears in 1499 when Diego must have been only a boy. His career is known to us by documents only after the year 1519. Certainly before this must be his decoration of a chapel at Santiago de la Puebla, a hamlet near Salamanca, the cost of which was borne by the scholar Toribio Gómez de Santiago, of the council of Fer-dinand and Isabella. In this chapel there is a tomb, standing clear of the wall, and another beneath an arch, both with pairs of recumbent effigies in black slate, with hands and feet of alabaster, which are enough to indicate Burgos as the provenance, for similar works abound there. The retablo is of Roman architecture, mean and disordered, still with Goth-ic fringes in the decoration of some of the niches, clusters of fruit in the framing borders, friezes with bulky cherubs amidst acanthus-leaves, with other leaves decorating the angles in the same way and finished with a claw below, scallop-shells with the hinge in front covering the vacant spaces, and panels full of grotesques with eagles and monsters between them; all of which constitutes Silóee's decorative reserve, afterwards to be largely increased. The statuary brings out also his characteristically passionate idealism, as shown in the Pietà, vigorous and harassed with grief; in the Virgin mother, his favourite subject, in which poetry and tenderness are always shown to the full; and in the intimacy of the other scenes connected with Mary. But there are two little groups, very fine and correct, with the donors being presented by their patron saints, in which we recognize, we believe with certainty, the hand of Balmaseda, more highly skilled than the young Silóee, and this reveals to us a friendship fruitful in ideas between the two. They bring to life the new ideal of passionate inspiration which had begun to stimulate the feeble efforts of Bigarny, as we have already seen.

In 1519 Silóee designed at Burgos the tomb of Bishop Don Luis de Acuña for the ca-thedral. It is of alabaster, a development of the same type as that of Gómez de Santiago, with the addition of mean little figures of Virtues in very flat bas-relief, while the recumbent

effigy is likewise flattened, perhaps in order to obtain a balance of masses favourable to the effect of the whole. Some ten years afterwards, after visiting Granada, Silóee made a third tomb of marble for the Patriarch Don Alonso de Fonseca, which is in Santa Úrsula at Salamanca. Insisting on the same plan which Domenico Fancelli had begun with his tomb for Prince Juan, Silóee made a further advance, endowing it with Evangelists in relief, with that austere and dramatic vigour which his style then expressed, without spoil/ ing the balance of the figures. Seeking delicacy when the subject required it, making play with the details of the costume, arranging the dresses so that the nude is discreetly revealed, he possessed a technical virtuosity superior to that of all his Spanish contemporaries, and this enabled him to give due value to each part of his work, and a softness to the flesh attained both by the smoothness of polishing and by the uniform composition of the stone, a technique which he perfected, following the example perhaps of Balmaseda.

In this same year of 1519, Silóee realized another work in Burgos Cathedral, with which at one stroke he placed himself at the head of all Spanish architects. This is the stairway in the north transept leading to the "Puerta Alta", original and splendid as no other, an everlasting model of its kind and full of beautiful ornamentation, including certain mon/ sters typically his, and plump little children like those of Ordóñez. Nevertheless, at this time he knew no more of Roman architecture than the commonest *motifs*. Perhaps Ordó/ ñez improved his knowledge of the classic orders; in any case the above/mentioned retablo of St Peter in the Constable's Chapel shows Doric and Ionic compositions with columns and entablatures, correct although filled completely with very fine decoration. A little later, with Felipe Bigarny, he undertook in 1523 the chief retablo of this same chapel where, owing perhaps to the latter's influence, he went back to the use of little Gothic canopies, but the pleasing form of the architectural composition and its decoration are his own.

In this retablo the left/hand group, with Mary and Joseph holding the Child, and the woman with the turtle/doves, seems to be from his hand, as does the base of the opposite side with the Birth of Christ and the Visitation, the whole most beautiful and suggestive, and further, the children supporting the brackets of the central portion, a possible imitation of Forment; above, the figures of the Christian Church, Christ at the Column, children, and other features of secondary importance. Here Felipe developed perhaps also under the influence of Balmaseda. It is enough to compare the Virgin and St John at the Cross with their counterparts upon the high altar in the cathedral of Toledo. Silóee's work is distinguished by a sense of the plastic and by an inner lifelike spirit, albeit with a defect, frequent in him, namely, that of making the heads too large, to the loss of good propor/ tion though they perhaps gain thereby in power of expression.

His last outstanding work at Burgos is the tomb of Canon Diego de Santander in the cloister of the cathedral. Its relief of the Virgin, who has left off reading the holy book in order to meditate upon the mystery of the Child Jesus, who watches her attentively, is a veritable poem. Here also, just before the year 1528, he made, perhaps as a demonstration, the panels alluding to the monastery of San Juan at Burgos for the stalls of San Benito *Plate 38* at Valladolid. These stalls are commonplace work, directed by Andrés de Nájera, with reliefs by Guillén de Olanda, as is proved by the comparison with their counterparts in the stalls of the cathedral at Santo Domingo de la Calzada; the panels of the Baptist, his decollation and the inscription describing it, however, are undoubtedly by Silóee. They are worthy of being remembered as a very choice work, worthy too of the inspiration it offered Berruguete for the choir of Toledo, and typical of the forces which the Renaissance was able to let loose in Castile with Michael Angelo as the fount of inspiration.

Established at Granada after 1528, Silóee produced there an innumerable quantity of works, for the most part purely decorative and upon which he was assisted by pupils. It will suffice to recall the principal relief in the choir-stalls of San Jerónimo, showing the Virgin clasping the child, a rival in delicacy to the St John at Valladolid; a dragon of mar- *Plates 39, 41 a* vellous originality, in the same place; the kneeling effigies of Ferdinand and Isabella at the foot of the retablo in their chapel; a Christ at the Column in the church of San José; the doors of the cathedral sacristy with very impressive heads of apostles; the retablo of the convent of Santiago at Guadix, and a medallion with the head and shoulders of the young Baptist, in the museum. In stone: two pairs of Virtues, one in the spandrels of the Portada *Plate 40* del Perdón in the cathedral, and the other above an arch in the monastery of San Jeró- nimo, models of sober elegance; four warriors in the same place, of striking realism, etc. Although this series contains so many ornamental statues, never did he make use of the human figure in simple attitudes as a means of decoration, an unfortunate consequence of his Italianism and lack of ideas, nor did he use feminine grace to stimulate beauty. An honourable and Christian sincerity always inspires Diego's creations, which are rich in spiritual concentration, and he succeeded in founding a school which popularized above all his decorative principles both at Burgos and throughout Andalusia.

THE SCHOOL OF SILÓEE

Amongst his pupils from Burgos there stands out Miguel de Espinosa, who made two fine retablos of stone in San Francisco at Medina de Rioseco, other decorations in San Zoilo at Carrión and Salamanca and, earlier it seems, the chapel of San Pedro in the

cathedral of Burgo de Osma, with surprisingly lifelike statues, which he completed in 1530. At his side worked the iron and bronze-worker Cristóbal de Andino, author of the two kneeling figures in bronze in the above church at Medina de Rioseco, but better known for his magnificent "rejas".

At Granada Silóee was very closely followed by Diego de Aranda, who received from him the models for his statues, the absolute conformity of style being thus explained. Another disciple was Toribio de Liévana, but his spirit was more faithfully adhered to by Baltasar de Arce, whose St Christopher, in the church at Granada dedicated to that saint, is an arrogant figure.

ALONSO BERRUGUETE

It remains to present the other great contemporary master, whom fame has raised to be the representative of the Spanish sculpture of his days, and who enjoyed greater celebrity and esteem than all his colleagues: Alonso Berruguete, the son of Pedro, the admirable painter, who in Italy and later in Castile was the prince of Spanish art at the dawn of the Renaissance.

Alonso was born about 1490 at Paredes de Nava near Palencia; he likewise studied art in Italy, copying Michael Angelo in Florence, and in Rome the Laocoön. He returned in 1518; Charles V appointed him his own painter at Saragossa, and as a man at Court he appears for some years, obtaining by royal bounty after 1523 the office of criminal registrar at Valladolid, a sinecure, for the work connected with it was always discharged by a substitute. At Saragossa, he sculptured a tomb of alabaster for the great Chancellor Selvagio, Charles's favourite, who had just died; but it disappeared during the French siege, there remaining only a mutilated fragment, perhaps belonging to it, of a child holding the royal arms, in the local museum.

Afterwards, at Granada, from 1520 to 1521, his activity was restricted to the making of studies for the mural paintings of the Chapel Royal, which were never executed, nor, for want of money, were his other offers to make sculptured works accepted. Of his relations there with Jacopo Florentino and Machuca, as likewise with his presumed associate Felipe de Borgoña, there remains no vestige. In 1526 he returned with the Court from Seville to Granada, to insist upon his claims. No notice was taken of his petition; the Emperor, indifferent to matters of art, passed him over for all time, and Berruguete had to seek work in monasteries and cathedrals and the favour of the clergy, like all his poor colleagues, setting up a workshop in order to carry out his commissions.

The first of these was a retablo, now at Olmedo, for the monastery of La Mejorada,

which he was ordered to make in 1526. In this, the character of the sculpture and of the columns, fluted at the base with the rest ornamented, seems to proclaim reminiscences of Jacopo Florentino; but if we study the composition and technique, the work is seen to be of far smaller merit. Regarding the sculpture, no outstanding influence can be proved; the genius of Berruguete appears in the fulness of development and perhaps even more individual than in succeeding works; here both his defects and his virtues reach their highest pitch. It is significant that in two small reliefs upon the base there are pairs of reclining female figures in the nude, with little angels crowning them, a rare example of the introduction of profane elements in the Italian manner, but with an absence of grace and femininity in tune with the ugly medallion of St Catherine at one side and a characteristic which is scarcely ever disowned in all Berruguete's works. Upon the other side, the medallion of St Mark sums up all the rest that we have to learn in the great master: a lack of development in the rendering of the human body, which the softness of the execution scarcely reveals beneath the folds of the attire, ample and deep; the absence of anatomical study, although he delights in the exaggeration of muscles; attitudes of strong dynamic expression very foreign to the rhythm of Michael Angelo; faces with features not always suitable but suggestive; carelessness and clumsy handling in the technique. They seem to be improvisations made, hesitatingly, in clay, without the artist looking to see how they were turning out, and in which he sets everything aside in his striving after features of the dramatic passion which stirs within him, without formulas, without types, overflowing with fertile invention almost misplaced. At first sight these perversions offend, but afterwards they become understandable; they obsess us, and the suggestive effect pleases. It is the same process as with El Greco and the comparison may be taken as a historical sign of influence upon the abstruse Cretan painter, which may have constituted the turning-point of his transformation in Spain.

The eight groups, besides the Calvary, which compose the chief statuary of the Olmedo retablo, are models of audacity and originality; they recall no earlier work, nor even Michael Angelo, while perhaps they surpass Donatello in the unexpected manner of their solutions; but we must not attempt to look for perfection or study. This Berruguete, inexperienced and thoughtless, can best be summed up in the word "fury". His ideas must have been disturbing at that time (though not so much perhaps as they deserved), because of the lack of inherent precedents among the Castilians; now they amaze us as a pathological case bordering on madness.

Later on, Berruguete's workshop improved somewhat, advanced progressively in technique, dispensed a little with the frenzied improvisations and looked towards the formulas

common in other workshops; above all, originality wanes in the composition of the scenes and its place is taken by attention to the individual, the expression being concentrated in the single figures. It reaches a state of equilibrium in the execution of the high altar of San Benito, the fragments of which now fill the museums of Valladolid, and in that of the College of Santiago or the Irish Nobles at Salamanca.

Plate 43 c In the St John of the Calvary from San Benito the ancient vigour remains, dexterously employed though somewhat restrained. In the Pietà of the Irish College we find the pathetic, as also in the Abraham (the comparison of which with that of Donatello does not prejudice it), and a little also in the relief of the Mass of St Gregory. A certain return to Plate 42 the classical seems to be noticeable in that of the Adoration of the Kings, but here also a new formula appears in which the draperies cling to the nude, exaggerating it above Plate 43 b all known precedent. In the little figure of St Sebastian he obtained a perfect model, and one unmatched for its perception of beauty in all the range of Berruguete's art. The series Plate 43 a of prophets and apostles on both retablos remains unforgettable, unnamed figures for the most part, but animated and worthy to rival in their way those of Buonarroti, so varied and original are they. There are certain mighty soldiers who seem to be trembling beneath a load; there is another, with a shield in front of him, who manages to free himself from being amongst the plagiarisms of Donatello's St George; and there are two pairs of female figures, meditating arm in arm, in which Berruguete reached the charm of the Greek *stelae:* in addition, two panels with Evangelists painted in grisaille upon gold are like translations from sculpture which prove the vocation of the artist, and as a counterproof there are the other polychrome panels, very wearied and poor. Lastly, the gilding with large expanses of gold in the garments and decorative accessories of the sculpture, and the flesh colours, strong and warm, assist greatly in the plastic effect: they may be considered as models in the difficult problem of polychrome sculpture.

Coming to the inquiry of 1533 concerning the retablo of San Benito, one realizes somewhat the clash of opinion which Berruguete's stylistic revolution unloosed. He was anxious to have Silóee as his appraiser, perhaps because he considered him sufficiently talented to win justice for his cause, but it was not easy to bring Silóee from Granada; he therefore contented himself with a good man, Andrés de Nájera, but the monastery brought the latter over to its side; in the end it was an Italian, Julio de Aquiles, who defended his interests but did not succeed in imposing his own opinion nor submitting his views; then there came, as a third in this dissension, our old acquaintance Felipe Bigarny, he who had been a friend of Berruguete at Saragossa. All the boastings of perfection and satisfaction in his own work of which Berruguete bragged were denounced by his judges: there was

54

no design, only a sketch which he did not attempt to show; the St Benedict, the principal figure in the retablo, had to be substituted, as well as others besides; obvious mistakes had been made in the arrangement of the pieces, etc., and far from considering him worthy to remedy these defects himself, it was advised that another artist should undertake the work. The possible professional jealousies undoubtedly had ground for complaint, but the monastery inclined towards the side of Berruguete and this triumph cleared the path for future opinion.

Two other retablos show the evolution of the master: that of the Kings in Santiago at *Plate 44* Valladolid which dates from 1537, and that of the Visitation in Santa Úrsula at Toledo, a little later. If we compare the former with that of Olmedo we see at once the artist's new predilections, his manner of showing the nude through the garments as Silóee had done before him; on the other hand there reappeared the "fury" which seemed to be restrained in the retablos of San Benito and the Irish College, but which loses all reserve in these other retablos; the single figures remain inert and listless, but the groups are carried away as if fused in a common impulse, or as if the various personages were rising up in argument against one another. The Adoration of the Magi in San Benito is calmly portrayed; that of Santiago is shown between agitated and enraptured groups on either side and with extravagant richness in the centre; in this work there appears a new factor, a grandeur which gives the keynote to the group of the Visitation and decides the ultimate, the triumphal phase of the master.

We now reach his most remarkable work, the choir-stalls of Toledo Cathedral, executed together with Bigarny, after 1539. To Berruguete belongs the right side with thirty-six panels of wood in the backs of the upper stalls and thirty-five of alabaster in the can- *Plate 47* opy; they are all single figures in medium relief representing biblical personages, apostles and a few saints. Here we return again to the Michaelangelesque in Berruguete, the sculptor with types overflowing with expression, never repeated, rugged and thoughtful, with no concession to beauty, to placidity, or even to equilibrium. The naked Eve surpasses in austerity Buonarroti's Aurora; the other Eve, mourning over the body of Abel, seems scarcely female; the magnificent Job and the Baptist, composed entirely of muscles, excel *Plate 46b* as virile studies of the nude; the St Peter is admirably foreshortened and amongst the other *Plate 45b* apostles St Andrew and St John win distinction by their splendid apparel; the Moses be- *Plates 45a, 46a* fore the burning bush is a new example of the "fury", to be compared with the calmness of his flock; in the modern saints the artist was prevented from exhibiting his force in the attire, and in the female saints scarce only does he maintain this in the St Catherine. He is always captivated by softness and delicacy of modelling which, without the advantage

55

of polychrome, was necessarily carried to an extreme. This must have been due rather to his assistants Francisco Giralte, Isidro de Villoldo and Manuel Alvarez, since assuredly Berruguete was not a clever artisan; he made the drawings and the models in clay and wax, but if he interpreted them they became unsuccessful, and there resulted the mistakes already condemned. If the actual sculptors were accomplished in their technique like those mentioned, the work reached the necessary point of correctness, but no one was able to copy Berruguete's talent for giving life and value to all to which he put his hand, which won for him the admiration of the greatest minds, as his contemporaries declared.

The choir-stalls having probably been already completed, Berruguete undertook the crowning feature of the west end and trascoro in 1543. This is a Transfiguration of large size, made of alabaster and encircled by a tabernacle of gilded wood, with reliefs upon the base showing groups of Nereids and Tritons upon one side and of men fighting upon sea-horses on the other; but beneath, towards the trascoro, there is a gigantic medallion with God the Father surrounded by the Evangelists, all of alabaster, partly gilded. He finished this in 1548 and then made a retablo for the chapel of El Salvador at Úbeda, with another huge group of the Transfiguration, since spoilt by the additions of Churriguera. These works, being so large, were too much for the powers of Berruguete. Neither he nor perhaps anyone else could give plasticity to a subject so anti-sculpturesque, although the composition of the one at Toledo is saved by its magnificent *encadrement,* which is of high decorative value if we forget the group of the apostles, wrongly placed and out of perspective. In these reliefs and in the children, playful and smiling, touches of paganism are suggested which show the lack of classical understanding in Berruguete but also his own independent creative genius. In the Transfiguration of Úbeda the figure of St Peter is more wild than human, with reminiscences of the Laocoön in the head, while that of

Plate 48a

Moses exhibits a new type no less extraordinary than Michael Angelo's; on the other hand, the Christ in both groups is wanting in majesty.

Plate 49

The same subject was treated in the principal panel of the sacristy doors in Cuenca Cathedral, which have been attributed to Berruguete. Half the work is certainly worthy of him, but if it were his we should have to assign to him a special merit as a decorator in bas-relief, a quality revealed in no authentic work of his. With greater probability it belongs to a local artist, who made at the same time the tympanum representing the Birth of Christ over this doorway, as well as a few beautiful retablos, besides forming a school here, one of whose salient productions is the retablo of the chapel of the Muñoces with its group of the Virgin with Jesus and the two Johns as children. As a mere hypothesis, the idea springs to mind that this figure-sculptor may have been Diego de Tiedra, who is

known to have been alive between 1538 and 1557 and who, it appears, was esteemed at Cuenca as a fine artist.

The last years of Berruguete produced two other works: the retablo in Santiago at Cáceres and the tomb of Cardinal Tavera in his hospital at Toledo. The former, although certainly his, adds nothing to his glory; commissioned in 1557, it was completed long after his death; the statue of the Virgin between two angels is beautiful; as a group in relief few are so well composed in their way as the Adoration of the Kings and, regarding the design, the influence of the Toledan masters upon Berruguete's never happy ideas in architectural composition remains evident.

The Tavera monument was begun in 1554; it is of white marble and seems to have been more or less finished when death overtook the artist in the same hospital in 1561. It seems probable that he only made for it the drawings and models, the execution belonging to some highly skilled but tranquil and colourless artificer. The recumbent effigy *Plate 48b* is worthy of the master, with its realistic power only explained by the fact that the face, so vividly dead, is taken from a real death/mask; in the rest, vitality and freshness are lacking; hardness of material never ceased to hinder the Spaniards, and for this reason their marbles are commonly of slight and superficial execution.

The recumbent effigies, also in Carrara marble, of the Constables of Castile, in their chapel at Burgos, must also be counted as a posthumous work. First Bigarny had been commissioned with them, and later, by a deed of 1559, Berruguete, who constructed a model in wax. The greater portions had been worked before his death, as his son attested; nevertheless, certain characteristics favour their attribution to a Burgalese artist who left a number of similar works in the same place, with ornamentation in Silóee's manner, but nothing which approaches even approximately to the work of Berruguete.

BERRUGUETE'S CONTEMPORARIES

The phalanx of imitators of the great Castilian master, more or less attached to his workshop, is very large but of little value, for none inherited his genius, but only his formulas and details. Included in this group, there are also important works by unknown authors, examples being the large retablo of San Antolín at Medina del Campo and the beautiful altar with the Adoration of the Shepherds in Valladolid Museum, dated 1546.

Among his pupils Isidro de Villoldo came nearest to the master; he collaborated upon the choir/stalls at Toledo and left abundant works at Ávila, in particular the retablos of San Segundo and of the oratory in the cathedral sacristy, both of alabaster, of exquisite *Plate 50*

workmanship and with beautiful subsidiary features, but wanting in vigour and individuality. In 1553 he moved to Seville, and worked on the retablo of the Cartuja de las Cuevas, left unfinished at his death in 1560.

More independent and fertile in ideas, not always praiseworthy, was Francisco Giralte, by whom are the retablo and tombs in the Bishop's Chapel in San Andrés at Madrid, the large monument to the Marqueses de Poza in San Pablo at Palencia, and the little retablo of a chapel in the church of La Magdalena at Valladolid; the latter is Giralte's earliest known work, and was executed before he was brought to assist Berruguete upon the choir-stalls in Toledo Cathedral. This retablo reveals him as already formed, with leanings towards a Berruguetesque but weak type of expressive movement; he left a school at Palencia and Madrid, and one of his last works is the retablo of Espinar; he died in 1576.

Manuel Alvarez, Giralte's brother-in-law, is recorded to have been a pupil and disciple of Berruguete; he worked for the Jesuits at Villagarcía, where a crucifix made by him in 1579 is to be specially commended; earlier are the retablos at Santoyo and others at Palencia, perhaps also a beautiful tomb at Madrigal, dated 1556-59, and the trascoro of Burgo de Osma. He began under the influence of Giralte's style, and became the most original and progressive of this group; he is grand, elegant, and composes well, but is difficult to classify because of his eclecticism.

Gregorio Pardo or Gregorio Bigarny, the eldest son of Maestre Felipe, stands out because of the finesse and attractiveness of his feminine types, an exquisite technique in bas-relief and an extraordinary power of invention in ornamental composition, human figures predominating. He worked from 1537 in Toledo Cathedral, where he made the two principal medallions on the inside of the transept doors; that of alabaster on the archbishop's throne in the choir, and the wardrobes of the chapter ante-room. To him can be attributed another, portable medallion of alabaster, with the Virgin and Child, in the Constable's Chapel at Burgos, and perhaps the tombs of the Bishop of Túy and his brother in the church of Espeja. He is last mentioned in 1551.

Diego Velasco of Ávila is likewise worthy of esteem, though less well known. To him belongs the retablo of Miraflores de la Sierra, finished in 1557; that of San Román at Toledo may be attributed to him, and in the cathedral of the same city he did much work as a carver between 1539 and 1565.

Cristóbal de Villalón, in 1539, praises three brothers named Villalpando of Palencia as image-makers and workers in plaster. In truth, decorations of this type abound, although of slightly later date, such as the chapel of the Kings in the cathedral of the above city, dated 1552, that of the Benaventes in Santa María at Medina de Rioseco, finished in 1551, *Plate 51* and the Casa Blanca at Medina del Campo, executed from 1556 to 1563. All this is identical in style, the first being documentarily proved as a work of the Corrales and the second signed by Jerónimo del Corral. In addition there figure as *rejeros* or iron-workers, and brothers, the celebrated Francisco de Villalpando, Ruy Díez del Corral and Juan del Corral: a whole family of artists.

Francisco is the author of the magnificent screen of iron and bronze in the Capilla Mayor in Toledo Cathedral. Andino designed and executed a model for it in 1540, but died two years later, and Villalpando alone carried the plan to fulfilment adding, later, the very rich pulpits, the other magnificent *reja* of the altar in the choir and the grille for the Puerta del Perdón, all of bronze and left unfinished at his death in 1561. He made also the portal of the college of Los Infantes in the same town, with caryatids, a medallion of the Virgin and Child, Faith and Justice; lastly, he published in 1552 the Castilian translation of the third and fourth books on architecture by Sebastiano Serlio. His decorations, filled with statues and fascinating compositions in the best taste, followed from work to work the style of Berruguete, perhaps through models by Gregorio Pardo and Velasco.

But the most surprising are the plaster decorations mentioned above, and in particular those of Rioseco. If in Castile the hardness of material always hindered her artists, naturally the use of a medium so easy to work as plaster raised their creative powers and provided them with gifts of freshness and spontaneity. So it is that the Corrales appear as wonderful decorators, and their work is the most vividly suggestive and characteristic of the Castilian Renaissance, the spirit of Berruguete reigning unfettered therein, with baroque touches of enchanting vivacity. Worthy to be remembered are the group of Eve, the temptress, consoling Adam and preceded by Death, who plucks at a guitar; the groups of animals worshipping the Creator; the damned in hell; the heavenly host, and the Virtues, in the cupola; prophets, evangelists, apostles; innumerable happy ideas in the fantastic architecture which fill the whole, leaving space for three tombs between mighty caryatids of mournful demeanour, and with pairs of recumbent effigies in alabaster. And the retablo added by Juní, with the Virgin Immaculate in ecstasy, helps to complete the unbridled theological poem which the whole of this chapel represents.

It is a foreigner, however, who gives the keenest note of passionate inspiration in Castile, namely Juan de Juní, whom Berruguete considered the best of all sculptors who had come to this country, choosing him as the valuer of his Transfiguration at Toledo. He must have been born about 1507, perhaps in Champagne, where there is a village called Joigny, the probable origin of his name, and he came to León about 1533, the first known stage in his artistic career. In the cathedral there and in the convent of San Marcos he executed decorative figure-sculpture, being recognized as of greater merit than his other colleagues. From his hand must be, in the trascoro of the cathedral, certain little statues of the Sibyls, very Burgundian, and other small figures which constitute the most prominent works of his earliest phase; in San Marcos: the colossal busts of heroes upon the façade; the great but mutilated reliefs of the Descent from the Cross; two others, high up, in the aisle re-tablos near the church portal; a relief in the cloister with the Birth of Christ, and the best of the panels in the choir-stalls, especially the series of apostles. In addition, in the museum, a clay statue of St Matthew and a bas-relief in perspective, with certain converted heretics burning their books.

Juní must have left León about 1538, for we find him at Medina de Rioseco, modelling for the church of San Francisco groups of clay representing St Sebastian and St Jerome; later, he was at work in Salamanca Cathedral, carving a fine retablo with the Pietà, in *Plate 52* the cloister, and the figures of St Anne and John the Baptist placed in the trascoro; there he married and fell gravely ill in 1540, afterwards living at Valladolid until his death, which occurred in 1577. In this last stage of his career he executed a certain number of retablos and single figures, all of them of wood, painted and gilded, except the kneeling effigy of St Segundo at Ávila, which is of alabaster and was made in 1573.

We happen to know that Juní did not go to Italy, but studied art in France, yet it is difficult from this to explain his style, as fully advanced as that of Bandinelli, before the school of Fontainebleau had been formed, nor even supposing him to have come from the workshop of Jean Juste at Tours. Juní is a sensualist who takes a delight not in seduc-tions but in the torments of passion, or at least in heavy anxiety; his technique is exquisite but his correctness of forms battles with a contempt for the nude which brings him to disfigure it with agitated and intricate draperies, attention being thus concentrated upon the heads and hands, unrivalled in their powers of expression. His works at León show him to be a master of pictorial relief, of deep perspectives and graduated distances recalling Donatello; his feminine types are of a rich fleshiness comparable to Rubens; his poses and

compositions acquire a tense vivacity, unbalanced and violent in a manner never seen before; but all this follows a certain chronological development. In León his technique, his contortions, his haughty or thoughtful countenances, his vivacity, are already typical, but refinement of feeling and character are lacking; it is the same with his clay figures at Medina de Rioseco; the same with his Pietà at Salamanca. But in the latter case there are a few heads intensely expressive, even more marked those of the Baptist and of St Anne teaching the Virgin to read. Later, his first work at Valladolid, the imposing group of the Entombment now in the museum, which cost him five years of labour, enters com/ *Plate 53* pletely into the Castilian cycle, made as it is of painted wood, and very expressive: only the Christ retains characteristics of northern coarseness, which Juní in the end forebore, giving us in the repetition of the same subject possessed by Segovia Cathedral another fine and *Plate 56* graceful type, worthy of an Italian.

At Salamanca and Valladolid Berruguete was in favour and his works in demand when the impetuous Frenchman arrived on the scene; but later, this rival being occupied at Toledo, Juní was left in possession, and won the pre/eminence which was his due pre/ cisely by taking Berruguetesque models as the fount of his creative inspiration. The vehe/ mence, a little empty, and the contortions of his earlier style were exchanged for ardour and passion; the dramatic energy of his later works knows no bounds; it is the same phe/ nomenon as with El Greco, and to be ascribed, it seems, to the same influence.

Among the crucifixes by Juní, that of the Jesuits at Valladolid, although little known, may be called a masterpiece; perhaps in emotion it yields to no other. Next to it in value comes that in the church of Santiago in the same town; the Christ is dead and calm, whilst that of León Cathedral, relegated to a garret, is one of his last works and is full of his usual exaggeration. The Dolorosa, known as the Virgin of the Swords, is a sovereign work in which the pathetic is rendered with unprecedented power. But this figure does not represent all his fathomings into grief: sometimes it is rapturous, as in the unforgettable group of Mary and John in the Valladolid Museum; sometimes it is harrowing and over/ *Plate 53* whelming, as in the Calvary of the retablo of Santa María la Antigua, now in the cathe/ dral of the same town; sometimes it is bitterly weeping, as in the Calvary at Ciudad Rodrigo; sometimes desolating, as in that at Tordesillas; sometimes overwrought, as in that of El Salvador at Arévalo; sometimes dismayed, as in the Pietà of Salamanca; sometimes fervently contemplative, as in the Entombment at Segovia. As opposed to these paroxysms *Plate 56* of grief, we have a model of entrancing happiness in the Virgin Immaculate of Medina de *Plate 55* Rioseco, another perfect work of Juní, and again in the Assumptions of the retablos of La Antigua and the cathedral at Burgo de Osma, as well as the Virgin Expectant of Allariz.

61

The Holy Family of the Jesuit church at León; the magnificent St Segundo; the bust of
Plate 54 St Anne in Valladolid Museum, a type of irreproachable realism, and the four arrogant prophets who crown the retablo from La Antigua: each one of these is a model work in its class. A very expressive work of his is the Death of the Virgin in the museum of Valladolid, wrongly attributed to Becerra.

Another notable characteristic of Juní is his architectural ordonnance, of a type already used in his time by Juan de Badajoz. Berruguete put no spirit into the architectural design of his retablos; perhaps it was Silóee who first succeeded in imposing that of Roman type, going beyond the timid advances of Pedro de Guadalupe at Palencia, as we already know. But now, with Juní, the retablo reaches a state of freedom, that is to say it has become baroque: the architectural elements are retained with a certain degree of purity which, to its detriment, Juní accentuates towards the end of his career, guided by the classicism of Herrera. Before this, however, in the great retablos of La Antigua and Burgo de Osma,
Plate 55 and in the Immaculate Conception at Medina de Rioseco, picturesque solutions hold sway: flattened arches, caryatids, pilasters in the form of inverted pyramids, brackets and consoles, a profusion of horizontal lines, children everywhere, fruits and ridiculous etceteras. As a result, each of the constructional and ornamental features vibrates with life in harmony with the agitation of the figure-sculpture; it is like a Wagnerian concert in which the instrumental tones combine together, giving us that nervous tension which is necessary for the theme to carry us along in its development.

To continue, we see that Juní was lavish in the use of figures between the columns of his retablos, the architectural composition of which would seem to require a certain reticence; but the turbulent character of the artist forbade this: his figures are crammed to overflowing, almost bursting out of their places, protesting their anguish with an incredible extravagance of gesture. Here another point must be noted: well known is the role played by monastic dress in the creation of unforgettable saintly types by the Spanish figure-sculptors of the seventeenth century. We shall see too how, late in the sixteenth century, the sculptured portrait becomes predominant; but before this it seems that custom discouraged artists from representing the commonly worn clothes of the day; the consequence being that in order not to fail in their undertakings they had to sacrifice their freedom of expression. So it is that Berruguete loses his artistic power in several of the reliefs at Toledo and in the St Benedict at Valladolid, as large as it is poor; the same with Juní, who, in order to represent St Anthony, in a retablo entrusted to Gaspar de Tordesillas, St Francis in another small altar-piece in Santa Isabel, St Anthony of Padua and others, deadened the natural fall of the habit as if avoiding difficulties; — as if the figure in real life, without

62

the careful arrangement of the dress, was too much for his powers. All the ancient prin-
ciples were abandoned even to the point of disregarding the structure of the body, hidden
beneath a profusion of folds in the attire, the object being to bring forth the dynamic emo-
tion of the spirit. As to his qualities as an artificer, it was this word, spirit, which was hurled
at him as a supreme tribute: "the spirit of one of the figures made by Juan de Juní is
worth more than all the work of Giralte" — said a priest in a certain judicial controversy
of the time.

JUNÍ'S CONTEMPORARIES

Some near and some far from the style of Juní, there wandered through Castile a large
group of foreign sculptors, probably trained locally, to judge from their homogeneity of
style, which is characterized by lack of depth and by the abuse of decorative elements;
they were itinerant artisans, very skilful in and devoted to secular *motifs* of French and
Flemish type. It will suffice if we mention those who most distinguished themselves in
works of figure-sculpture.

At León, Juní was preceded by one Jaques Bernal, the author of the retablo in San Ni-
colás at Castroverde de Campos (1531) and of the very rich one at Villanueva del
Campo (1542). Then follows Guillén Doncel, known by his signature, carved in 1542
upon the choir-stalls of San Marcos; he made also, under the influence of Juní, a retablo
for Valencia de Don Juan, of which portions remain. Nicolás de Colonia carved the epis-
copal throne of the choir at Astorga in 1547, likewise in Juní's manner; while Lucas Mi-
tata, who worked at Salamanca, Ciudad Rodrigo and Plasencia, at least from 1558, is
not very different and it may be that the retablo at Fuenteguinaldo is his.

Separately, we meet with a Fleming, Guiot de Beogrant, at Bilbao after 1533, con-
structing the retablo of Santiago, of little account, to judge from what remains. His brother
Juan, also a figure-sculptor, outlived him and appears as a witness to the will of Forment's
wife in 1539. Pierres Picart embellished the University of Oñate, after 1545, with a portal
and buttresses filled with statues, recalling the later style of Forment in his fondness for
mythological compositions; and he subsequently made a considerable advance in style,
as is revealed in his retablo in San Juan at Estella, executed in 1563.

It is not recorded whether Juan Picardo, of Peñafiel, was a foreigner. He was evidently
esteemed, since in 1538 he was among those called to choose the artisans for the choir-
stalls at Toledo. To him, together with his son-in-law Pero Andrés, is due half the retablo
(1550-1554) of Burgo de Osma Cathedral, including the central group with the death
of the Virgin, worthy of all praise. The influence which he received in this from Juní,

who made the other half, was very considerable, if we may judge from the prophets, dated 1552, and apparently his, in the lantern of Burgos Cathedral.

The Sevillians are well represented in this group with Guillén Ferrant, and afterwards with Roque de Bolduque, the authors, between 1547 and 1551, of the large retablo of Santa María at Cáceres, the greater portion of which is due to the latter; cold, finicky and with Flemish touches in the female costume. Guillén, on the other hand, is strong and vivacious; typical of him are the reliefs of Evangelists in the above retablo, and still more so the statue of the Virgin in the collegiate church at Osuna. Before this, from 1533, he was engaged in the town hall at Seville and upon the wardrobes in the cathedral sacristy. Bolduque left as his last complete work the Calvary (1560) surmounting the retablo at Medina Sidonia, besides others finished by Juan Giralte, a Fleming. To his companion Cristófer Voisín and to Jerónimo de Valencia, are due the choir-stalls of the Cartuja at *Plate 57* Jerez, now in the church of Santiago, executed in 1547; later, he collaborated with Bautista Vázquez and was still living in 1575. The principal panel of the above stalls, with the Virgin holding the Child in her arms, is a most beautiful and typical example of the foreign manner of this group. To it belongs likewise Esteban Jamete, born at Orleans, whose most important work is the magnificent portal in Cuenca Cathedral, giving entrance to the cloister, and dating from 1546 to 1550.

VI

THE PERIOD OF CULTURE AND SECULAR ART

HITHERTO we have followed the development of what we might call the spontaneous in Castilian art: the continuance of Gothic tradition, its purposes and ideals; the growth of popular taste without the intervention of very rich patrons. It was only necessary for artistic genius to be the devout interpreter of a collective religious ideal. Art was valued simply as a means of pious education; as a tribute to the Divinity, and as a reminder of the life beyond the grave. It was expressed in portals, choirs, retablos, processional images and tombs; if there was a little vanity in these last, the guise of sanctity vindicated its expression, and if the best artists were preferred, it is because they were more likely to satisfy the instinct of the people by picturing their ideal with vehement and religious expression. This spiritual repose, however, did not entirely reflect the feelings of Spain.

Once the nation's protest against despotism, breaking out in the rising of the Commons, had been stifled, the country was hushed, and this suited the taste of the *camarilla* round the Emperor; the problems at home were ignored, but affairs abroad brought sufficient glory to dazzle the people: the taking of Rome, the victory of Pavia with the capture of the king of France, the conquest of Tunis and, above all, the progress made in the domination and exploitation of America, gave to Spain more than ever before a stimulant to power and wealth. At last it was possible to cherish the illusion of eternal prosperity, and with this came a flood of enterprises which for art spelt increasing activity. In every corner of the land palaces, churches, convents and chapels were raised, retablos and tombs set up; the demand was enormous; artists flocked from abroad, as we already know, and the schools of Burgos, Valladolid, Toledo, Granada and Saragossa flourished exceedingly. At first, the invasion of imported artists and their works seemed to reach the point of foreign domination as in France and Flanders, but Castilian pride defended its principles, perhaps as a new sign of protest against European influences: Spanish art nationalized itself and the native artists recovered their predominance, as we have seen.

Nevertheless, the link with Italy was unseverable. Literature allowed itself to be seduced by the adulation of classicism, and in 1526 a Toledan priest, Diego de Sagredo, published one of the first books on art which the Renaissance produced; it was called "Medidas del Romano" ("Essence and forms of Roman art") and its praises of the antique extended to Felipe de Borgoña and to the iron-worker Cristóbal de Andino, proving that it was in the neighbourhood of Burgos that the book was composed and that there

was some hostility towards her most famous champion, Silóee, who finds no mention. This was followed by a clerical apprentice, one Cristóbal de Villalón who, adventurous and learned, printed in 1539 the "Ingenious comparison between the ancient and the modern", upholding the audacious theory that modern art surpasses that of the ancients, and, as witnesses, he praises, besides the great Italian masters, Berruguete, Maestre Felipe, Silóee and the iron-workers Andino and Salvador de Guadalajara, and also the Gothic cathedrals, colleges and palaces, the tomb of Cisneros, the wonderful silver *custodias,* the printing-press, stained-glass windows, and lastly, the imagery, which we already know, of the Villalpandos, in comparison with which, he says, "antiquity seems worthy of scorn". Such appreciations serve as a lesson for our instruction as to the condition of Castilian mentality, which could tolerate such boasting — boasting which would not pass muster even in Italy. Villalón had discovered in the Spaniard an artistic quality which he never found in his wanderings through Italy, France, Flanders and Turkey; that is to say, the glorification of baroque art, so typically Spanish, a feature which he appreciates above all else. The independence and originality of the Spanish Renaissance was, then, a direct product of that same force which she imposed upon the whole world by her indomitable vitality.

THE HEROIC AGE

In the meantime, the indifference which the Emperor Charles showed to everything connected with art left a free scope for development. When the Marquis of Mondéjar, warden of the Alhambra, presented him with the plans made by Machuca for his palace, the reply was that he was to do what seemed to him best, and we have already seen incidentally how he ignored Torrigiano and Berruguete; nevertheless, in the decoration of this palace in the Alhambra a place was found for certain flattering sculptures in honour of the Emperor. It was a Milanese sculptor, Nicolao de Corte who executed, from 1537, the decoration of the southern façade, with military trophies of very delicate workmanship, large allegorical scenes, the triumph of Neptune and the rape of Amphitrite amongst other allusions to the sea; all these in marble reliefs of spirited type, recalling a little the style of Verrocchio. Upon a fountain, also erected there and known as the Fountain of Charles V, he made certain medallions with mythological scenes. A monumental mantelpiece may likewise be his, with two nymphs and a relief of Leda, so lewd that Hübner considered it a work of classical antiquity. Upon the other façade of the palace
Plate 58 in the Alhambra, a Spaniard, Juan de Orea, sculptured certain bas-reliefs of the battle of Pavia and the triumph of Peace, probably taken from drawings by Machuca. The

66

Fleming Antonio de Leval completed this work and added statues of nymphs and chil-dren as well as medallions with battle-scenes, all this dating from before 1550 to 1563. In addition, in 1591, the Sevillian Andrés de Ocampo inserted, high up, two medallions of Hercules slaying the lion and the bull.

There were many other examples of secular sculpture in Granada: the façade of the Casa de los Tiros was decorated with statues of Mercury, dressed as a herald; Hercules, Theseus and Jason, in Roman costume; Hector in modern armour. Likewise, the ceiling of the principal hall was filled with ugly busts of thirty-two heroes, ancient and modern, with explanatory inscriptions, besides medallions on the walls representing Penthesilea, Lucretia, Semiramis and Judith; all this dating from about 1530. Shortly afterwards, when Silóee had finished the Capilla Mayor of San Jerónimo, he placed in the vaulting figures of biblical and classical personages, namely, Caesar, Hannibal, Pompey, Marcellus, Ci-cero, Homer, Marius and Scipio; Abigail, Judith, Deborah, Esther, Hersilia, Artemis, Penelope and Alcestis, whose virtues were fit to compare with those of the Gran Capitán and his wife.

In Seville, the City Hall (known as the Casa del Ayuntamiento or Casas Capitulares) is the most sumptuous of the civil edifices of the Renaissance. Nevertheless, its profusion of sculptured ornamentation is wanting in expression and in subject matter; it is capricious and nothing more; only the few medallions with classical heads are of value, and these are due to our acquaintance Guillén Ferrant; in addition, the ceiling of the council chamber displays in its panels as many as thirty-five figures, in high relief, of the kings of Spain, as well as heraldic designs, Virtues and saints in the customary manner. There are other fig-ures, allegorical it seems, in the cupola over the staircase, all without inscriptions, thus adding to the lack of interest which their identification would dispel.

Much later there was another influx of secular sculptures, in the work of the able sculp-tor Diego de Pesquera. In 1574 he made the statues of Hercules and Caesar, the alleged foun-ders of Seville, which surmount the columns in the Alameda. Afterwards he was occu-pied in decorating the fountains of the Alcázar with gilded bronzes cast by Bartolomé Morel; they represent Mercury standing upon an urn or large jar, richly ornamented and placed in the middle of a pool; and Mars, which is now in the garden of Las Delicias. The reliefs and statues in the chapter ante-room of the cathedral possess the same mythical character and, as we shall see, Pesquera was also engaged here.

From the point of view we are now following, Úbeda is the city of caryatids, as is the case to a certain degree with Baeza and Jaén. They are usually female figures of French type, as is seen by their tendency to sensualism, and the finest are in the sacristy of the church

of El Salvador and on the façade of the town hall, both works superintended by Andrés de Vandaelvira, between 1540 and 1550. The latter are complemented by another series of similar statues which serve as the supporters of heraldic shields, like those on the façade of El Salvador. It is worthy of note that on the portal of the sacristy are statues of "Otabianus imperator" and the Sibyl, kneeling on either side of the Virgin Mary, the former in the dress of a modern emperor.

Castile offers less abundance of classical statuary. As examples may be mentioned a bust of Hercules over the doorway of the palace at Peñaranda de Duero which dates from the second decade of the century; the façade of Salamanca University, finished in 1529, upon which there are portraits of Ferdinand and Isabella within a medallion; the Pope amongst his cardinals; small copies of the Venus of Cnidos and of the Farnese Hercules; a bust which seems to be Antinous and another of Hercules, etc.; lastly, at Burgos, the city gate (Arco de Santa María) displays portraits of five Castilian heroes presided over by the Emperor Charles, and, above, the guardian angel of the town between two kings-of-arms; statues all of little merit, made by Ochoa de Artiaga, about 1550.

LEONE LEONI

The fascination of Italian art finally overcame the Emperor when he was in Italy from 1541 to 1545. During that time he commissioned portraits from Titian and medals from the bronze-worker Leone Leoni of Arezzo, whose patrons were Andrea Doria and the Marqués del Vasto. But perhaps the most happy turn of fortune for Leoni came through Prince Philip, with whom, in 1548, he travelled from Milan to Brussels in quest of the Emperor. There he prepared models for a number of bronze statues, which, later, upon his return to Milan in 1551, were cast and finished by 1556, the year in which he sent them to Flanders prior to their being transported by sea to Spain. The Emperor wished to bring the artist as well, but he declined, and it was his son Pompeo who was entrusted with the finishing touches to these figures, but he arrived in Spain with such disfavour that in the following year the Inquisition of Valladolid discovered traces of Lutheranism in the young sculptor and he was imprisoned for a year. In Spain, royal protection was of less avail than it was with his father in Italy, who was reprieved from sentence of death for various crimes.

The works of Leoni include eight statues and busts of bronze, among them the group of Charles trampling upon Rage, seven or eight marbles, and, in particular, two reliefs *Plate 59* with a decorative *encadrement*. All of these are portraits of Charles and the Empress, of his

68

sister the Queen of Hungary, and of Prince Philip; nearly all are preserved in the Prado Museum and since they are well known, and also exercised little influence upon the development of Spanish taste, we will not linger over them. In fact, in spite of their great cost and importance, they remained in the workshops of the Alcázar at Madrid during the long reign of Philip II; later they were placed as ornaments in the royal gardens and no one took any notice of them. Although Philip had probably been the inspiration of these works, it would seem as if his youthful tastes, once diverted in the peaceful atmosphere of the Escorial, changed into an aversion for all that signified paganism. For not only is the statue of Philip armed like a Roman, and in heroic attire, but that of the Emperor can be shown entirely in the nude; such portraits, being so unusual in Spain, were never regarded as anything but an almost indecent parade of self-glorification. In the end this helps to prove the sterility of foreign influence, however superior its productions may be.

In addition, Leoni made for the Duke of Alba three bronze busts now lost. Undocumented, but worthy of him, is the bronze effigy in Málaga Cathedral of the Archbishop *Plate 60* of Salerno, Don Luis de Torres, who died in 1554: it represents him resting his head on his left arm, the whole upon an urn and marble base, all very Italian, and the statue of surpassing merit. Fine also are those of Francisco Duarte and his wife, in the University chapel at Seville: they are in medium relief and accompanied by the epitaph and coat of arms, with crest and highly decorative mantling, all in bronze. Duarte died in 1554; he was the purveyor to the Imperial Armada and prevented Leoni from being sent to the galleys in 1541; nevertheless, as the technique of this monument does not seem to be that of the Aretino we must attribute it to a Flemish workshop.

This glut of importations, thrust upon the shoulders of peninsular activity, remained at first ignored, but, just as Bigarny had been eclipsed by Berruguete, so now the current of Italianism, represented by Leoni, led to a modification of style, the harking back to old *motifs,* and this impulse reacted, as was natural, upon the weak point of Berruguete, namely his technique; but it also regained that which Berruguete had exalted — Reason, the criterion of artistic accomplishment.

Nevertheless, the Renaissance had come to influence the nations to their heart's core; the reform brought a revaluation of the past, a revaluation which was cold and conflicting, a reaction from the uncontrolled affections of the Middle Ages and one that was bound to make itself felt more and more. All that was spontaneous, all that was sincere, all that made pre-classic works of art so enchanting, all this was to be exchanged for a profane and sensual style, with its cult of form and its false emotion, clothed in theatrical garb, for genuine feeling was lacking.

Very soon the feverish developments of the Corrales and of Juní were forgotten, while the others strove for serenity as a means of interpreting emotion. It is pure classicism imposed at last in defiance of Spanish ruggedness. Beauty, which Berruguete and Juní seemed to despise, now constitutes the ideal, poor in resources, and fast becoming monotonous, even sugary; but in the meantime these graceful figures of the new school are pleasing; they are posed in easy sweeping attitudes, bending as if about to swoon, their dresses clinging to the body; one leg rigid, the other thrust forward; one hand active; the other in repose; the whole originally studied with great care, and constantly repeated. They are correct, majestic and attractive; and soon there comes an entirely new scheme of polychrome decoration; no longer does the gold shine as formerly, but in subdued tones, shaded with blues, purples, violets and delicate tints, harmonized in the same scale of tones with astonishing perfection: from a distance, a mellow harmony; from near, an enchantment.

BAUTISTA VÁZQUEZ

The finest representative in sculpture of this development is Bautista Vázquez, as Francisco Comontes is in painting, both Toledans and followers of Berruguete. It is even possible that Vázquez assisted Berruguete in the tomb of Cardinal Tavera, for later he and Comontes were called upon to value his share in the work. Vázquez's technique seems to be founded upon that of Berruguete towards the end of his life and we can explain the relationship between the two by saying that Vázquez is the feminine counterpart of the other; his style complementary in the sense that it is harmonious and elegant, never contradictory. His work at Toledo embraces few years: after 1555 he was closely associated with Vergara the elder, and his works include two medallions of prophets and the angel Gabriel in the inner portal of the north transept of the cathedral; the decoration of two retablos now in the Seminary, and that of Santa María la Blanca; and likewise the very large one in the parish church at Mondéjar. Later on, at Ávila, he seems to have executed the decoration of a chapel in the cathedral, with a Pietà and children in white marble for the retablo; from there he went, in 1561, to Seville where we shall meet him again. The above-mentioned Pietà is a copy of that by Michael Angelo; in the other retablos, particularly fine is a relief of the Last Supper, of masterly composition, and some Virtues, who are represented partly nude. All this work possesses vivid and passionate emotion, while in the church at Mondéjar we find a series of statues in which the conception of refinement is carried to an extreme.

Plate 61

70

To what degree the artistic personality of Nicolás de Vergara the elder can be distinguished from that of Vázquez, at first, and at the end, from that of his son and namesake, we cannot say. Son of a Burgalese stone-cutter and grandson of a Flemish glazier who had established himself there, he followed as his principal trade that of his grandfather, being occupied permanently in Toledo Cathedral after 1542. Together with Vázquez he made the Virgin of the Annunciation and a crucifix for the cathedral; the former very much in the manner of Vázquez, and the latter Berruguetesque: afterwards he undertook two large works in bronze: the railing round the tomb of Cardinal Cisneros at Alcalá, begun in 1566, and the two gilded lecterns in the choir at Toledo, made between 1570 and 1572; *Plate 62* lastly, the marble statues of the trascoro, representing Innocence and Guilt. In all this he did not go beyond making the designs, sketches and models, superintending the work of his son and artisans, as he himself declares. His work strikes one, moreover, as coldly Italian and might be termed academical, learnt perhaps from engravings, and possessing ornamental *motifs* of the highest order. Francisco Merino and Juan de Arfe, the famous silversmiths, followed as alleged disciples this same course.

JUAN BAUTISTA DE MONEGRO

Another pupil of his seems to be Juan Bautista de Monegro, cited as a sculptor in 1566, who three years later made for the cloister of the same cathedral two statues of Faith and Charity, under the direction of Vergara and in conformity with his style. Again, we may attribute to him certain Toledan retablos of that date, such as that in Santa Isabel, finished in 1572; they are, however, confused with those of another contemporary sculptor, Pedro Martínez de Castañeda, who made the retablo at Sonseca between 1574 and 1588, which is still a little Berruguetesque. Suddenly an event came to disturb the artistic life of Toledo: in 1577 there arrived Dominico Theotocópuli, El Greco, in order to paint the classical retablos of Santo Domingo el Antiguo, the plans for which he himself made, while the carving and sculpture were confided to Monegro. It is composed of continuous bands of foliage in the friezes, which tell of a new departure in ornament; two children supporting a medallion, upon the first stage of the large altar-piece; two prophets at the sides and three Virtues standing upright above, all in wood, flatly gilded, except for the children, who are painted to resemble life.

The figures are very graceful and the draperies flowing, with ample and simple folds,

full of movement but unexaggerated: the Charity carries a child in her arms and there are three others beside her; the Faith raises her left arm, holding the chalice, and Hope clasps her hands above her head. They cannot be properly appreciated, placed high up as they are, otherwise they would be recognized as masterpieces with a charm that does not lie in the display of the nude nor in the careful arrangement of the poses, consistent with their period, but in their gracefulness, their expressive vehemence, their vitality, as shown in the garments, which recall Berruguete but possess an air of refinement typical of the new era. The miracle is certainly due to the influence of El Greco upon Monegro, and this has to be admitted all the more when it is known that El Greco kept a large stock of models in clay, wax and plaster in his studio, and that he used to make models in order to gain a plastic sense in his creations.

Monegro was engaged at the Escorial before the arrival of Leoni, executing the colossal statues of St Lawrence and the six kings of Judah upon the façades, which he finished in 1584. His style developed in the same direction, with the impulsive rendering of the costumes never revealing the nude and thereby lending an air of grandeur to the figures, somewhat in the manner of Rustici in Italy; similar, and of even happier effect, are his statues

Plate 63 of the Evangelists, executed in marble for the fountain of the principal court and finished in 1593; their sober and austere character distinguishes them from the style of Leoni. The bust of Giovanni Turriano, the celebrated clock-maker, in the museum at Toledo, and the

Plate 64 kneeling effigy of the prior Soto Cameno, in the church of San Pedro Mártir, may also be works of his, the latter being extraordinarily realistic.

EL GRECO

It seems likely that El Greco practised sculpture in addition to that which he executed

Plate 65a for his own private purposes. A little figure of Christ resurrected has been assigned to him through documentary evidence, and the statue itself authorizes one to believe the attribution correct: it is completely in the nude, of fine and accurate workmanship, and was made for the tabernacle of the high altar of the Tavera Hospital, about 1595. It is likewise recorded that, ten years before, he made for his picture of the Spoliation, in the cathedral sacristy, a retablo with pilasters, a pediment, and sculptured figures on the base, which represented the giving of the chasuble to St Ildefonso; the original retablo no longer exists,

Plate 65b but Señor Cossío has identified this group with one discovered by him in the Seminary, a piece of sculpture disconcertingly baroque and anticipating the evolution of the seventeenth century.

72

DOMINGO BELTRÁN

Only for their similarity of tendencies can one include here the works of Domingo Beltrán, such as the retablo of the Jesuit church at Murcia, begun in 1565; a crucifix in the Jesuit church at Toledo, and probably the Virgin of Good Counsel in San Isidro at Madrid, which may have belonged to the retablo finished by Beltrán in 1589. He was born at Vitoria and became a Jesuit in 1561, being already by then a well-known sculptor, but we know nothing of his earlier work. He died in 1590. The above works are thoroughly classical with their very graceful nudes; his crucifixes were celebrated; the Virgin at Murcia is elegantly wrapped in her cloak, and that at Madrid possesses a loving and thoughtful expression; they are far from the style of Vázquez, which they surpass in correctness.

POMPEO LEONI

Upon reaching Spain in 1556, Pompeo Leoni was engaged upon the bronze and marble statues, the royal portraits which he had already studied and which came, half finished, from Italy. In 1570 he began to receive orders, two of them especially noteworthy: the tomb of Archbishop Don Fernando de Valdés, in 1576, for the Asturian village of Salas, and that of Cardinal Espinosa, in 1577, for Martín Muñoz de las Posadas. Besides these, he must have made about this time that of the secretary Francisco de Eraso at Mohernando. The first, entirely of alabaster, is an architectural composition with kneeling effigies of Valdés among his family, surrounded by the seven Virtues; separately, there are kneeling figures of his parents. The tomb of Espinosa is simple, with a kneeling effigy of marble, as is likewise that of Eraso, grouped with another of his wife, with their patron saint, *Plate 66* St Francis, behind them; the whole is unaffectedly naturalistic and simple in composition, while the portraits are very fine and all nobly characterized. As to the allegorical figures at Salas, the Charity recalls Michael Angelo's Leah; all of them are agreeably classical, without vigour or surprises, but also without diligent care; the equal spacing of the Cardinal Virtues seems to be a novelty worthy of praise; but the Faith subduing Heresy is a repetition of the well-used theme exploited by Leone Leoni, derived no doubt from Buonarroti's Victory. Another work of his, perhaps earlier, is the kneeling figure of the Infanta Doña Juana, daughter of the Emperor, in the Descalzas Reales at Madrid.

Hitherto the casting of large figures had not been practised in Spain, so that when Pompeo was commissioned in 1579 with the colossal statues of gilded bronze for the high altar at the Escorial, he was forced to go to Milan, where his father was still living, and there to-

gether they passed the years 1582 to 1589. Later he returned, bringing with him fifteen images representing the Crucifixion, the Evangelists, Doctors of the Church and four Apostles, of progressively increasing size according to the height at which they were to be placed; there were also other little figures for the tabernacle. The elder Leoni must have inspired this proud series of sacred heroes, but the crucifix surpasses all; it is a grand and magnificent work, one of the masterpieces of the century.

Plate 67

To be compared with this there is, in an oratory in the Escorial, the marble crucifix, with the Christ entirely in the nude, which Benvenuto Cellini signed in 1562; it is ugly and more displeasing than any other, although as a study from life, without thought for the aesthetic or feeling, it is perhaps a perfect model. There also came from Italy a marble figure of St Lawrence, now placed in the Escorial, so strongly inspired by the classical that it has been supposed to be derived from some antique statue.

Pompeo became more Spanish in his latest period, which lasts till 1608, the date of his death. In 1593 he made the two royal groups of kneeling effigies, of bronze, gilded and painted, for the Capilla Mayor of the Escorial, where they are lost amidst the mighty architecture around them; nevertheless, they produce the sole effect of grandeur contrasting with this austere building. Afterwards, about 1598, he set up his workshop at Madrid, being entrusted with the wooden figure-sculpture for several retablos both here and at Valladolid, as well as other kneeling statues in alabaster and bronze. These last were those of the Duke and Duchess of Lerma, now in Valladolid Museum, and that of the Archbishop of Seville, Don Cristóbal de Rojas, at Lerma. Others collaborated upon them, but the hand of Leoni displays singular mastery in the head of the Duchess. Several in alabaster are attributed to him, but only one is documented, namely that of the captain Sotelo, in San Andrés at Zamora (1598). Misfortune has befallen the retablos for which he made the statuary, since all those at Madrid have disappeared, though one, from San Diego, remains in Valladolid Museum, incomplete and unfinished. The crucifix in the Royal Academy of San Fernando is the finest of his religious works.

LEONI'S ENTOURAGE

Leoni had as collaborators in the above series of works the Italian Milán Vimercado and Alonso de Vallejo, an artist of merit, to judge by his statues at Madrigal; another friend of his was Antón de Morales, of Granada. At Toledo there developed with Monegro the classicist Giraldo de Merlo, author of large retablos at Sigüenza, Guadalupe and Ciudad Real. Valladolid produced a series of kneeling effigies in alabaster, very richly adorned

and elegant, within a discreet naturalism. Documentarily known as by Pedro de la Cua-
dra, two of this type are preserved in Santa Catalina, and from their resemblance may be
attributed to him those of the Calderones in the convent of Portaceli; those of the Guilla-
mas in the convent of Las Madres at Ávila, those of the Marquis and Marchioness de Santa *Plate 68*
Cruz at El Viso and of the third Marquis and Marchioness de Poza at Palencia, if, that
is to say, some of these are not by Leoni himself, as has been maintained. There worked
also at Valladolid one Francisco del Rincón, author of the statues upon the façade of Las
Angustias, and perhaps of its beautiful retablo; in Madrid there were Juan de Porres and
Juan Muñoz, amongst other less-known sculptors.

All these followed an academical and pompous style, typical of the decadence of classi-
cism, with the airs of nobility and richness in the costumes. Each figure, taken separately,
pleases and even satisfies but, as a whole, technically correct though they may be, they
weary and disgust as much by their monotony and studied repose as by their lack of in-
spiration and the touch of genius. Thus the art of sculpture becomes crystallized under the
freezing influence of the Escorial, and the seventeenth century begins and continues with-
out noticeable changes, not even when the Portuguese Manuel Pereira appears in 1624;
thus also does the court school of sculpture expire — a victim of conventionalism.

VII

FROM THE CLASSICAL TO THE BAROQUE

To maintain a certain degree of unity within the academic cycle, we had first to follow its evolution from Toledo to the Escorial and Madrid, with the branch at Valladolid which, imposed by the court at the beginning of the seventeenth century, flourished for a few years in the ancient home of Berruguete and Juní. Now we have to return once more to Valladolid in search of the tradition which these had founded, and which provoked a fresh awakening of the native Castilian spirit with three artists who co-operate in forming the evolutionary movement precursor of Gregorio Hernández, who represents already the coming century. These artists were Gaspar Becerra, Esteban Jordán and Juan de Ancheta. Quite separately we have to observe the same phenomenon in Andalusia.

GASPAR BECERRA

About 1557 there arrived from Rome Gaspar Becerra, probably born at Baeza, of a family of artists. Coming to Valladolid he soon became entrusted with the important work of the high altar of Astorga Cathedral, almost the only work of his in sculpture which we *Plate 69* possess. Philip II employed him later to paint in fresco a certain cabinet in the palace of El Pardo; we can appreciate the insignificance of this work when it is remembered that he had followed Vasari and Daniele da Volterra and had assisted them in Rome; that is to say, he belonged to the last school of Michael Angelo, who was still alive. As a sculptor, it is enough to look at the base of the above retablo, with its four Virtues, partly in the nude, athletic and insipidly classicist, in order to understand Becerra's ideals in art, his lack of emotion and grace, his characterless formulas and puppet-like figures, his purely anatomical skill. Nevertheless, fame has placed him above Berruguete because his figures are better proportioned and more fleshy, which is true, but modern criticism, far from confirming such undesirable advantages, has to relegate him to the crowd of mannerists, together with his masters, and to condemn the meekness of his genius, which did not allow him to rebel against the bad example of Italy.

As a designer, he is worthy of more consideration, since his retablo at Astorga completely revolutionized the art of decorative composition. One can dispute its beauty and the desirability of creating such a jumbled and at the same time disagreeable specimen of architecture, both from the point of view of classicism and that of the baroque extravagances like

those of Juní; nevertheless it certainly destroyed the usual standards, and was the model for many retablos conflicting with that other dry and tasteless style of the Escorial retablo, which likewise formed a school, particularly at Valladolid. The retablo of Las Descalzas Reales at Madrid, made later by Becerra and no longer existing, was better arranged and more graceful, to judge by its design. The artist died, still young, in 1570.

ESTEBAN JORDÁN

Another master, honoured with the title of Sculptor to the King towards the end of life, was Esteban Jordán, who in 1555, when he was little more than twenty years old, began at Valladolid by collaborating with his brother-in-law, a nephew of Berruguete, named Inocencio. This was in the retablo of Santa Eulalia at Paredes de Nava, in which the figures of St Peter and St Paul are already very characteristic of his style, grandiose and sober, with much attention to the nude shown through the draperies, cold and academical; moreover, he allows himself to plagiarize to the point of impudence Becerra, his superior in every way, Juní and Michael Angelo. His best work as a whole is the large
Plate 70 retablo of La Magdalena at Valladolid, which dates from 1571; that of Santa María at Medina de Rioseco, dated 1590, is unworthy of him, and between the two fall the four reliefs and uppermost figures upon the trascoro of León Cathedral, the Crucifix which crowns it being better than the rest. Two effigies of alabaster, known to come from his hand, are of little value. He died probably in 1598, and his activity and influence seem to have been very great, judging from the number of works scattered throughout Castile which recall him.

A friend of his and of Juní was Juan Bautista Beltrán, the author of the sculpture on the retablo at Simancas, begun in 1562 in company with Inocencio Berruguete, and following the same tendencies as Jordán, but without merit. He was imitated also by Adrián Alvarez and the already-mentioned Pedro de la Cuadra, at the very end of the century.

JUAN DE ANCHETA

In his will of 1577 Juní declared that there was no other sculptor to whom he could entrust the retablo of Santa María at Medina de Rioseco, which he was then engaged upon, except Juan de Ancheta; and in fact no one harmonized better a dramatic and plastic correctness with the sense of proportion characteristic of Becerra; but, the son of his time, he clung even more desperately to the formulas of the Michaelangelesque poses. Ancheta

was a Biscayan, from Azpeitia; the earliest mention of him is at Valladolid in 1565, when he was keeping company with a Burgalese lady by whom he had a son; in León he exe⁄cuted various works of which we know nothing; he went repeatedly to Briviesca about 1569, and was befriended by the above⁄mentioned Juan Bautista Beltrán, which proves his connection with Juní, Jordán and Inocencio Berruguete. Works recorded in 1578 to be his are the Assumption and Coronation of the Virgin on the high altar of Burgos Cathedral, a copy of that at Astorga, in which Rodrigo and Martín de la Haya took part after 1562, their leanings towards the classical revealed by their love of feminine nudes.

Before this, Ancheta must have executed the magnificent retablo of Santa Clara at Briviesca, which has been wrongly attributed to others. Its figure⁄sculpture is of the most extravagant type imaginable, both as to the large images and the myriad of tiny reliefs, each full of interest and variety, which cover the whole. No doubt Becerra's example guided the hand which produced this sumptuous piece of decoration, for in correctness it is scarcely inferior to his own work, but it was Juní who gave life and feeling to the figures. To confirm these influences it is enough to compare, for example, the Assump⁄tion or the Pentecost, directly copied from similar scenes by Becerra; on the other hand, the Birth of the Virgin is closer to Juní, who most certainly would not himself have repudiated the Visitation, a baroque version of the delightful group by Andrea della Robbia; in the same way, the Moses at the top, without being a copy, is derived from that of Michael Angelo. These personages with long curly beards, the youths, almost nude, who take the place of angels, the garments with distended folds, a certain compo⁄sure in the attitudes, etc., show the style of Ancheta.

His must be the altar⁄piece of St Casilda in the parish church at Briviesca, in which he begins to cover the base with animated bas⁄reliefs, a characteristic repeated in all the retablos of this series. Such is the case with that of St Gabriel in the old cathedral of *Plate 71* Saragossa, with its alabaster statues and reliefs; likewise the famous retablo of the Holy Trinity in Jaca Cathedral, finished in 1575, and others in the same church. Of about 1577, and documented, is the retablo of St Peter at Zumaya; the remains of that at Aoiz are attributed to him with reason; he made that at Cáseda in 1581, that of Ta⁄ *Plates 72, 73* falla in 1592, and completed his days at Pamplona, where the imposing crucifix of the trascoro in the cathedral is held to be his work. Both in this and in the Tafalla retablo he surpasses himself in the note of sculptural magnificence, with wonderful capacity for invention, the boasting of his powers of foreshortening and of overcoming difficulties in the reliefs; the group of the Descent from the Cross at Tafalla is admirable, together with its crowning scene of God the Father offering the Crucified Word. If Berruguete

sums up the spirit of Castilian genius forming itself upon Michaelangelesque principles, Ancheta is a Biscayan by birth, possessed of eternal youth, who comes undaunted from his mountains to impose upon the same ideal an air of restlessness and power.

Andrés de Araoz may be regarded as a forerunner of Ancheta. After 1561 he made various retablos in the Basque Provinces, which were continued by his son Juan, already influenced by the new school. Notable also is the retablo at Ávalos with its large statues of Adam and Eve on either side of the Crucifixion, which recall Forment. Nearer to Ancheta are those of Alquézar in Aragon, very rich and of great decorative effect, of Valtierra in Navarre, and of Monteagudo near Soria. Other disciples of the great sculptor must be Martín Ruiz of Zubiate, near Briviesca, who was the author of the retablo at Durango; Juan de Iriarte and Ambrosio de Vengoechea who made that in San Vicente at San Sebastián and others; Pedro González de San Pedro who, together with the last-named, made that at Cascante; Lope de Larrea, author of the retablo at Salvatierra, and likewise other Biscayan sculptors until well on into the seventeenth century. Pedro Arbulo de Marguvete, of the Rioja, enjoyed an undeserved celebrity; it is recorded that he made the retablo and choir-stalls at San Asensio in 1567, the former crowned with a vast composition of the Last Judgement, borrowed from Michael Angelo, just as the Assumption is a plagiarism of Becerra and, as a whole, of little value.

If we cast our minds back to the impressions left by all these masters, there only remain in our memory the splendid creations of Ancheta, the racial vigour of his personages, an understanding of humanity compelling more by its character than by its pleasing qualities, for he, like Buonarroti and all the great Spanish artists, repudiated feminine attraction.

Afterwards there comes another mighty sculptor, Gregorio Hernández, but by his time the brilliant lights of the Renaissance had nearly died out. He expresses the vulgarity of his prosaic age, the outlook of a narrow life; he begins by experimenting with the human structure in his dead Christs and ends by diverting the people with Jews and ruffians; but while Ancheta the Biscayan is unfeeling, Hernández places a certain degree of Gallegan lyricism in his works.

IN ANDALUSIA

Sevillian art continued to live by the assistance of immigrants during this last period of the Renaissance. It has already been stated that Isidro de Villoldo of Ávila had been living here for seven years, at work upon the retablo of the Cartuja, and, at his death in 1560, his place was taken in the same city by Bautista Vázquez, accompanied by his

pupils Jerónimo Hernández, Juan de Oviedo and Miguel Adán; later on, there arrived a Diego de Velasco, probably the son of his namesake of Ávila, who worked at Toledo, as we have already seen.

DIEGO DE PESQUERA

Meanwhile there appeared at Granada a sculptor of unknown antecedents, but so exceptional and fine that he may be suspected to have studied in Italy. This is Diego de Pesquera, who was engaged upon various decorative works in the cathedral after the death of Silóee in 1563, there being due to him the Virtues of the portal of the chapter-room, a relief of the Coronation of the Virgin inside this hall and another of St Jerome, above a doorway; likewise the group of St Anne, of painted wood; the retablo at Ugíjar Bajo and parts of those at Montejícar and Colomera. His style is more robust and personal than that of Vázquez and his schemes of composition better, but above all he gives a noble and enchanting plasticity to his figures, which attract by their gentleness; this sculptor revived the tradition of Jacopo Florentino more than that of Silóee. *Plate 74*

Plate 75

After 1571 Pesquera reappears in Seville, where he must have died about 1580. A collaborator of his was a certain Juan Marín who had been working in the cathedral for many years previously; together they made the decorative statuary of the Royal Chapel, Pesquera beginning with a St Rufina, the most beautiful figure in this series, and again together they completed the images of clay which adorn the trasaltar. Later he made the other statues of Hercules and Caesar for the Alameda and those of Mercury and Mars, with their accessories, for some fountains in the Alcázar, which have been alluded to before. Lastly, he began the decoration of the chapter ante-room in the cathedral, where one can recognize his style perfectly in two lunettes of St John and St Mark, and in a few reliefs of allegories and biblical scenes, particularly in those which represent Wisdom and Ignorance with their respective accompaniments, Moses leading the chosen people, and the worship of the golden calf. Nothing authorizes us to attribute to him other reliefs and statues of Virtues, which are a veritable plagiarism of the antique marbles preserved in the Casa de Pilatos, though despite this we cannot discover who made them.

VÁZQUEZ AND VELASCO

We meet again with Bautista Vázquez at Seville in 1561, and although the retablo which he finished for the Cartuja has disappeared, his style is recognizable in the group of the Flight into Egypt, his first work in the cathedral, and in the little figures of the

Tenebrario (a monumental bronze candelabrum) and the lectern, which are moreover very Berruguetesque. We can attribute to him the three reliefs of Virtues which decorate the portal of the chapel in the hospital of La Sangre, dated 1567, and another of the Virgin holding the Child in that of the University, pieces of marble classically beautiful although mannered. Better than these is the tomb, also in marble and known to date from 1564, of the Inquisitor Corro, who is represented leaning his head upon one arm and reading, a figure exquisitely modelled from life, at San Vicente de la Barquera. In 1569 he decorated for Don John of Austria the poop of the splendid royal galleon with mythological figures, Virtues, angels, shields etc., and for this work he was given the title of Sculptor to the King. Afterwards he undertook the figure-sculpture of two large retablos, one of which was executed in company with a certain Melchor Turín, otherwise unknown, at Medina Sidonia (where is the Calvary, made by Bolduque), and is completely filled with groups carved in the round, coarse but overflowing with grace and feeling. The other

Plate 76 retablo, that at Lucena, possesses reliefs in which attention is devoted to the finish and details rather than to the expression, as is also the case with the single figures, which are in general unworthy and show the interference of pupils. Those of the retablo of Priego, which were made earlier, preserve on the other hand the characteristic elegance of composition typical of Vázquez.

His last great enterprise was the decoration of the chapter-hall in Seville Cathedral with eight large reliefs made of white stone. An equal number of smaller ones, added in 1590 by Marcos de Cabrera, are of little value. In the large reliefs Vázquez was assisted between 1580 and 1586 by the already-mentioned Diego de Velasco. The two in the middle, representing the Assumption and the Adoration of the Lamb, are distinguished by their vigour and magnificence, the splendid fulness of the robes, which seem as if blown by the wind, the animation of the faces and poses and the perfect technique of the relief, while, if we recall the Pietà at Ávila, some plagiarism of Michael Angelo is not to be wondered at. The six other reliefs, nearly all apocalyptical, belong more entirely to Velasco, who sharpens the folds of the draperies in a peculiar manner; a few portions, such as the group of the vintage, captivate us by their spontaneous Hellenism; the figure of the Evangelist engrossed in his book is very able and there are quantities of beautiful little angels; but as a whole it is cold and unsuccessful. Velasco's last works (1592) were the three little figures of Virtues which crown the archbishop's throne in the same church, so free that they seem to be modern; also there appear to belong to him four panels with reliefs of the Holy Fathers, on a sacristy wardrobe, graceful and original in those portions which are free from the obsession of Michael Angelo.

82

These two masters prepare the way for the great Andalusian school of sculptors, remarkable for its uniformity until it falls under the spell of baroque naturalism inspired by Alonso Cano, when the seventeenth century was already well advanced. Vázquez died in 1589 but, ten years before, his son Juan Bautista Vázquez, the younger, had been at work, and evidence can be found for attributing to him the retablo of the Conception in the University Chapel at Seville, constructed about 1585, but without its additions, including the principal image; the rest appears to be copied from the elder Vázquez. The same (excluding its final enlargement) may be said of the immense retablo of San Jeró *Plate 77* nimo at Granada, where another nucleus of sculptors was formed, including, in particular, Pablo de Rojas, the master of Juan Martínez Montañés.

At Seville Vázquez the elder trained his pupil Jerónimo Hernández of Ávila, who col laborated with him upon the retablo of the Cartuja. By him and of 1570 is a St Jerome *Plate 78* penitent in the cathedral, inspired by that of Torrigiano, but much more expressive. Amongst his other works there stands out the proud figure of the Mother of God in the convent of La Madre de Dios, a Christ resurrected in San Pablo, and a few special re liefs upon the retablo of San Leandro, together with others by Velasco. In addition he undertook the carving of the retablo at Lucena already referred to, filled with reliefs, of children in particular, and certain Evangelists on the base, fascinating for their poetic spirit. He died young in 1586.

Companions of his were Miguel Adán and Juan de Oviedo the younger. By the for mer are known two recumbent effigies of marble in the convent of La Madre de Dios at Seville, and he collaborated upon several retablos; the same may be said of the latter, the author of that at Cazalla de la Sierra, very original as far as the design is concerned, and that of Constantina, although he does not go beyond already-known sculptural precepts.

Greater credit and more work as a figure-sculptor were obtained by Andrés de Ocampo, a disciple of Hernández, mentioned above in connection with certain medallions which he made for the palace in the Alhambra. He also made a large relief of the Descent from the Cross in San Vicente at Seville and nearly all the statuary of the retablo at Arcos, in which he reveals himself as a loyal follower of his master, but with certain features exag gerated, such as the conversion of the draperies into a labyrinth of intersecting folds without regard to the forms of the body. He lived until 1623.

His companion Gaspar Núñez Delgado cannot have lived so long, since he is only recorded between 1581 and 1605. He made the retablo of John the Baptist in San Cle *Plate 79*

83

mente at Seville, the principal image of which is one of the most suggestive in this series. He distinguished himself in anatomy, as shown particularly in a few Ecce Homos of painted clay rendered with a powerful and sorrowful emotion.

There was a remarkable friendship between these artists, to judge from the documents preserved. They assisted and went surety for each other, so that it is difficult to distinguish their works with certainty, linked as they are by an absolute co-ordination of style, not far removed from that of Juan Martínez Montañés, likewise a friend of the above and influenced particularly by Ocampo in his earliest works after 1588, the year of his arrival at Seville. In reality Montañés was a disciplined follower within this school; he altered nothing; his value lies in the effective intensity and beauty which he gave to the faces of his images, but always within the limits of classical tradition in composition and costume.

The neighbourhood of Jaén produced good retablos during the prime of classicism, such as those of Alcaudete, Arjonilla, Martos, and that of the Holy Countenance in Jaén Cathedral; this last with figures by Sebastián and Francisco de Solís, of between 1602 and 1605; all of these without definite advances in style.

At Granada, Pablo de Rojas was at work from 1581 to 1607, specializing in crucifixes, with very little variety between them, as is also the case with his other figures; but in the end he had as collaborator Bernabé de Gaviria, who must have been a disciple of his, and who gives the decisive touch, a distinctly baroque note, if, as it seems, the series of apostles *Plate 80* is his which are grouped round the interior of the Capilla Mayor in the cathedral, finished in 1614. They are colossal figures, placed high up upon brackets and entirely gilded, giving life to Diego Silóee's splendid scheme of architecture with their severe and powerful expression, their varied gestures and attitudes, which reveal in each a different temperament, accentuated by the wreathing draperies which betray their spiritual agitation. It would be difficult to find another series like this surpassing it in strength of character. Later, Alonso de Mena, although a disciple of Ocampo at Seville, maintained the style of Rojas, bastardized, however, owing to the already fallen ideal of the Renaissance.

This transition came about amidst reactions of great depth of feeling, reactions which gave to the seventeenth century its individual character, uninfluenced from abroad since foreign sculptors had ceased to flock to Spain, where also by this time nothing was known of Italy. In all ways the sixteenth century had been prodigal; numerous as are the sculptors and numerous as are the works recorded in this book, they are but a limited selection; yet every retablo, every choir-stall, portal and tomb overwhelms us with its exuberance of ornament, its series of figures and groups. All this was of little account in the face of the yearning for religious expression which created through art a spiritual world in tangible

84

forms, poems of radiant and trustful faith, for life at this time ran its course untroubled.

But the political decadence of Spain was hammering at the gate, foretelling the ruin of her industries; ever-increasing poverty struck all hearts with fear, and to compensate for this a certain pious and revivalistic feeling set in, a mystic exaltation which invigorated the Spanish character.

Painters were the interpreters of the new ideal: in Castile, El Greco; in Seville, Roelas, and in Valencia, Ribalta, the immediate forerunners of the great school of the seventeenth century. They popularized painting on canvas, thus making possible works of great size in which the charm of colour learnt from the Venetians and, above all, a force of expression characteristically Spanish fired the religious enthusiasm of the people. In sculpture, by this time, ancient "legends" of simple narrative character had lost their interest, and in their place arose mystic types, each one repeated a hundred times upon the model of the *chef-d'œuvre* which had succeeded in capturing the imagination of the masses. The Immaculate Conception, the Crucifixion, the Children Jesus and John, St Francis, St Joseph, etc., were the favourite subjects to be represented, though these were not to the taste of the clergy, but to that of the religious orders and the devout who forced their special predilections on the form of service in the churches and chapels alike. The influence of the preaching orders, with its tendency to carry away its hearers with appeals to sentiment, prepared the way for this new outburst of popular passion. Thus it was that the sculpture of the seventeenth century, freed from classical encumbrances, recovered once again, in a baroque manner, the imaginative force of the ancient image-makers, brought back to life, however, by the study of that realism which gave its naturalistic and tender character to Spanish art, a cloak for its unconquerable pessimism.

BIBLIOGRAPHY

ABIZANDA Y BROTO, M., Documentos para la historia artística de Aragón, 1914-1917.

AGAPITO Y REVILLA, J., La obra de los maestros de la escultura vallisoletana, 1920-1929.

AGAPITO Y REVILLA, J., Los retablos de Medina del Campo, 1916.

ANDREI, P., Sopra Domenico Fancelli... e Bartolomeo Ordognes, 1871.

ANGULO ÍÑIGUEZ, D., La escultura de España, 1926 (in STEGMANN, H., La escultura de Occidente).

ARAUJO GÓMEZ, F., Historia de la escultura en España, 1885.

BAQUERO ALMANSA, A., Los profesores de las Belles Artes murcianos.

BERTAUX, É., La Renaissance en Espagne et en Portugal (in MICHEL, A., Histoire de l'Art, IV, p. 103; V, p. 100).

BOSARTE, G., Viaje artístico a varios pueblos de España, 1804.

CALVERT, A. F., Sculpture in Spain, 1912.

CAMPORI, G., Memorie biografiche degli scultori... di Carrara, 1873.

CEAN BERMÚDEZ, J. A., Diccionario histórico... de las Bellas Artes en España, 1800.

CORREIA, V., As obras de Santa Maria de Belem, 1922.

CORREIA, V., A sepultura de D. Luis de Silveira en Góis, 1921.

CORREIA, V., Nicolau Chanterene na inquisição, 1922.

CORREIA, V., O pantheon dos Lemos, 1928.

CORREIA, V., A escultura em Portugal no primeiro terço do seculo XVI, 1929.

DIEULAFOY, M., La statuaire polychrome en Espagne, 1908.

DOMÍNGUEZ BORDONA, J. and TORMO, E., Felipe Vigarni, 1914.

FÄH, Damián Forment, 1909.

FLORIANO CUMBREÑO, La iglesia de Santiago de los Caballeros en Cáceres, 1918.

GESTOSO Y PÉREZ, J., Ensayo de diccionario de artífices... de Sevilla, 1899-1909.

GESTOSO Y PÉREZ, J., Sevilla monumental y artística, 1889-1892.

GESTOSO Y PÉREZ, J., Noticia de algunas esculturas de barro vidrado, 1910.

GILMAN, Catalogue of sculpture in... the Hispanic Society of America, 1930.

GÓMEZ-MORENO, M., Guía de Granada, 1892.

GÓMEZ-MORENO, M., Palacio del emperador Carlos V en la Alhambra, 1885.

GÓMEZ-MORENO, M. (son), Vasco de la Zarza, 1909-10.

GÓMEZ-MORENO, M. (son), La capilla de la Universidad de Salamanca, 1914.

GÓMEZ-MORENO, M. (son), Estudios sobre el Renacimiento en Castilla: I. Hacia Lorenzo Vázquez; 1925. II. En la Capilla real de Granada, 1926.

Gómez-Moreno, M. (son), Catálogo monumental de León, 1925.

Gómez-Moreno, M. (son), Catálogo monumental de Zamora, 1927.

Gómez-Moreno, M. (son), Obras de Miguel Angel en España, 1930.

González Simancas, M., La Catedral de Murcia, 1911.

Güell, Escultura polícroma religiosa española, 1926.

Hispanic Society of America, The tombs of don Gutierre de la Cueva and doña Mencía Enríquez de Toledo, 1927.

Hispanic Society of America, Portrait medallions, 1927.

Hispanic Society of America, Pompeo Leoni, 1928.

Holanda, F. de, De la pintura antigua, 1548. Spanish edition, 1921.

Huidobro Serna, L., Artistas burgaleses, 1922-25.

Justi, C., Miscellaneen aus drei Jahrhunderten spanischen Kunstlebens, 1908.

Lacerda, A. de, O panteom dos Lemos, 1928.

Lafond, P., La sculpture espagnole, 1909.

Loga, V. von, Die Spanische Plastik, 1910.

López Martínez, Retablos y esculturas de traza sevillana, 1928.

López Martínez, Arquitectos, escultores y pintores... de Sevilla, 1928.

López Martínez, De Jerónimo Hernández a Montañés, 1929.

Martí y Monzó, J., Estudios histórico-artísticos relativos... a Valladolid, 1898.

Martínez (Jusepe), Discursos... del arte de la pintura, *about* 1673.

Martínez y Sanz, M., Historia de la Catedral de Burgos, 1866.

Mayer, A. L., Spanische Plastik, 1923.

Mélida, J. R., Catálogo monumental de Cáceres, 1924.

Mélida, J. R., Catálogo monumental de Badajoz, 1925.

Museo provincial de Bellas Artes de Valladolid, Catálogo de la sección de Escultura, 1916.

Orueta y Duarte, R. de, Berruguete y su obra, 1917.

Orueta y Duarte, R. de, La escultura funeraria en España, 1919.

Palomino, Museo pictórico, 1715.

Pérez Costantí, Diccionario de artistas que florecieron en Galicia, 1930.

Pérez Pastor, C., Colección de documentos para la historia de las Bellas Artes en España, 1914.

Pérez Sedano, F. and Zarco del Valle, M. R., Datos de arte sobre la Catedral de Toledo, 1914-1916.

Pérez Villa-Amil, M., La Catedral de Sigüenza, 1899.

PLON, E., Leone Leoni et Pompeo Leoni, 1887.

PONZ, Viaje de España, 1772/94.

QUINTERO ATAURI, P., Sillerias de coro, 1908.

QUINTINO GARCÍA and TEIXEIRA DE CARVALHO, J. M., João de Ruão, 1913.

RÍOS Y SERRANO, D. DE LOS, La Catedral de León, 1895.

SAGREDO, D. DE, Medidas del romano, 1526.

SALAS, Damián Forment, 1929.

SÁNCHEZ CANTÓN, F. J., Los Arfes, 1920.

SÁNCHEZ CANTÓN, F. J., Fuentes literarias para la Historia del arte español, 1923.

SANCHIS Y SIVERA, J., La Catedral de Valencia, 1909.

SERRANO FATIGATI, E., La escultura en Madrid, 1912/20.

SERRANO FATIGATI, E., Retablos españoles ojivales y de transición al Renacimiento, 1902.

TORMO Y MONZÓ, E., Gaspar Becerra, 1912/20.

TRAMOYERES BLASCO, L., El escultor valenciano Damián Forment, 1903.

UNIVERSITY OF SEVILLE, Documentos para la historia del arte en Andalucía, 1927.

UNIVERSITY OF SEVILLE, La escultura en Andalucía, 1929.

VIELVA RAMOS, M., La Catedral de Palencia, 1923.

VILLA-AMIL Y CASTRO, J., Iglesias gallegas de la edad media, 1904.

VILLACAMPA, C. G., La Capilla del Condestable de la Catedral de Burgos, 1928.

VILLALÓN, C. DE, Ingeniosa comparación entre lo antiguo y lo presente, 1539.

VIÑAZA, CONDE DE LA (MUÑOZ Y MANZANO), Adiciones al diccionario de Cean Bermúdez, 1889/94.

WEISE, G., Spanische Plastik, 1925/1927/1929.

ZARCO DEL VALLE, M. R., Documentos inéditos para la Historia de las Bellas Artes en España (in SALVÁ: Documentos inéditos... vol. LV), 1870.

Brussels, 68.

Buenavista, monastery of San Jerónimo: Virgin and St Jerome, 48, 83.

Burgo de Osma, Cathedral: retablo, 61, 62, 63; retablo in chapel of St Peter, 51-52, plate 41 b; trascoro, 58.

Burgos, 11, 29, 31, 32, 33, 34, 37, 38, 43, 44, 45, 46, 49, 50, 51, 57, 58, 64, 65, 68, 79. Arco de Santa María: statuary, 68. Cathedral: choir-stalls, 33, 43, 46; high altar, 37, 79; lantern, 64; portal of the Furriers, 37; reliefs upon the trasaltar, 32, 34, pl. 17; stairway in the north transept, 50; tomb of Archdeacon Diego de Fuentepelayo, 29; tomb of Bishop Don Luis de Acuña, 49-50; tomb of Canon Diego de Santander, 51; tomb of Canon Lerma, 34; Constable's Chapel: medallion of the Virgin and Child, 58; principal retablo, 33, 50, plate 22; recumbent effigies of the Constables of Castile, 57; retablo of St Anne, 38, plate 27; retablo of St Peter, 38, 50. Hospital of the King: doorway of the chapel, 38. Monastery of San Juan, 51. San Esteban: chapel, 37; retablo, 37.

Burgundy, 1, 43.

Cáceres, Santa María: retablo, 64. Santiago: retablo, 57.

Cadiz, 6.

Calatayud, Santa María: portal, 20.

Calatorao, crucifix, 20.

Cariñena, 20.

Carona, 7.

Carrara, 44, 57.

Carrión, San Zoilo: decoration, 51.

Casalarreina, Convent of La Piedad: portal, 33.

Cascante, retablo, 80.

Cáseda, retablo, 79.

Castile, 3, 11, 23, 25, 27-39, 41, 42, 43, 49, 51, 52, 59, 60, 63, 68, 78, 85.

Castroverde de Campos, San Nicolás: retablo, 63.

Catalonia, 3, 5, 23.

Cazalla de la Sierra, retablo, 83.

Cellas, retablo, 20.

Champagne, 42, 60.

Chaource, 36.

Cintra, retablo, 25.

Ciudad Real, retablo, 74.

Ciudad Rodrigo, 61, 63; Calvary, 61.

Coca, Fonseca tombs, 44.

Coimbra, 25, 26. Cathedral and "Especiosa" portal, 25. Convent of Santa Cruz: royal tombs, 25. Museum: Last Supper by Hodart, 26; Entombment by Hodart, 26. San Marcos: retablo, 26.

Cologne, 5.

Colomera, retablo, 81, plate 75.

Como, Cathedral, 36.

Compostela, see Santiago de Compostela.

Constantina, retablo, 83.

Cuéllar, San Francisco: tombs of Bishop Don Gutierre de la Cueva and Doña Mencía Henríquez de Toledo, 29-30.

Cuenca, 11, 56, 57, 64. Cathedral: cloister portal, 64; retablo of Muñoces chapel, 56; sacristy doors, 56, plate 49.

93

94

97

Arce, Baltasar de: Granada, San Cristóbal: figure of St Christopher, 52.

Arcos, Duke of, 48.

Arfe, Juan de, see Juan.

Arias Pérez Maldonado, 35.

Arnalte, accountant, 30.

Artemis, 67.

Artiaga, Ochoa de, see Ochoa.

Ascension, see Christ.

Assumption of the Virgin, see Virgin.

Aurora, 55.

Austria, Don John of, 82.

Ayamonte, see Zúñiga.

Bacchus, 10.

Badajoz, Juan de, see Juan.

Baeza, Francisco de, see Francisco.

Balmaseda, Juan de, 34, 37-39, 43, 49, 50. Becerril de Campos, retablo, 39. Burgos, Cathedral, Constable's chapel: retablo of St Anne, 38, plate 27; Hospital of the King: chapel door, 38. León, Cathedral: retablo, 38, plate 28. Madrid, Lázaro collection: Virgin and St John, 38. Oviedo, Cathedral: figure on high altar, 37. Palencia, Cathedral: Calvary on high altar, 37, 38; retablo of St Ildefonso, 39. San Cebrián de Campos, retablo, 38. Santa Maria de Nieva, retablo, 39. Santiago de la Puebla, Statuary, 49. Villamediana, retablo, 38.

Bandinelli, 60.

Barnaba da Pone, see Pone.

Bazán, Álvaro de, see Santa Cruz.

Becerra, Gaspar, 21, 38, 62, 77-78, 79, 80.

Astorga, Cathedral: retablo, 21, 77-78, plate 69. Madrid, Descalzas Reales: retablo, 78.

Beltrán, Domingo: Madrid, San Isidro: Virgin of Good Counsel, 73. Murcia, Jesuit church: retablo, 73. Toledo, Jesuit church: crucifix, 73.

Beltrán, Juan Bautista, 78, 79. Simancas, statuary of the retablo, 78.

Benaventes, the, 59.

Benedetto da Maiano, see Maiano.

Benedict, St, 55, 62.

Beogrant, Guiot: Bilbao, Santiago: retablo, 63.

Beogrant, Juan de, 63.

Bernal, Jaques: Castroverde de Campos, San Nicolás: retablo, 63. Villanueva del Campo, retablo, 63.

Bernard, St, 21.

Bernardini, Pier Angelo, see Pier.

Bernini, 42.

Berruguete, Alonso, 9, 16, 17, 18, 19, 22, 33, 34, 35, 38, 39, 43, 46, 51, 52-57, 58, 59, 60, 61, 62, 66, 69, 70, 71, 72, 77, 78, 79, 82. Burgos, Cathedral, Constable's Chapel: recumbent effigies of the Constables of Castile, 57. Cáceres, Santiago: retablo, 57. Cuenca, Cathedral: sacristy doors, 56. Monastery of La Mejorada, retablo (now in Olmedo): 52-53, 55. Salamanca, College of the Irish Nobles: retablo, 54, 55. Saragossa, Museum: tomb of Chancellor Selvagio, 52. Toledo, Cathedral: trascoro, 56, 60; upper choir-stalls, 35, 51, 55-56, 58, 62, plates 45-47;

Catherine, St, 39, 53, 55, plate 29.

Catholic Sovereigns, see Ferdinand and Isabella.

Cellini, Benvenuto: Escorial, crucifix, 74.

Chanterene, Nicolau: Cintra, monastery: retablo, 25. Coimbra, monastery of San Marcos: retablo, 26.

Charity, 45, 47, 71, 72, 73.

Charles V, 16, 27, 44, 52, 65, 66, 68, 69, 73.

Christ, 4, 5, 6, 18, 20, 21-22, 35, 36, 37, 38, 42, 44, 45, 46, 47, 48, 50, 51, 56, 60, 61, 74, 80, 83, 85, pl. 26, 27. Nativity, 6, 31, 50, 56, 60. Presentation in the Temple, 20. Flight into Egypt, 81. Casting out the money-changers from the Temple, 36. Transfiguration, 56, 60. Passion, 18. Entry into Jerusalem, 36. Last Supper, 26, 70. Agony in the Garden, 8. Bound to the column, 37, 50, 51, plate 11b. Ecce Homo, 84. Spoliation, 72. Via Dolorosa, 8, 17, 32, 45, plate 17. Crucifixion, 8, 22, 31, 32, 35, 37, 38, 47, 53, 54, 61, 74, 80, 85, plates 36, 67. Descent from the Cross, 17, 34, 42, 60, 79, pl. 32. Entombment, 26, 45, 46, 61, plates 30, 34, 53, 56. In Limbo, 4, 45. Resurrection, 4, 5, 16, 20, 21, 32, 37, 72, 83, plates 13, 65a. Appearing to St Thomas, 37. Ascension, 7.

Christopher, St, 52.

Churriguera, 56.

Cicero, 67.

Cisneros, Cardinal Jiménez de, 7, 8, 34, 44, 66, 71, plate 21b.

Civitale, 7.

Cobos, Francisco de los, 9.

Colombe, Michel, 28.

Colonia, Francisco de, 37, 38. Burgos, Cathedral: Portal of the Furriers, 37; San Esteban: chapel and retablo, 37. Peñaranda de Duero, palace, 37, 68.

Colonia, Nicolás de: Astorga, Cathedral: episcopal throne in the choir, 63.

Commons, Revolt of the, 27, 65.

Comontes, Francisco, 70.

Copín, 28, 31, 41. Toledo, Cathedral: retablo, 28.

Cornielis de Holanda, choir-stalls of Ávila Cathedral, 39.

Cornielles de Holanda, 36, 39. Pietà in the cathedral at Santiago de Compostela, 36, plate 26.

Coronation of the Virgin, see Virgin.

Corral, Jerónimo del, chapel of the Benaventes in Santa María at Medina de Rioseco, 59, plate 51.

Corral, Juan del, 59.

Corral, Ruy Díez del, 59.

Corrales de Villalpando, family of, 59, 66, 70. Palencia, Cathedral: chapel of the Kings, 59. Medina del Campo, decoration of the Casa Blanca, 59.

Corro, Inquisitor, 82.

Corte, Nicolao de, 66. Granada, Alhambra: decoration of south front of Charles V's palace, 66; medallions of the Fountain of Charles V, 66; monumental mantelpiece, 66.

Cosmas, St, 20.

Cossío, Señor, 72.

Covarrubias, Alonso de, 34, 37.

56. Tordesillas, retablo, 61. Valladolid, Cathedral: retablo from Santa María la Antigua, 61, 62; Jesuit church: crucifix, 61. Museum: Death of the Virgin, 62. Entombment, 61, pl. 53; group of Mary and St John, 61; figure of St Anne, 62, plate 54; St Anthony the Great, 62; St Anthony of Padua, 62; Nuestra Señora de las Angustias: Dolorosa (Virgin of the Swords), 61; Santa Isabel: retablo of St Francis, 62; Santiago: crucifix, 61.

Juste, Jean, 60.

Justi, Doctor, 9.

Justice, 59.

Lanuza, Juan de, 18.

Laocoön, 47, 52, 56.

Larrea, Lope de, retablo at Salvatierra, 80.

Lasaosa, Pedro de, 17.

Last Judgement, 8, 21, 80.

Last Supper, 26, 70.

Laurana, Francesco, 5, plate 4.

Lawrence, St, 22, 72, 74, plate 14.

Leah, 73.

Lebrija, Antonio de, 34.

Leda, 66.

León, Nicolás de, figure of St Andrew in San Andrés, Granada, 36.

Leonardo da Vinci, 14, 41, 47.

Leoni, Leone, 68-70, 73, 74. Statues for the Duke of Alba, 69. Madrid, Prado: Charles V trampling upon Rage, 68; portrait bust of Empress Isabella, 68, plate 59; portraits of the Queen of Hungary and Prince Philip, 69. Málaga, Ca-

thedral: sepulchral effigy of Don Luis de Torres, Archbishop of Salerno, 69, plate 60.

Leoni, Pompeo, 68, 72, 73-74, 75. Escorial: figures on high altar, 73-74, plate 67; kneeling effigies in Capilla Mayor, 74. Lerma, statue of Don Cristóbal de Rojas, Archbishop of Seville, 74. Madrid, Descalzas Reales: statue of the Infanta Doña Juana, 73; Academia di San Fernando: crucifix, 74. Martín Muñoz de las Posadas, tomb of Cardinal Espinosa, 73. Mohernando, Parish church: tomb of Francisco Eraso, 73, plate 66. Salas, tomb of Archbishop Don Fernando de Valdés, 73. Valladolid, Museum: statues of the Duke and Duchess of Lerma, 74; retablo from San Diego, 74. Zamora, San Andrés: effigy of Captain Sotelo, 74.

Leopardi, Alessandro, 9.

Lerma, Canon, 34.

Lerma, Duke and Duchess of, 74.

Leval, Antonio, façade of Charles V's palace in the Alhambra, 67, plate 58.

Librada, Santa, 36.

Libyan Sibyl, 45.

Liceire, Juan de, 20, 21. Saragossa, Old Cathedral: tomb of the mother of Archbishop Don Fernando de Aragón, 21.

Liévana, Toribio de, 52.

Llanos, Fernando de los: doors of the silver retablo of Valencia Cathedral, 13-14.

Lobato, Nicolás de, choir-stalls of El Pilar at Saragossa, 20.

PLATES 1–80

I

VALENCIA, CATHEDRAL
Trascoro: Samson carrying away the gate of Gaza.
Julián el Florentino
Photo Arxiu Mas

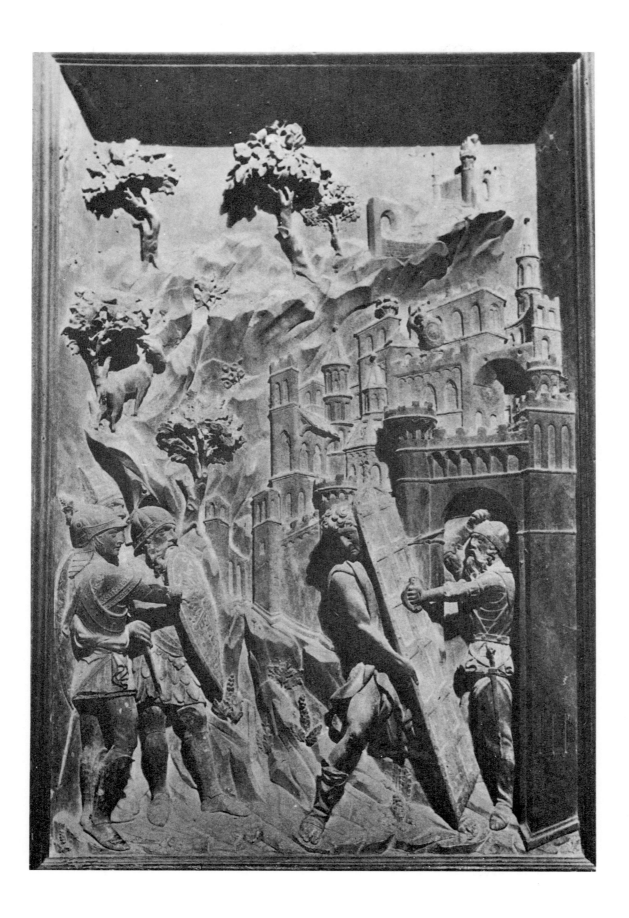

2

A. GERONA, CATHEDRAL
Virgin and Child.
DONATELLO
Photo Arxiu Mas

B. BADAJOZ, CATHEDRAL
Virgin and Child.
DESIDERIO DA SETTIGNANO
Photo Gómez Moreno

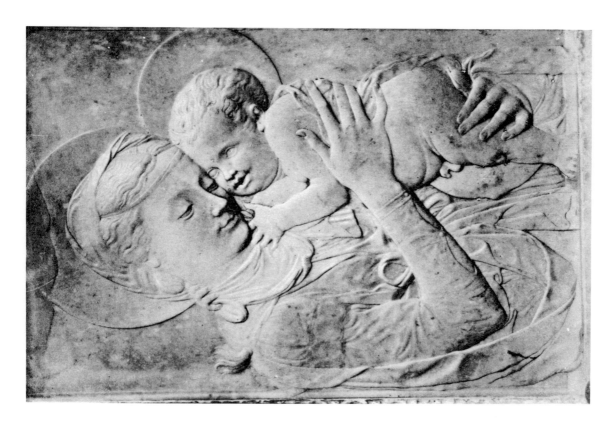

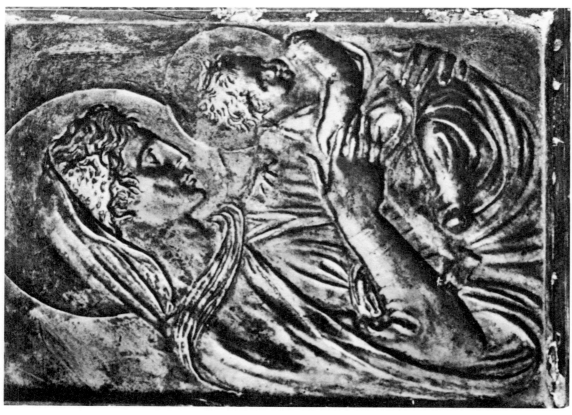

3

SEGORBE, CATHEDRAL
Virgin and Child with Angels.
SCHOOL OF DONATELLO
Photo Exp. Barcelona

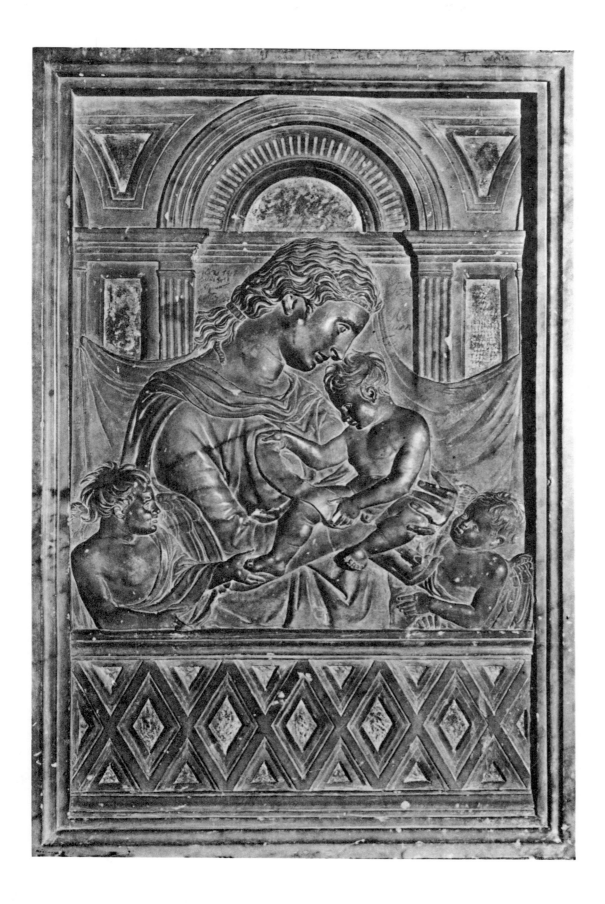

4

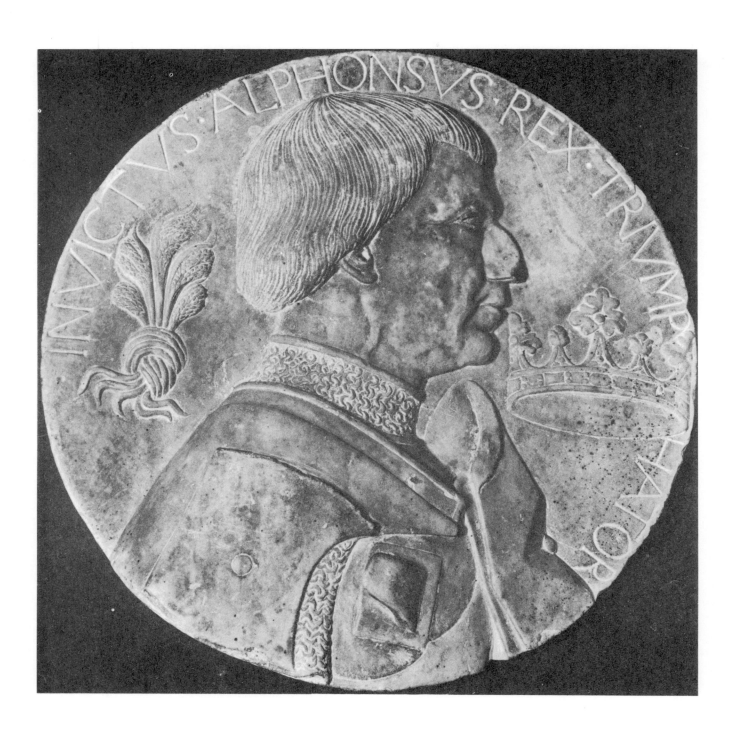

5

SEVILLE, CATHEDRAL
Retablo of Our Lady of the Pomegranate.
ANDREA DELLA ROBBIA
Photo Anderson

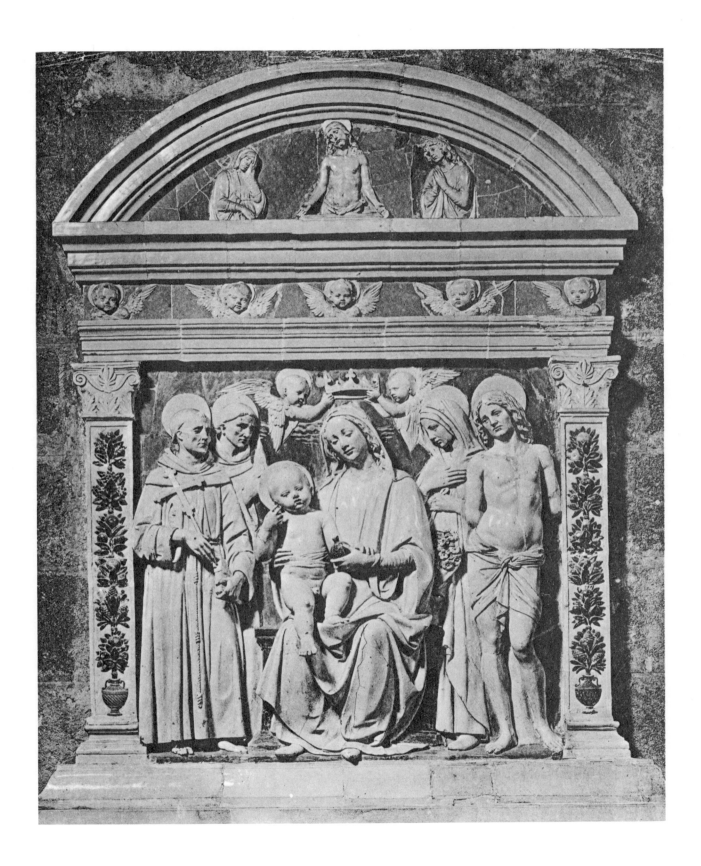

6

ÁVILA, MONASTERY OF SANTO TOMÁS
Tomb of Prince Juan.
DOMENICO FANCELLI
Photo Arxiu Mas

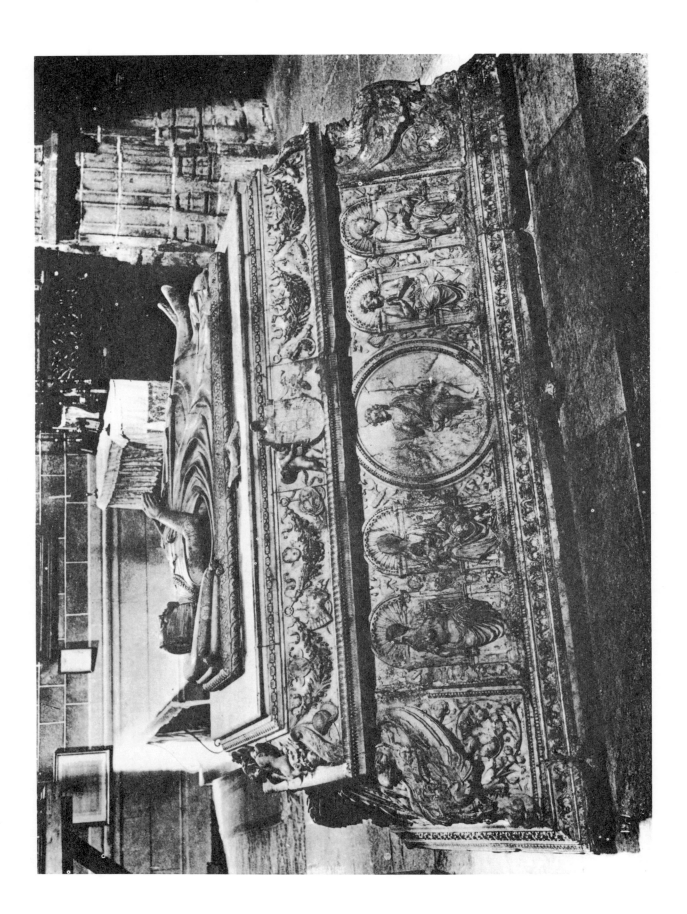

7

GRANADA, CHAPEL ROYAL
Recumbent effigies of Ferdinand and Isabella.
DOMENICO FANCELLI
Photo Gómez Moreno

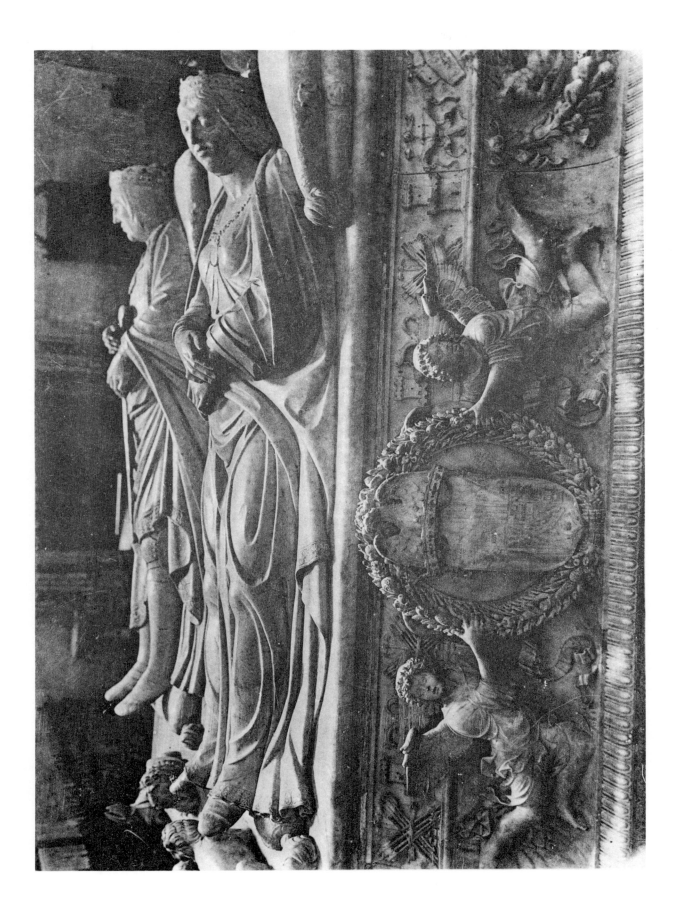

8

BADAJOZ, CATHEDRAL
Sepulchral slab of Lorenzo Suárez de Figueroa.
STYLE OF PIER ZUANNE DELLE CAMPANE
Photo Gómez Moreno

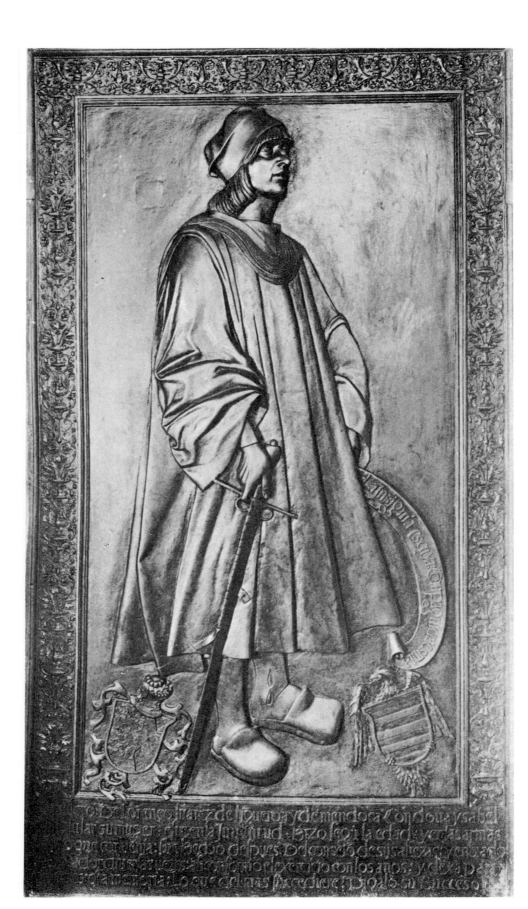

9

ÚBEDA, CHAPEL OF EL SALVADOR
John the Baptist.
MICHAEL ANGELO
Photo Orueta

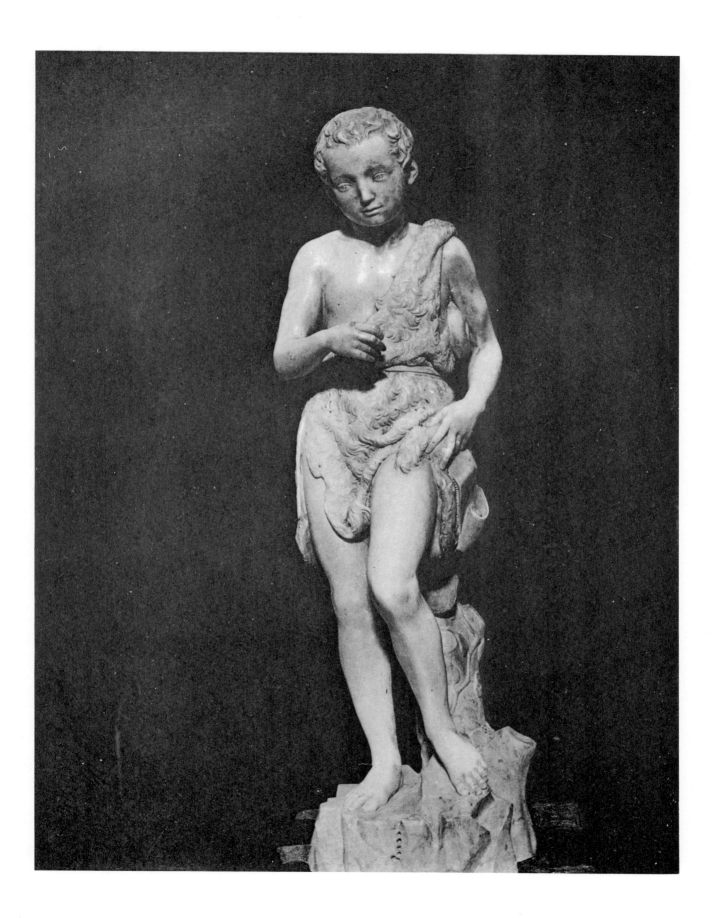

10

SARAGOSSA, CATHEDRAL OF EL PILAR
High Altar.
DAMIÁN FORMENT
Photo R. Vernacci

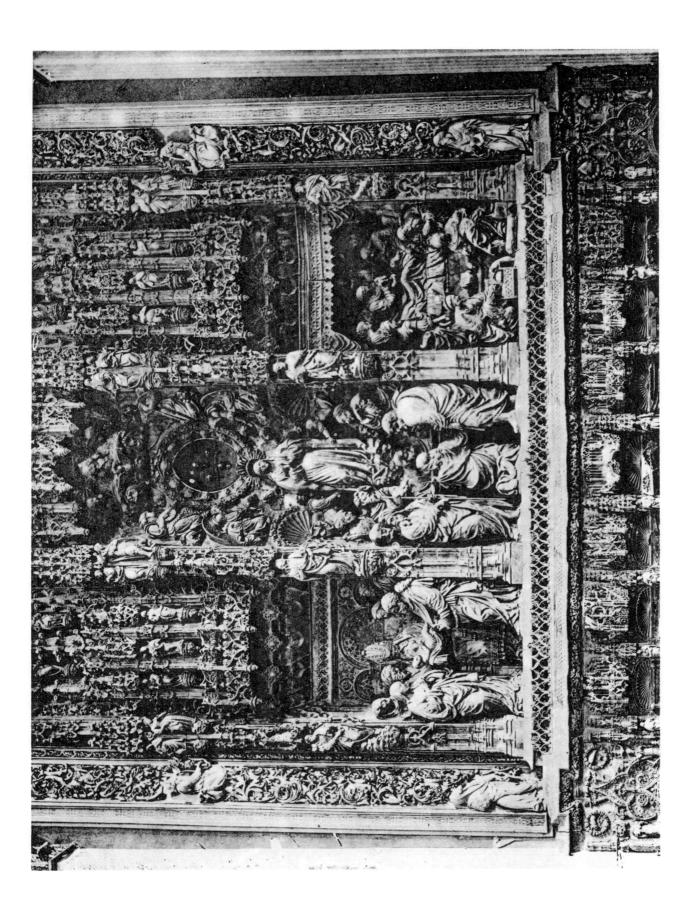

II

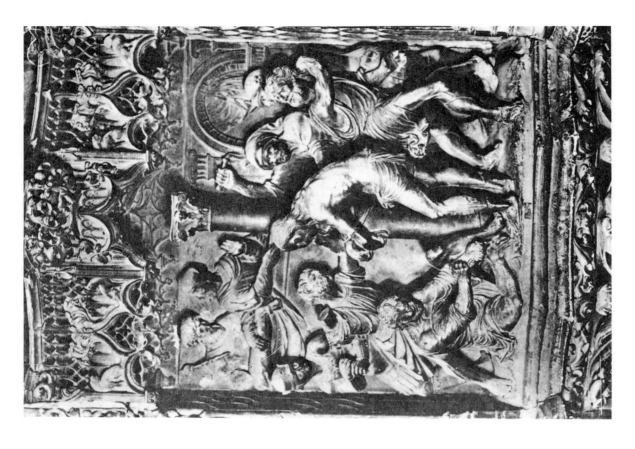

12

SANTO DOMINGO DE LA CALZADA, CATHEDRAL
High Altar.
DAMIÁN FORMENT
Photo Gómez Moreno

14

SARAGOSSA, LA SEO
Trascoro: The Martyrdom of St Lawrence.
MARTÍN DE TUDELA
Photo Arxiu Mas

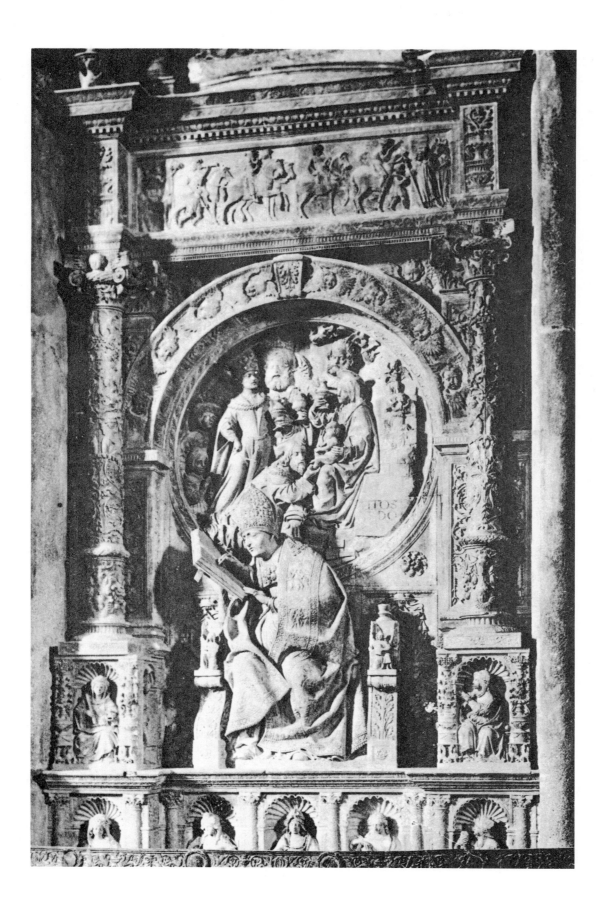

16

ÁVILA, CATHEDRAL
Trasaltar: St John the Evangelist and St James.
VASCO DE LA ZARZA
Photo Arxiu Mas

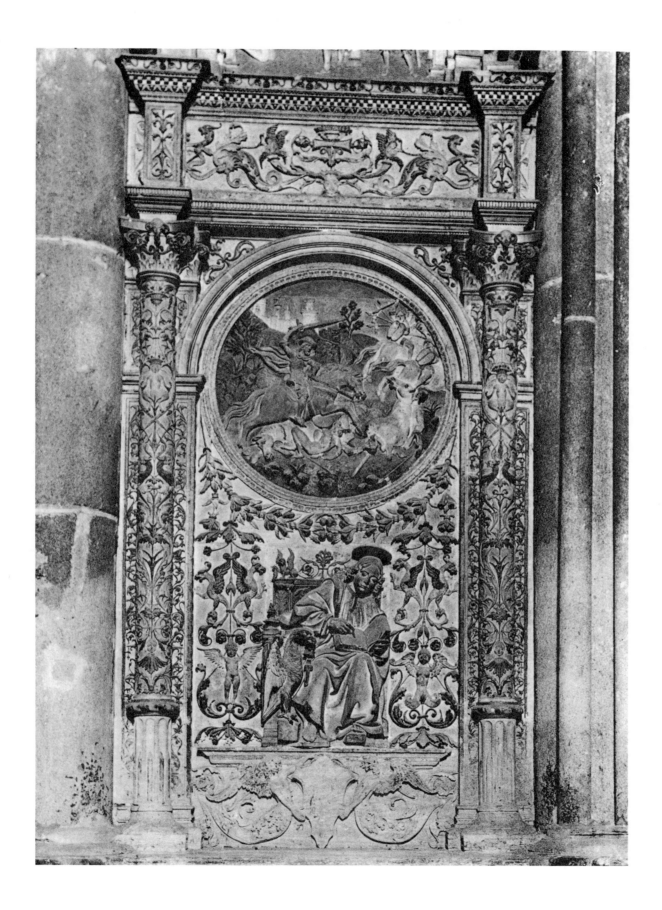

BURGOS, CATHEDRAL
Trasaltar: Via Dolorosa
FELIPE BIGARNY
Photo Hauser y Menet

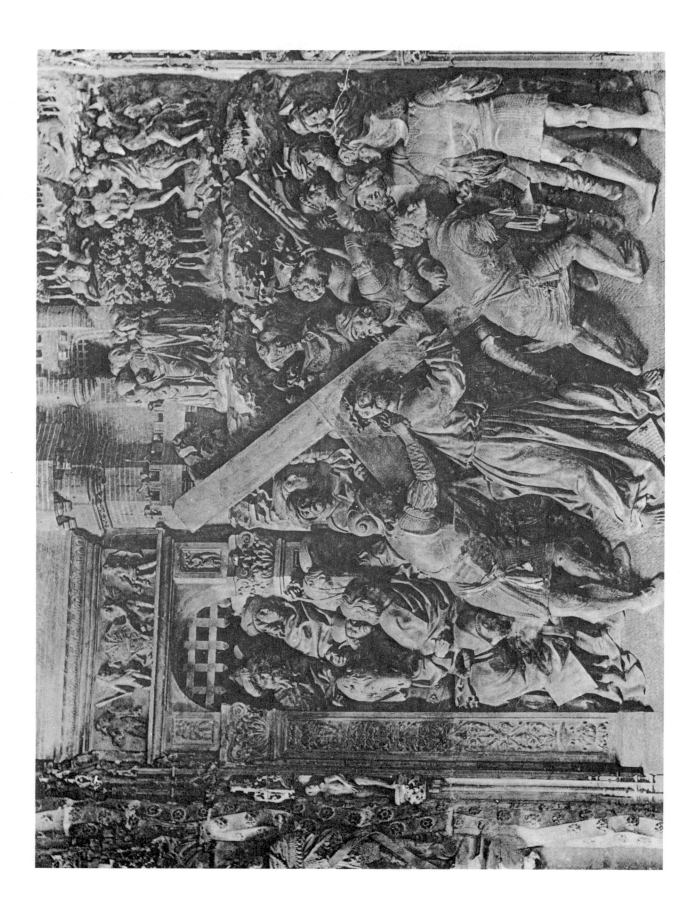

18

SALAMANCA, UNIVERSITY
A. The Virgin in Glory.
B. St Jerome.
FELIPE BIGARNY
Photos Gómez Moreno

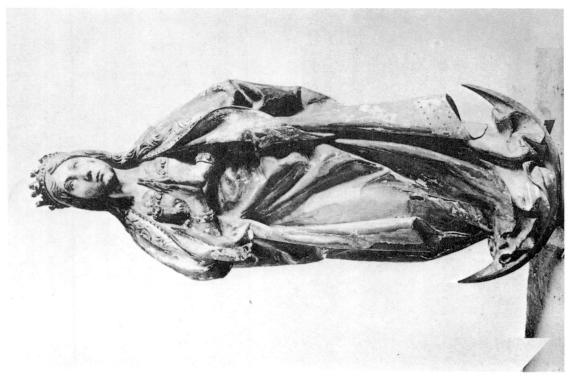

19

GRANADA, CHAPEL ROYAL

High Altar.

FELIPE BIGARNY

Photo Torres

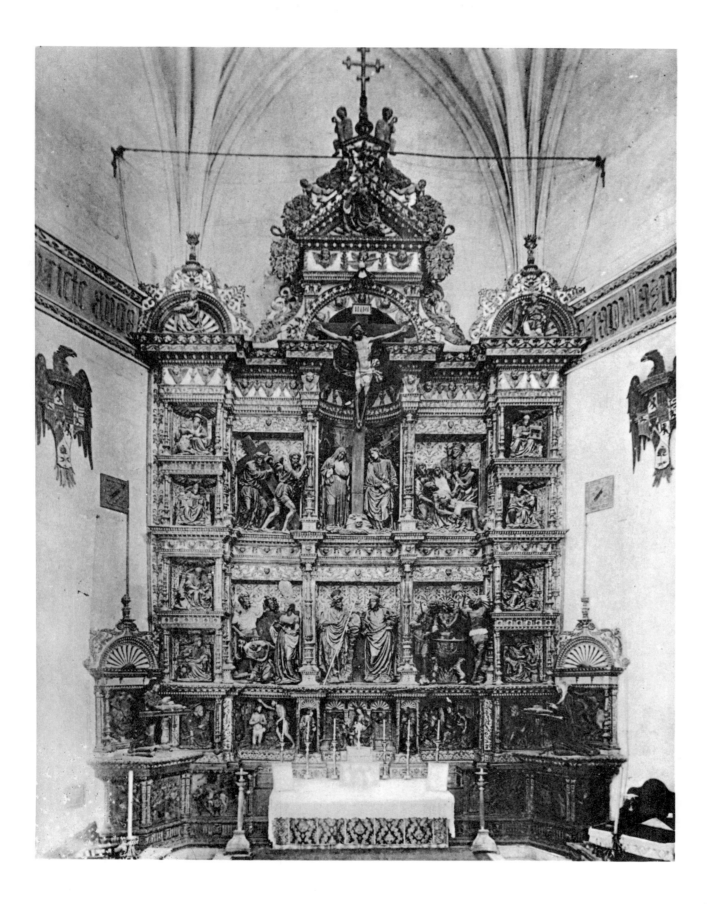

20

GRANADA, CHAPEL ROYAL
High Altar: Beheading of John the Baptist.
FELIPE BIGARNY
Photo Gómez Moreno

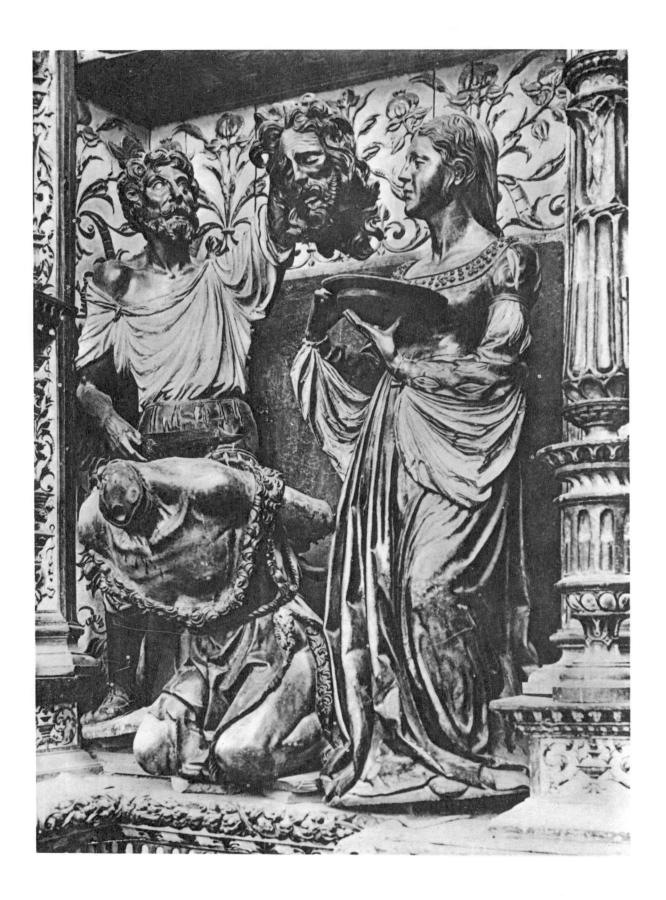

21

A. GRANADA, CHAPEL ROYAL
High Altar: The Capture of Granada.
FELIPE BIGARNY
Photo Arxiu Mas

B. ALCALÁ DE HENARES, LA MAGISTRAL
Medal of Cardinal Cisneros.
FELIPE BIGARNY (?)
Photo Gómez Moreno

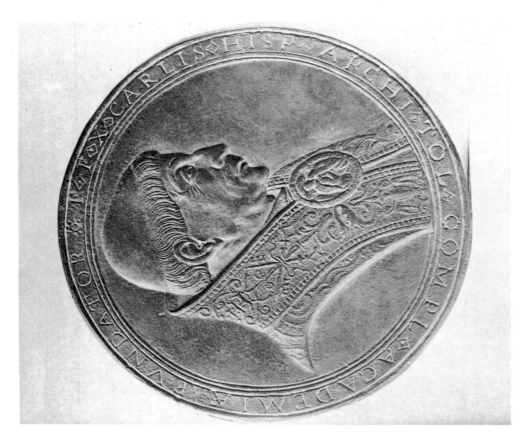

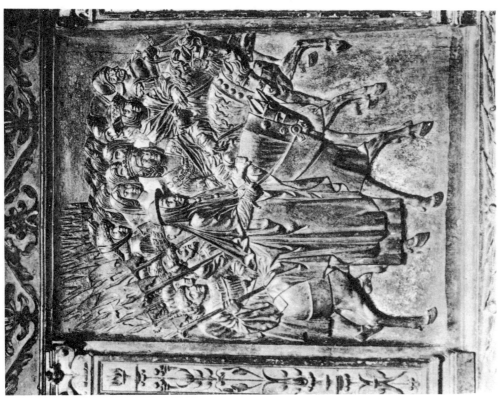

2 2

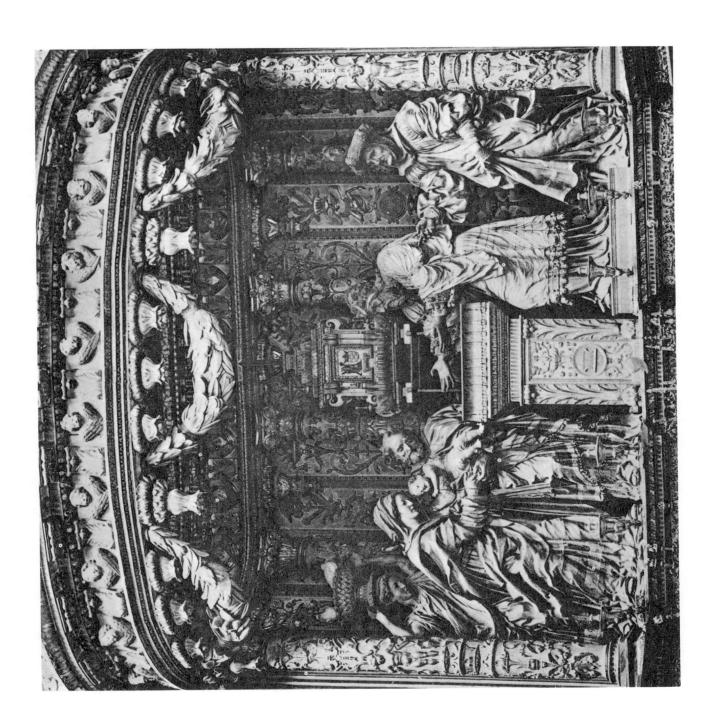

23

TOLEDO, CATHEDRAL
Choir-stalls: The Queen of Sheba.
FELIPE BIGARNY
Photo Moreno

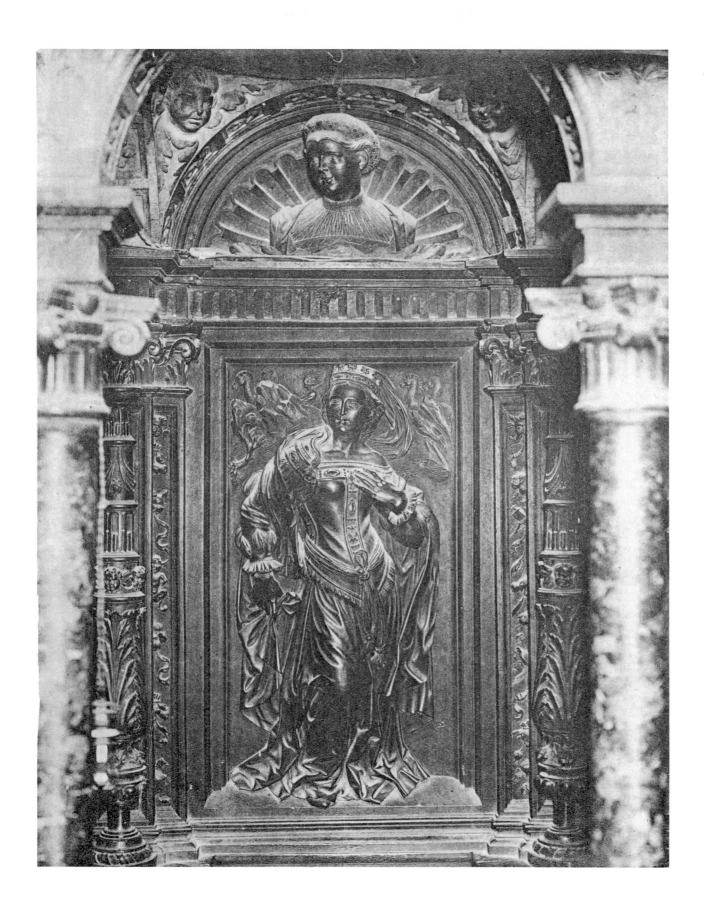

24

SALAMANCA, NEW CATHEDRAL
The Virgin at the foot of the Cross.
STYLE OF GIL DE RONZA
Photo Arxiu Mas

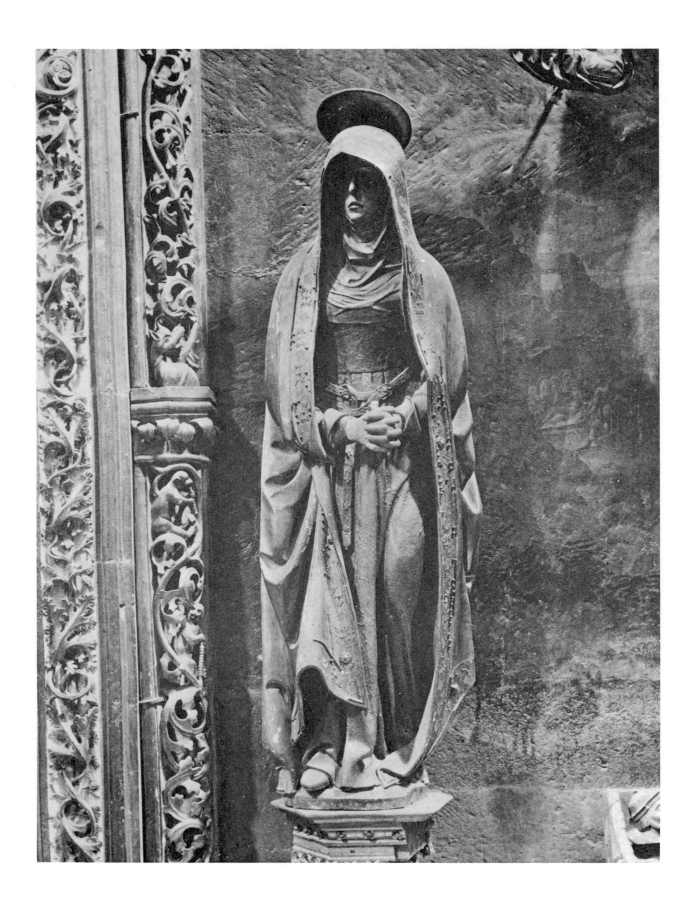

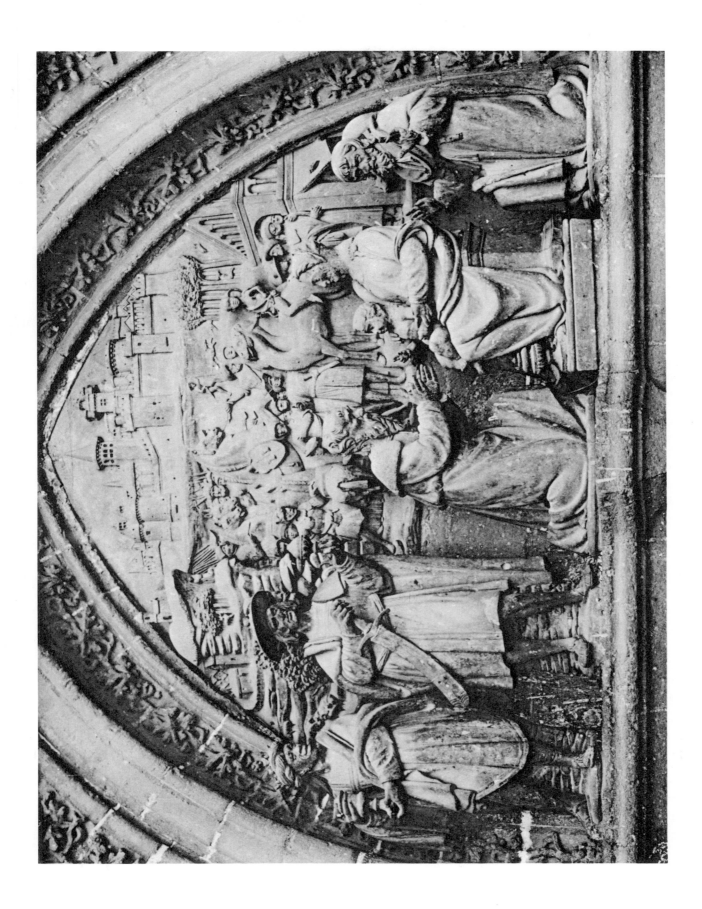

26

SANTIAGO DE COMPOSTELA, CATHEDRAL
The mourning of the dead Christ.
CORNIELLES DE HOLANDA
Photo R. Vernacci

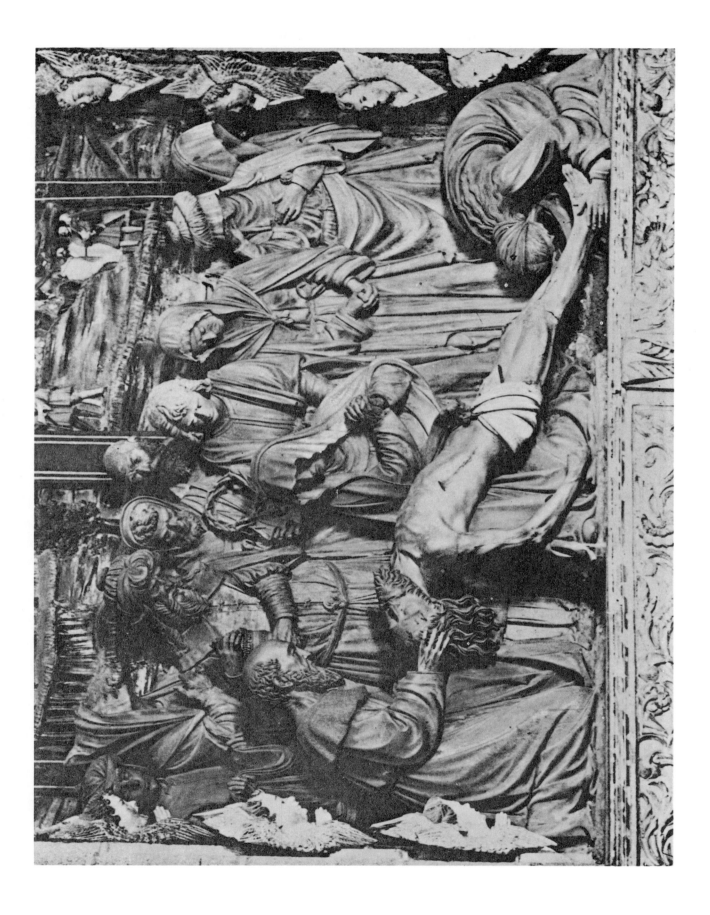

27

BURGOS, CATHEDRAL
The dead Christ supported by Angels.
ATTRIBUTED TO JUAN DE BALMASEDA
Photo Arxiu Mas

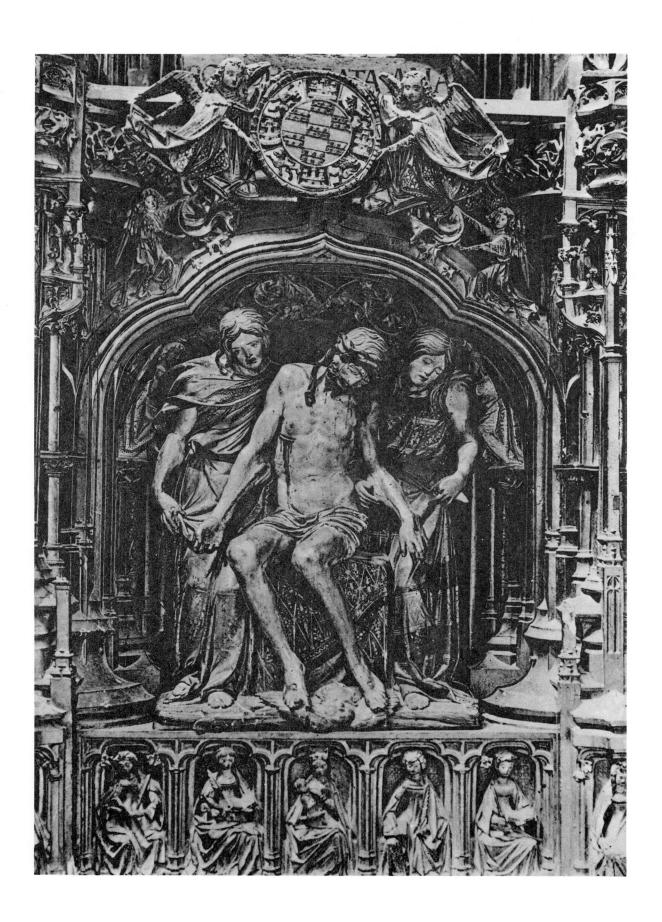

28

LEÓN, CATHEDRAL

A. St John.

B. St Luke.

JUAN DE BALMASEDA

Photos Exp. Barcelona

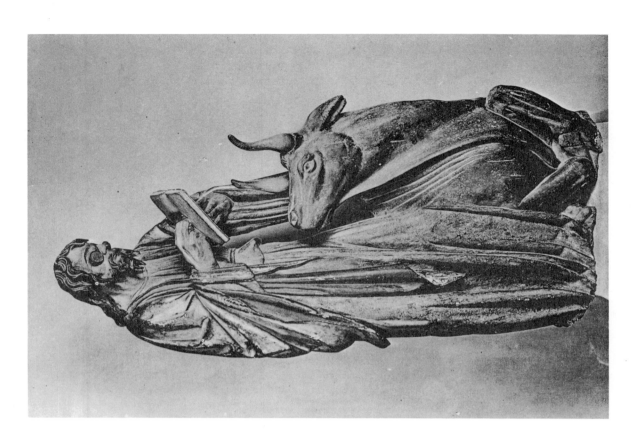

29

ÁVILA, CATHEDRAL
Retablo of St Catherine.
JUAN RODRÍGUEZ AND LUCAS GIRALDO
Photo Arxiu Mas

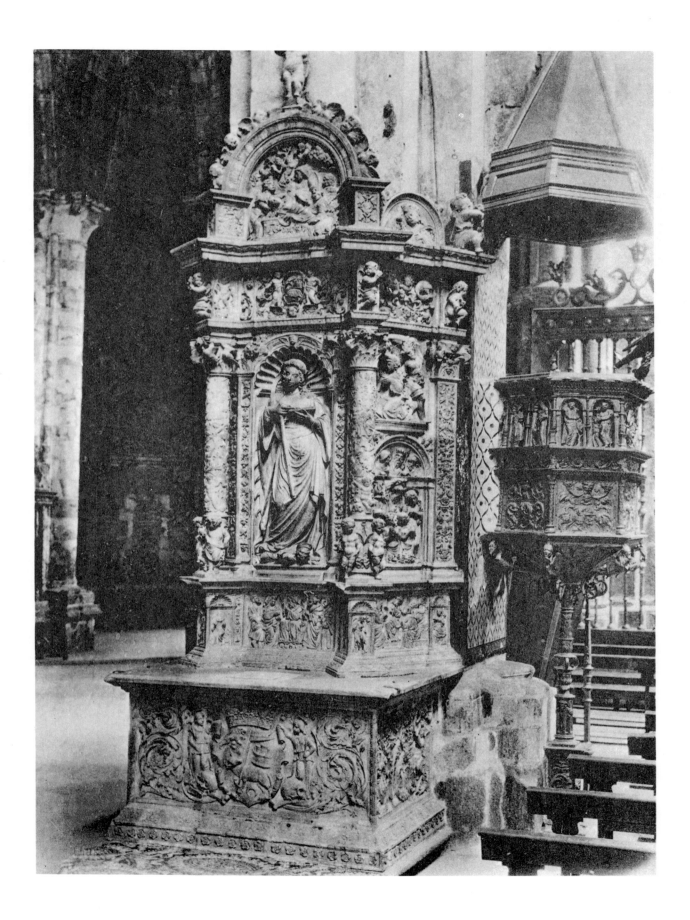

30

BARCELONA, CATHEDRAL
A. & B. Choir-stalls: Christ buried by Angels; Noah and his Sons;
The Virtues.

BARTOLOMÉ ORDÓÑEZ
Photos Arxiu Mas

31

A. GRANADA, CHAPEL ROYAL
Tomb of Queen Juana and King Philip: St John the Baptist.
BARTOLOMÉ ORDÓÑEZ
Photo Gómez Moreno

B. ALCALÁ DE HENARES, LA MAGISTRAL
Tomb of Cardinal Cisneros: St Jerome.
BARTOLOMÉ ORDÓÑEZ
Photo Moreno

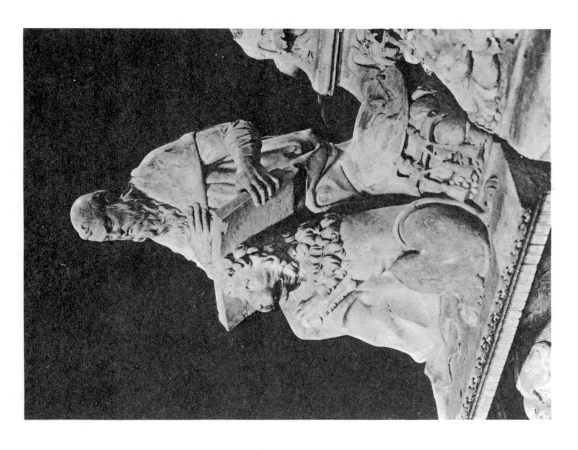

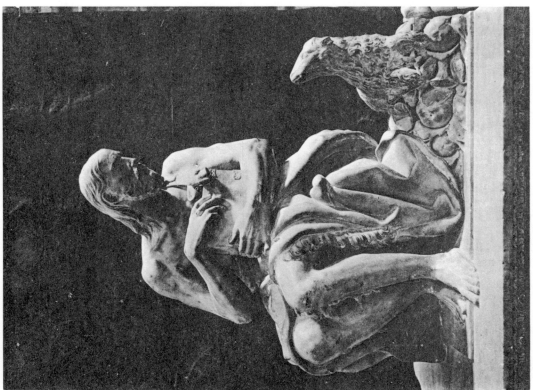

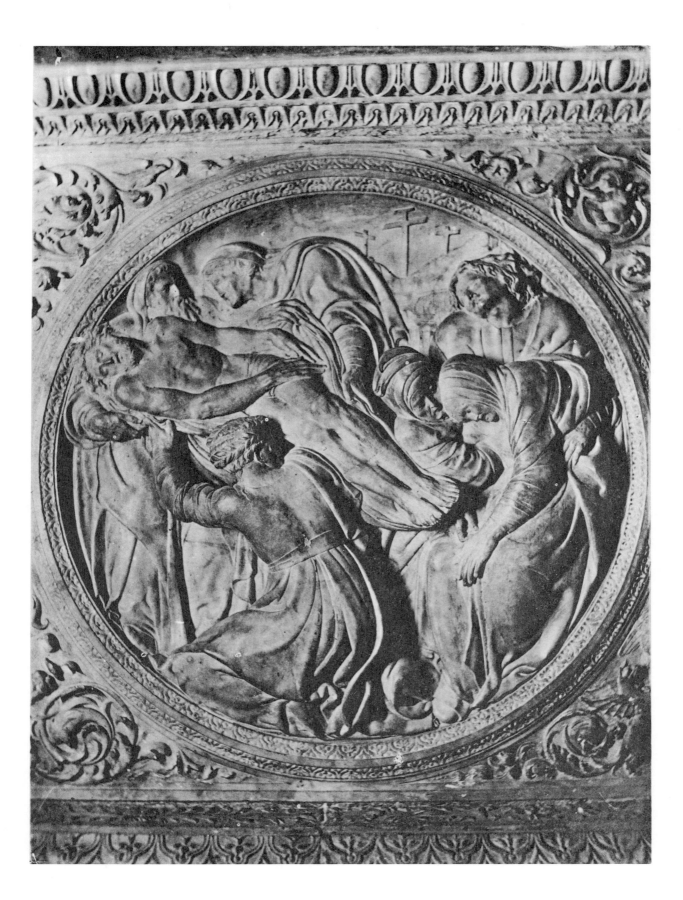

GRANADA, SAN JERÓNIMO
The Entombment.
JACOPO FLORENTINO
Photo M. Victoria

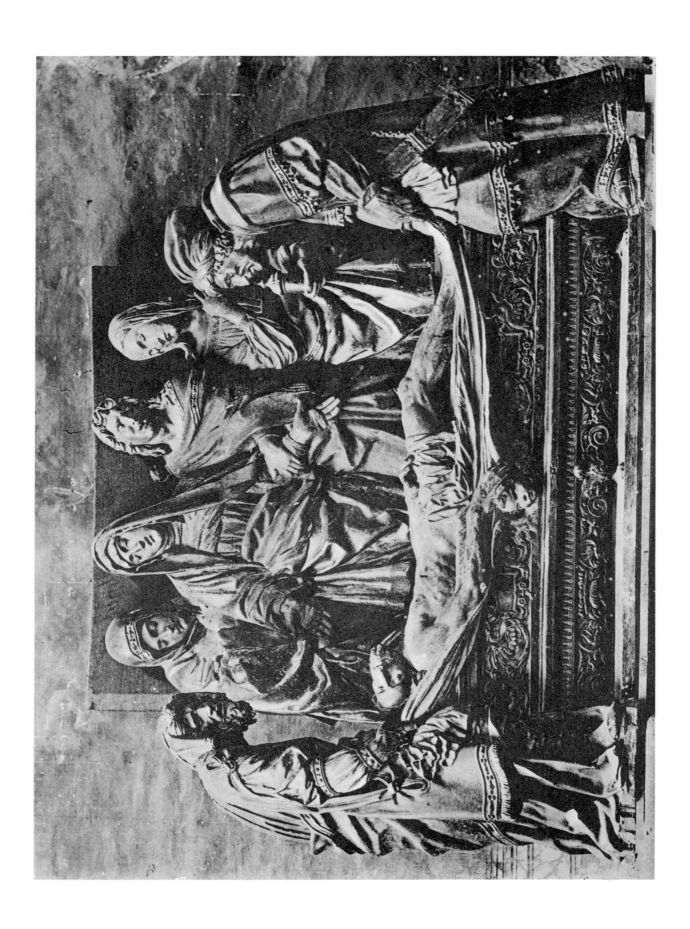

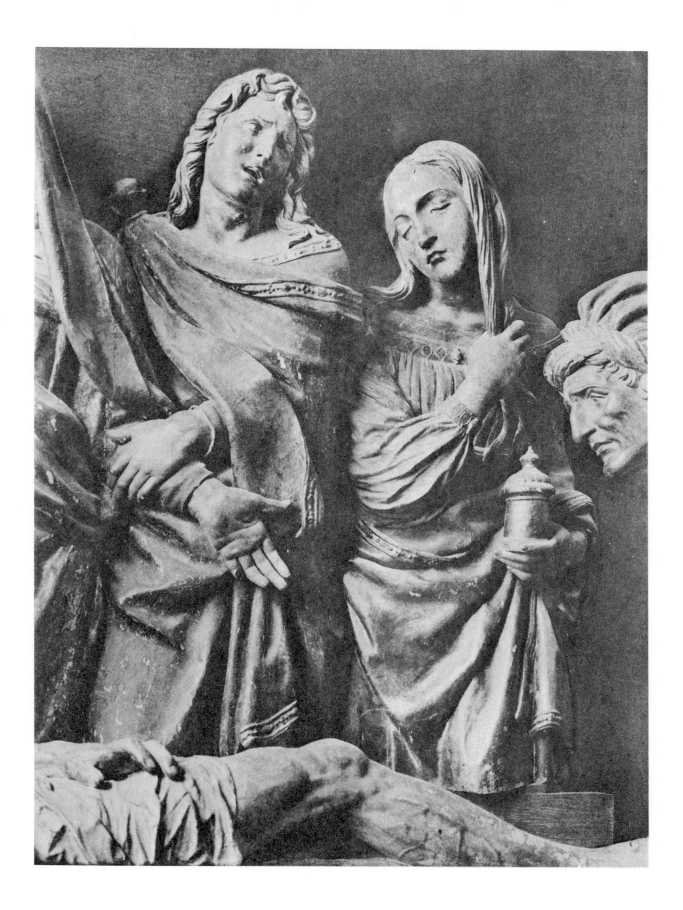

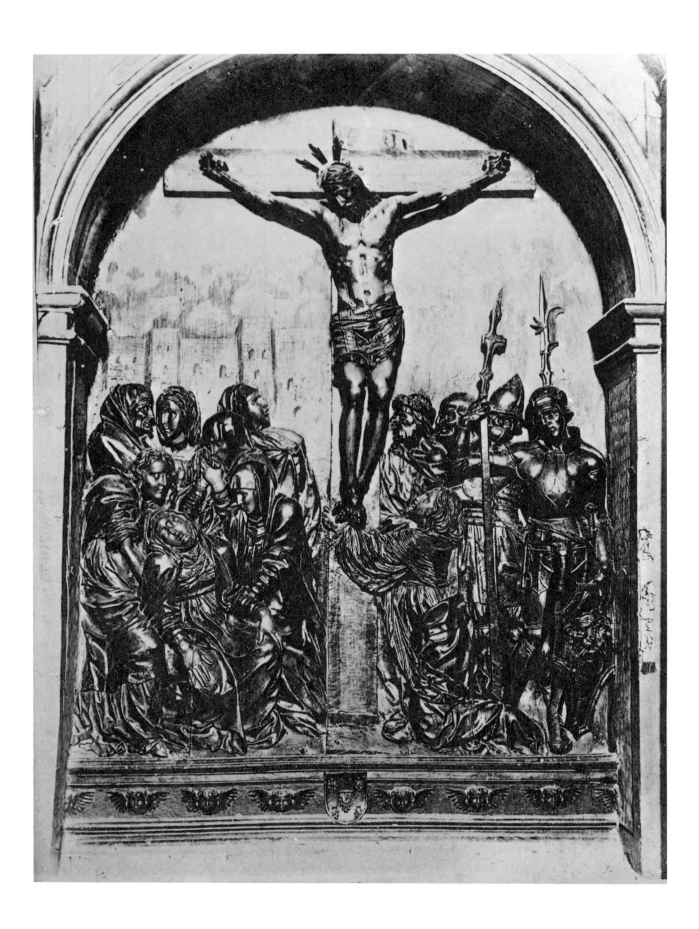

37

SEVILLE, MUSEUM
St Jerome.
PIETRO TORRIGIANO
Photo Gómez Moreno

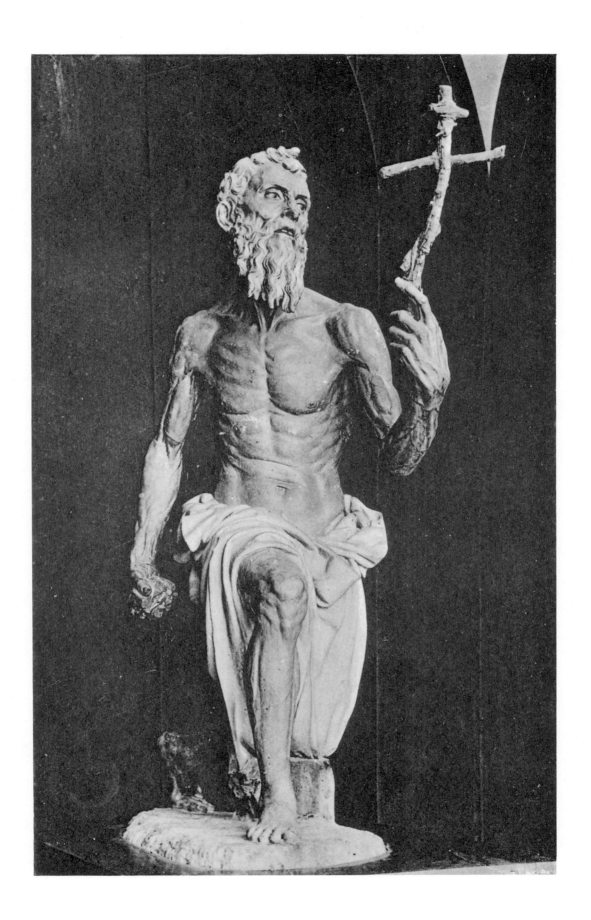

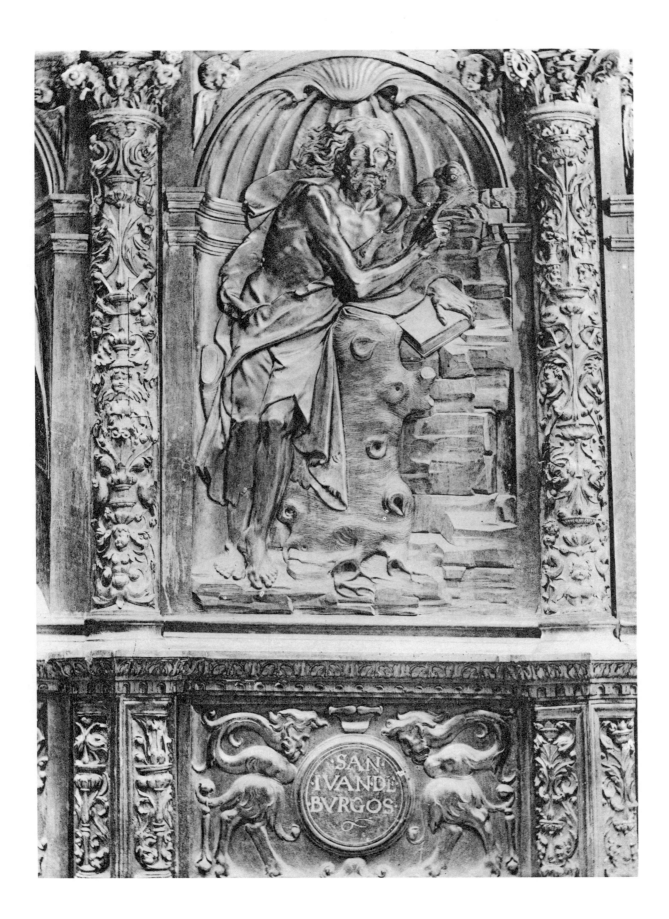

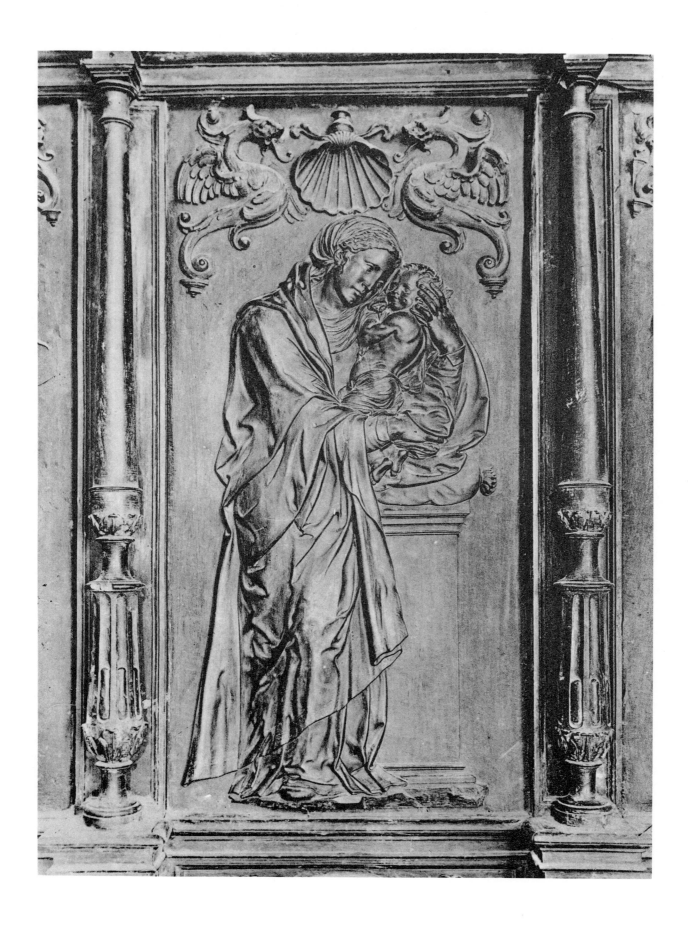

40

GRANADA, CATHEDRAL
The Gate of Pardon.
DIEGO SILÓEE
Photo Gómez Moreno

41

A. GRANADA, SAN JERÓNIMO
Choir-stalls: Monster.
DIEGO SILÓEE
Photo M. Victoria

B. BURGO DE OSMA, CATHEDRAL
St John the Evangelist.
ATTRIBUTED TO MIGUEL DE ESPINOSA
Photo Gómez Moreno

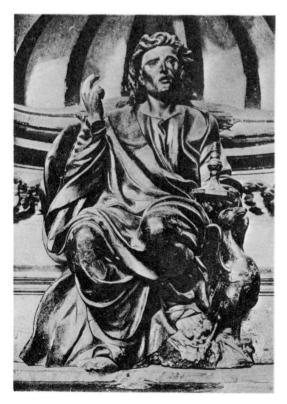

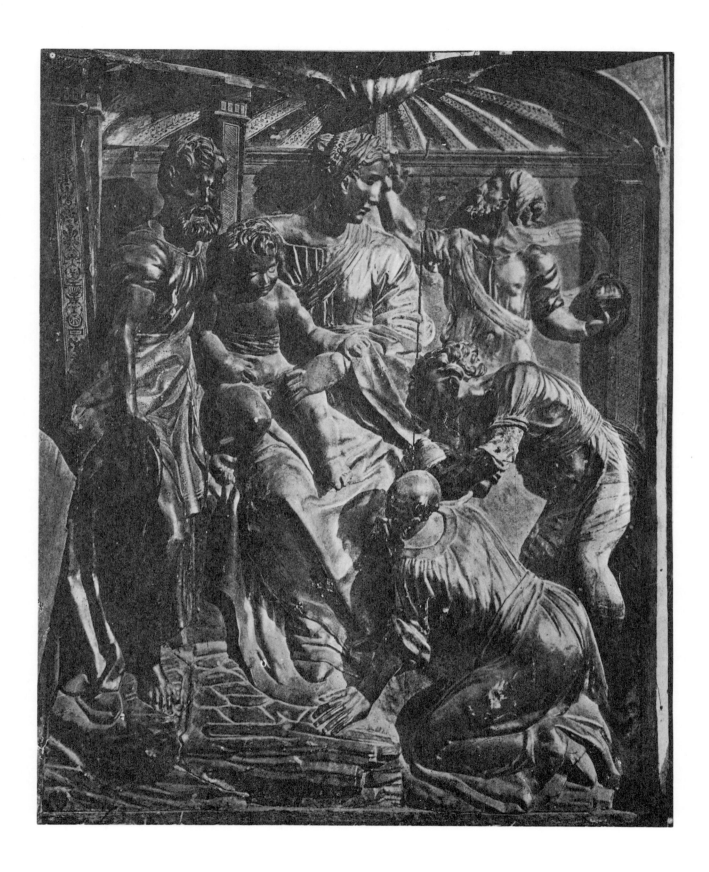

43

VALLADOLID, MUSEUM
A. An Apostle.
B. St Sebastian.
C. St John the Evangelist.
ALONSO BERRUGUETE
Photos Orueta

44

VALLADOLID, SANTIAGO
Retablo of the Kings.
ALONSO BERRUGUETE
Photo Orueta

45

TOLEDO, CATHEDRAL
A. & B. Choir-stalls: St Andrew and St Peter.
ALONSO BERRUGUETE
Photos Moreno

46

TOLEDO, CATHEDRAL
A. & B. Choir-stalls: Moses and St John the Baptist.
ALONSO BERRUGUETE
Photos Moreno

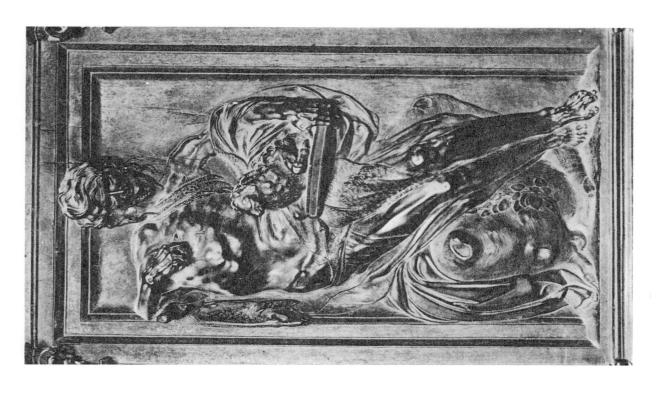

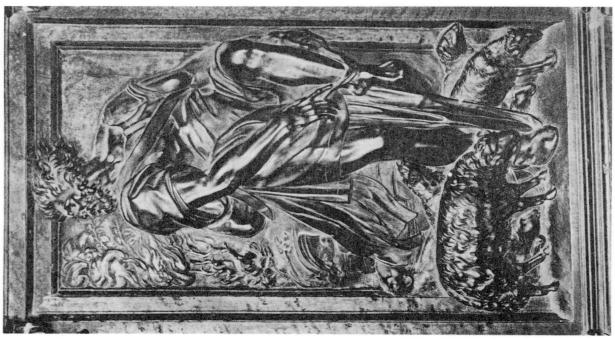

47

TOLEDO, CATHEDRAL
Choir: Canopy over the stalls.
ALONSO BERRUGUETE
Photo Orueta

48

A. ÚBEDA, CHAPEL OF EL SALVADOR
Head of Moses, from the group of the Transfiguration.
ALONSO BERRUGUETE
Photo Arxiu Mas

B. TOLEDO, HOSPITAL OF TAVERA
Recumbent effigy on the tomb of the founder.
ALONSO BERRUGUETE
Photo Orueta

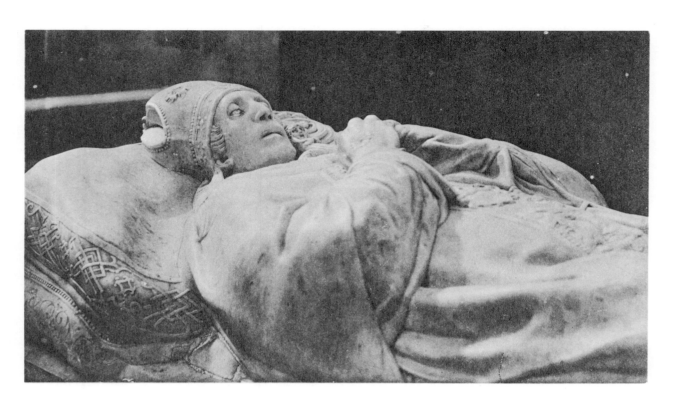

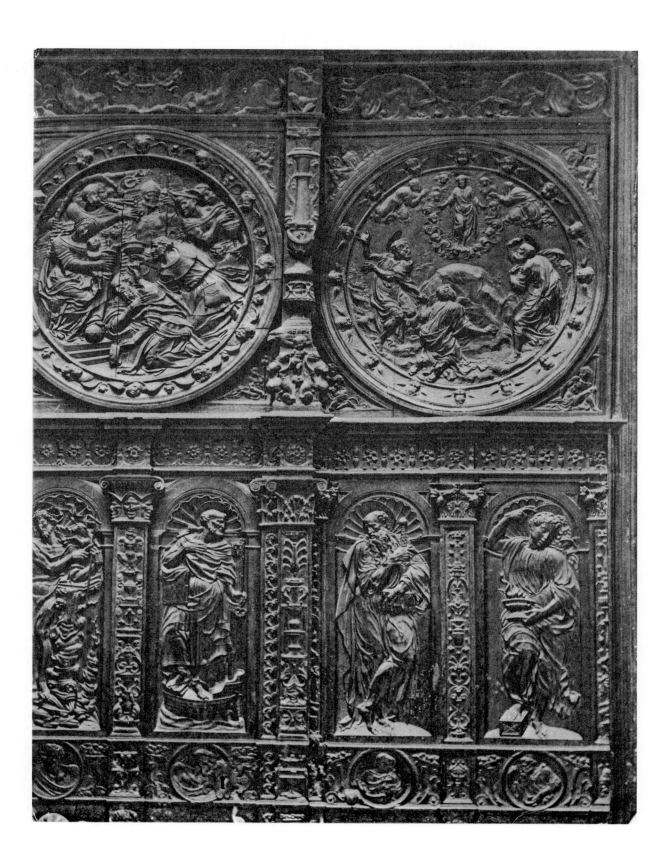

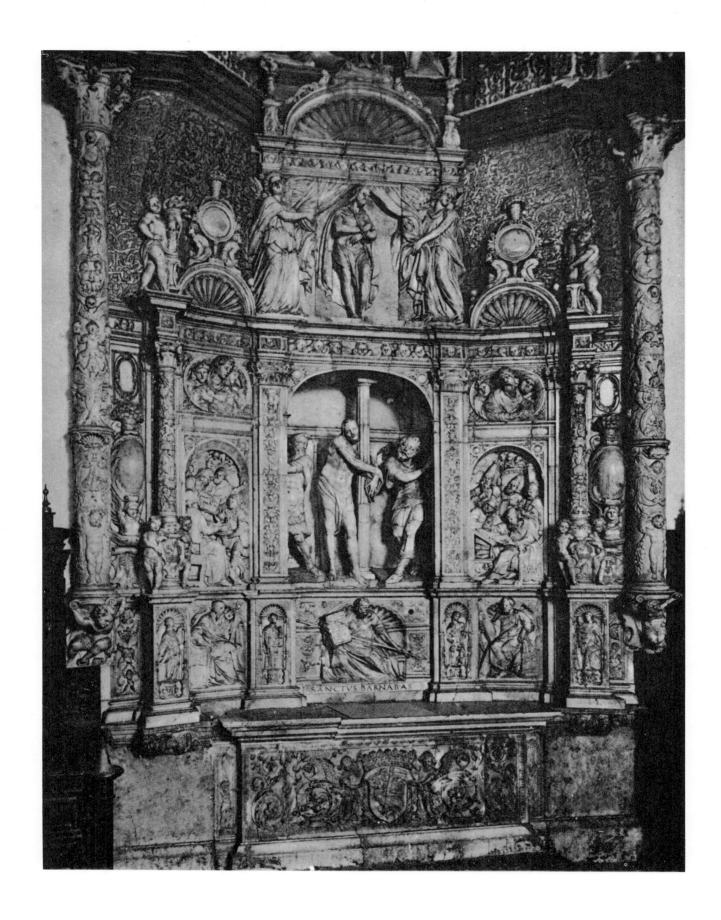

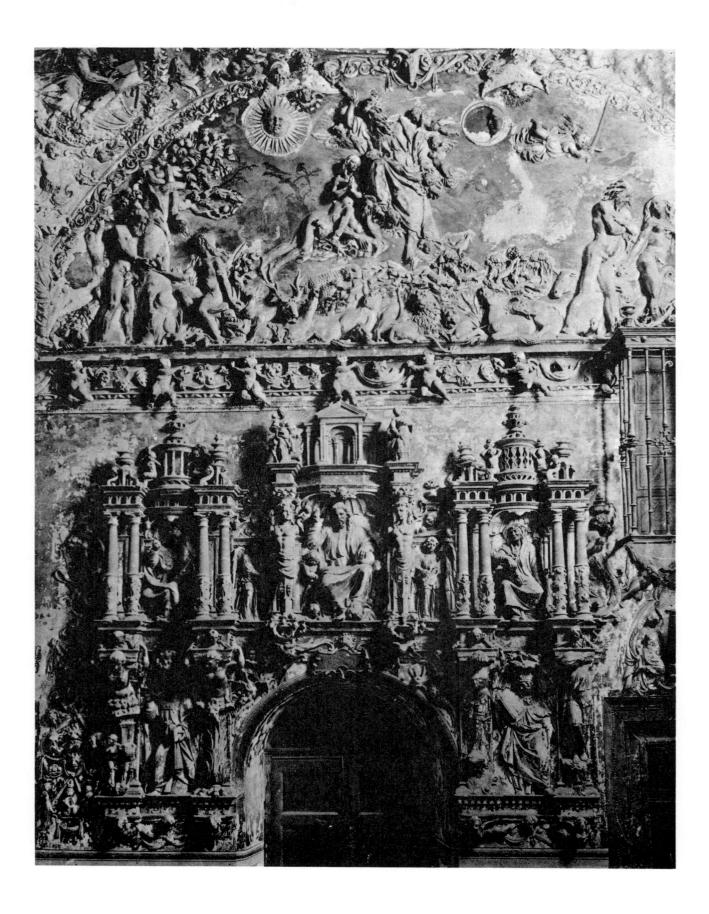

SALAMANCA, NEW CATHEDRAL

A. & B. Trascoro: St John the Baptist; St Anne and the Virgin.

JUAN DE JUNÍ

Photos Gómez Moreno

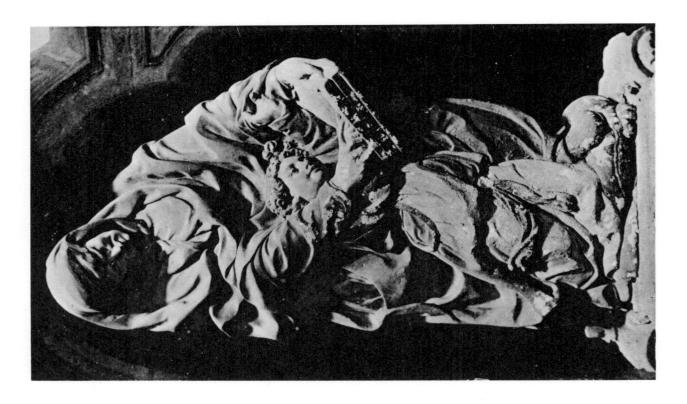

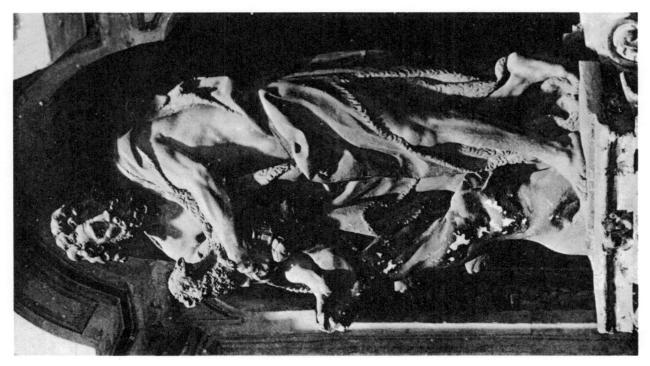

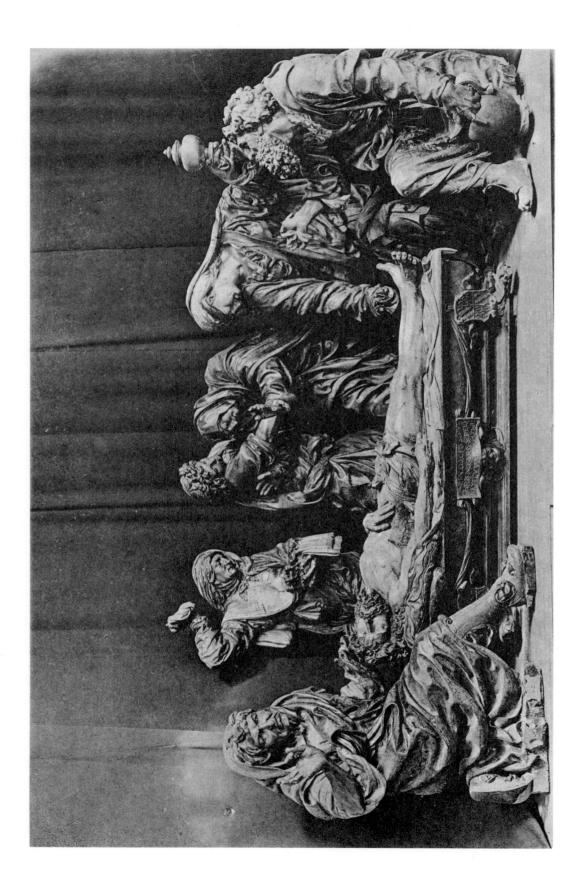

54

VALLADOLID, MUSEUM
Figure of St Anne.
JUAN DE JUNÍ
Photo Orueta

55

MEDINA DE RIOSECO, SANTA MARÍA

Retablo in the Chapel of the Benaventes.

JUAN DE JUNÍ

Photo Gómez Moreno

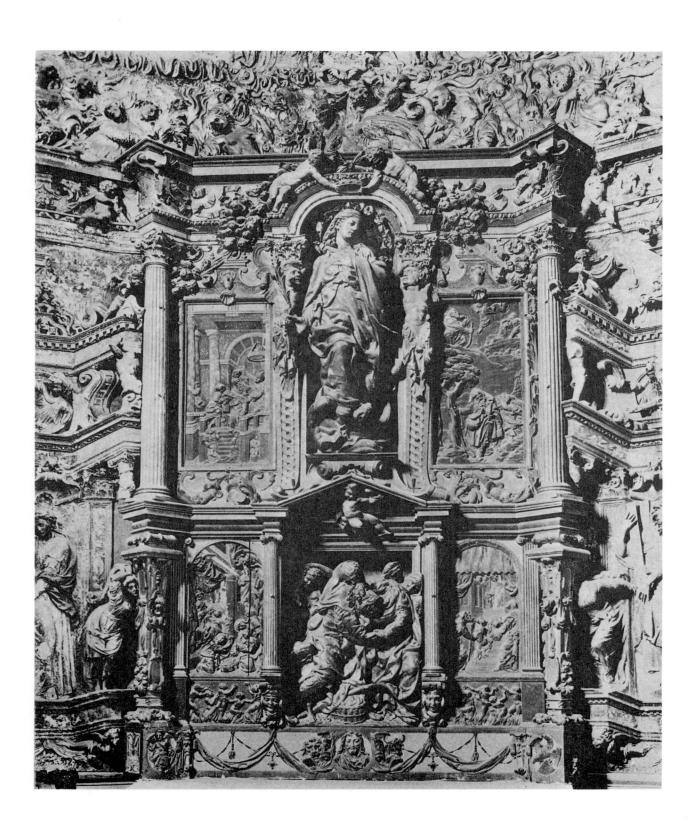

56

SEGOVIA, CATHEDRAL
The Entombment.
JUAN DE JUNÍ
Photo Inturbe

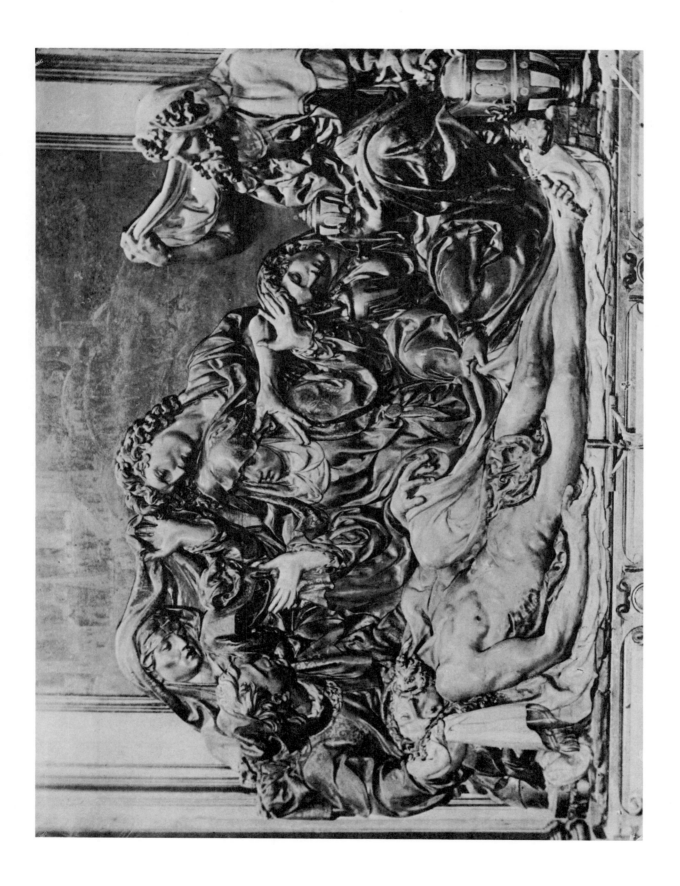

57
JEREZ DE LA FRONTERA, SANTIAGO
Prior's Throne from the Cartuja.
CRISTÓFER VOISÍN
Photo Arxiu Mas

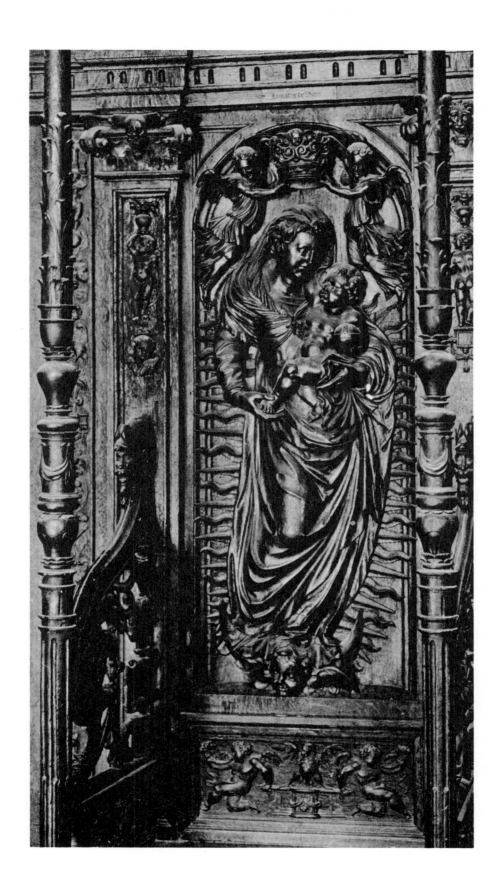

58

GRANADA, ALHAMBRA
Palace of Charles V: Part of the principal façade.
JUAN DE OREA AND ANTONIO DE LEVAL
Photo M. Victoria

59

MADRID, PRADO
Figure of the Empress Isabella.
LEONE LEONI
Photo R. Vernacci

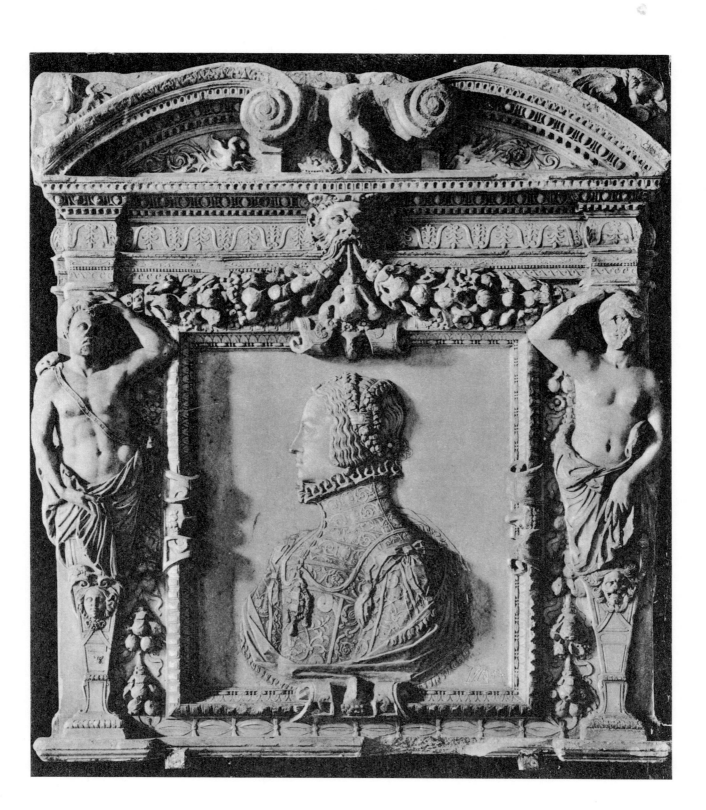

60

MÁLAGA, CATHEDRAL
Tomb of the Archbishop of Salerno.
ATTRIBUTED TO LEONE LEONI
Photo Gómez Moreno

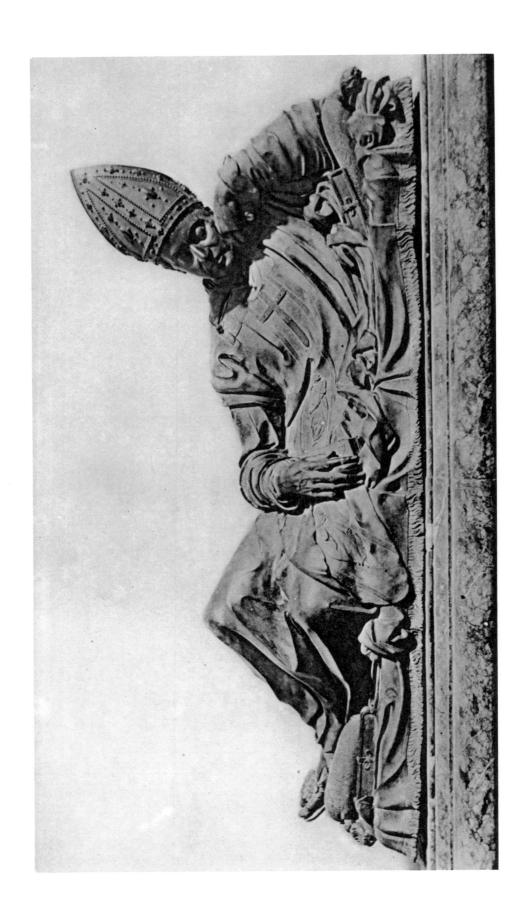

6 1

ÁVILA, CATHEDRAL
Pietà.
BAUTISTA VÁZQUEZ
Photo Lladó

62

TOLEDO, CATHEDRAL
Lectern in the Choir.
Nicolás de Vergara
Photo Orueta

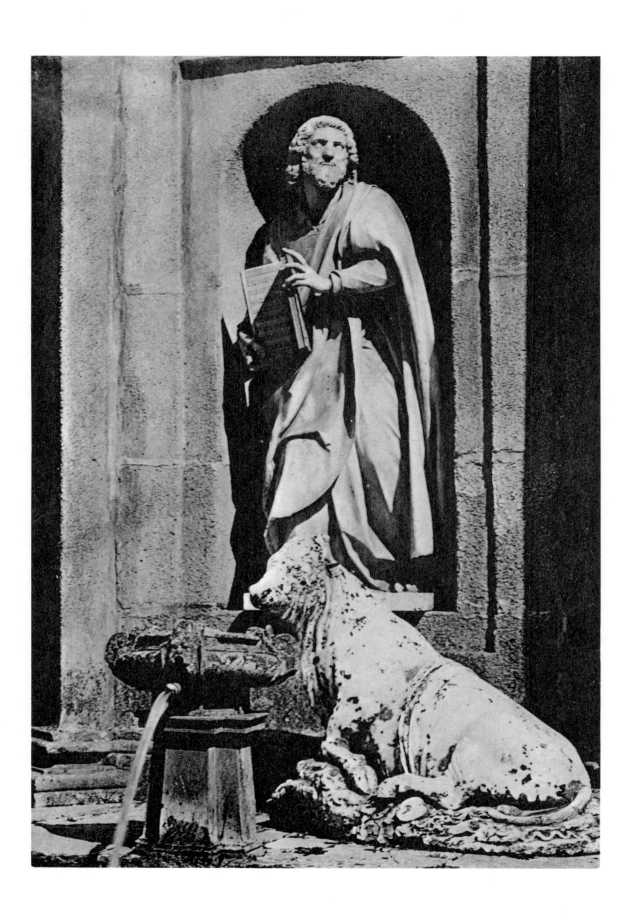

64

TOLEDO, SAN PEDRO MÁRTIR
Statue of the Inquisitor Soto Cameno.
ATTRIBUTED TO JUAN BAUTISTA DE MONEGRO
Photo Orueta

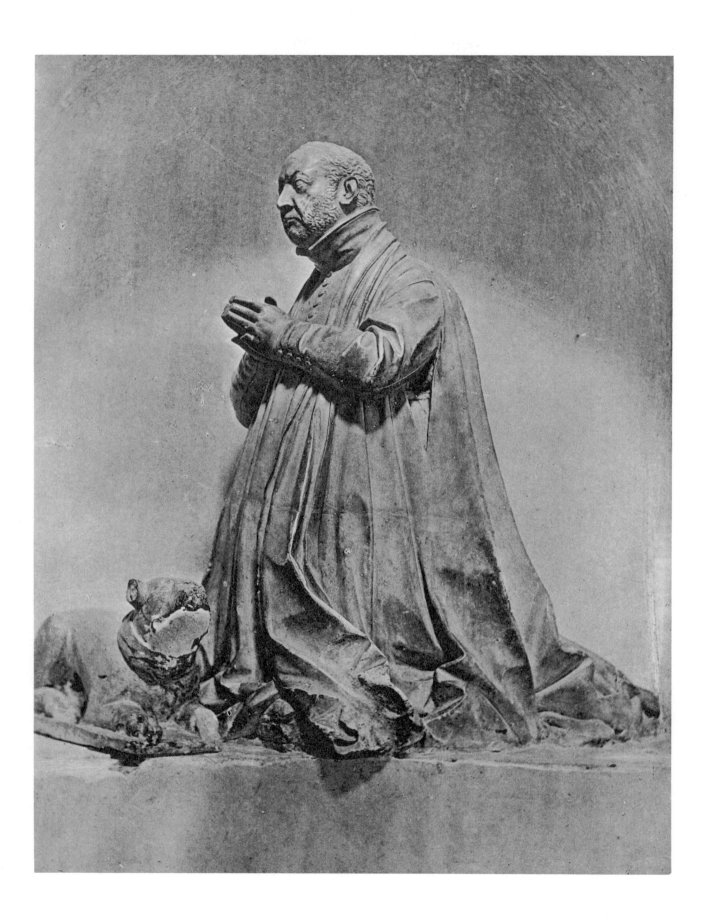

65

A. TOLEDO, HOSPITAL OF TAVERA
The Resurrection of Christ.
DOMINICO THEOTOCÓPULI, EL GRECO
Photo Gómez Moreno

B. TOLEDO, CATHEDRAL
Sacristy: The Virgin and St Ildefonso.
DOMINICO THEOTOCÓPULI, EL GRECO
Photo Orueta

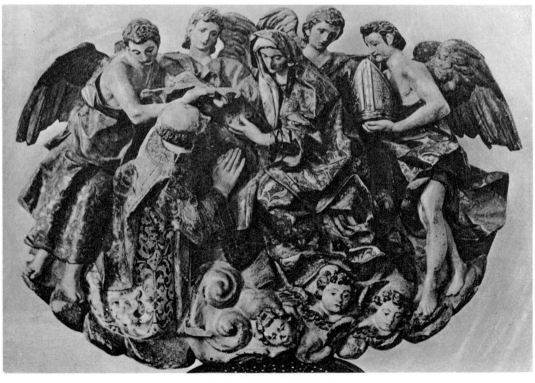

66

MOHERNANDO, PARISH CHURCH
Tomb of the secretary Eraso.
ATTRIBUTED TO POMPEO LEONI
Photo Orueta

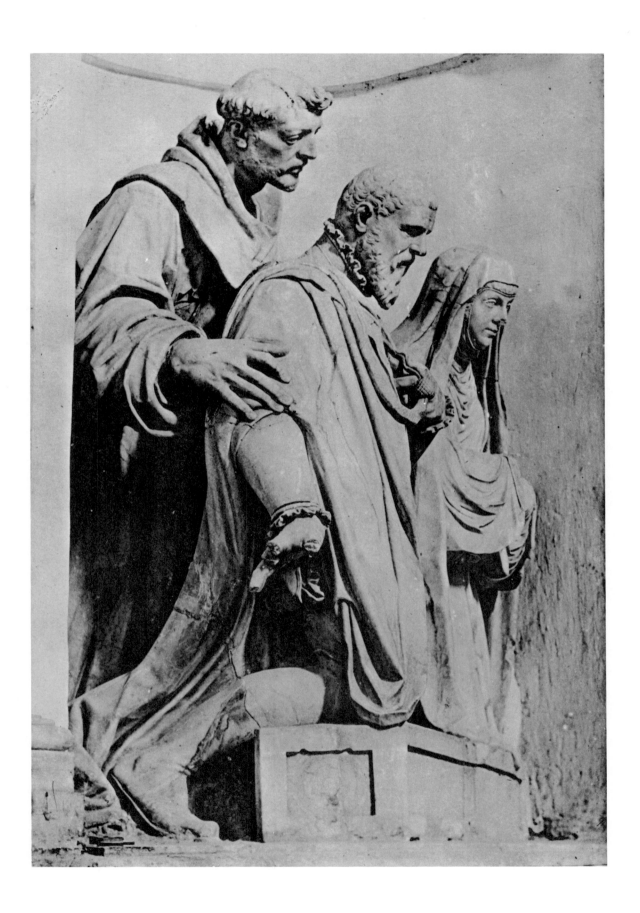

67

THE ESCORIAL
High Altar: The Crucifixion.
POMPEO LEONI
Photo R. Vernacci

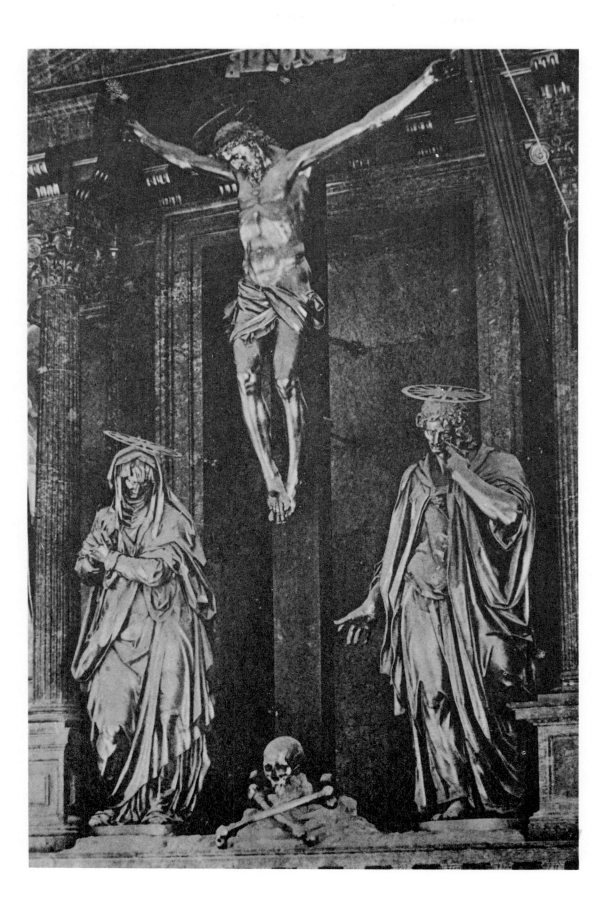

68

EL VISO DEL MARQUÉS, PARISH CHURCH
Statue of Don Álvaro de Bazán.
UNKNOWN SCULPTOR
Photo Orueta

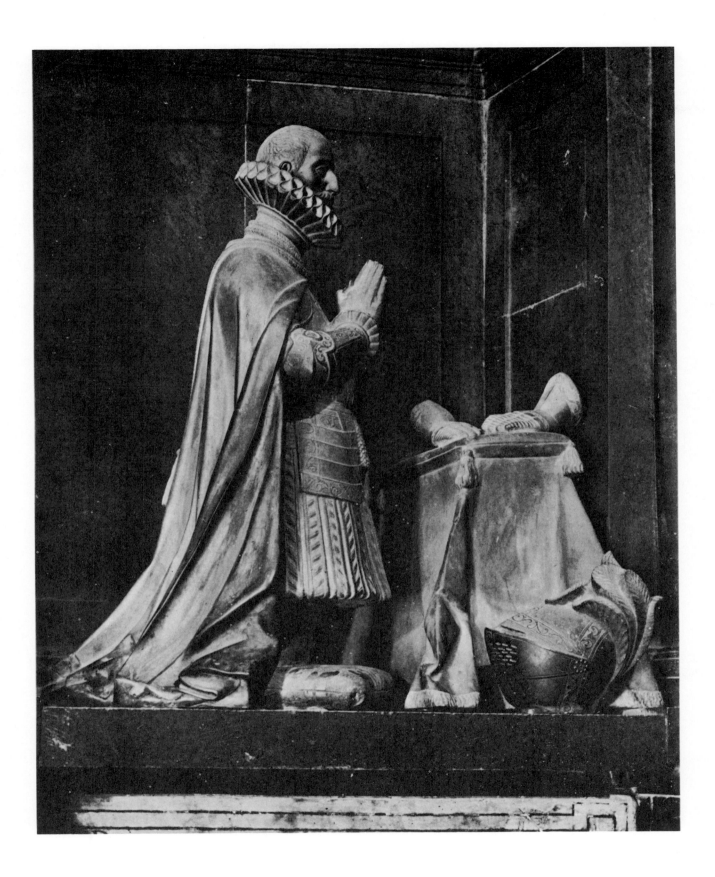

69

ASTORGA, CATHEDRAL
Part of the High Altar.
GASPAR BECERRA
Photo Gómez Moreno

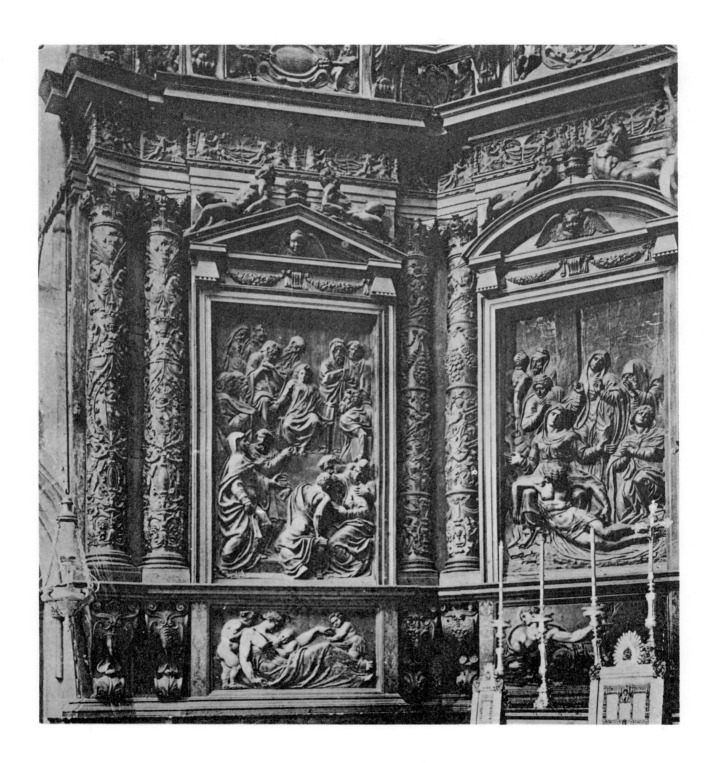

70

VALLADOLID, LA MAGDALENA
High Altar.
ESTEBAN JORDÁN
Photo Orueta

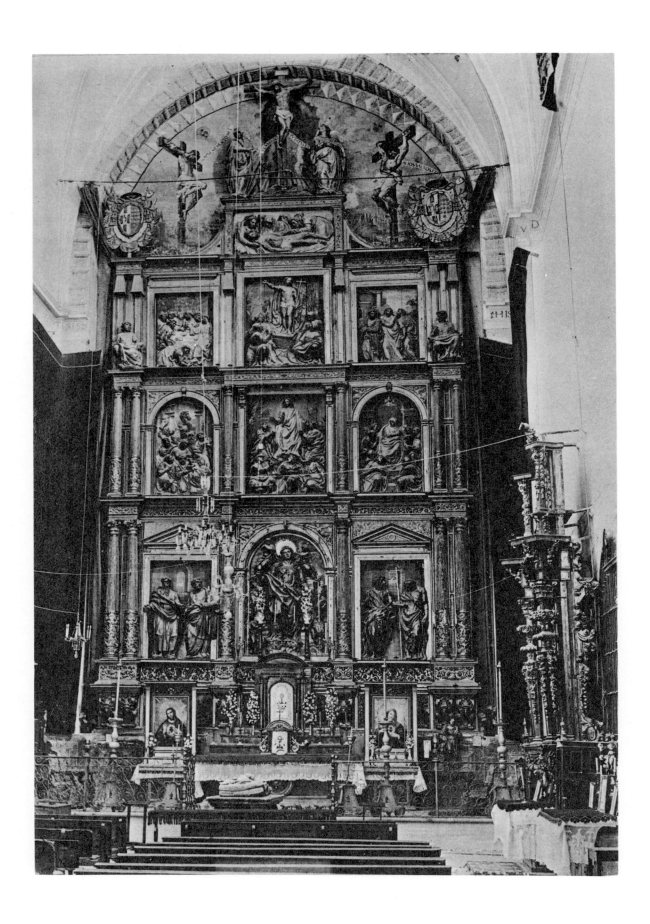

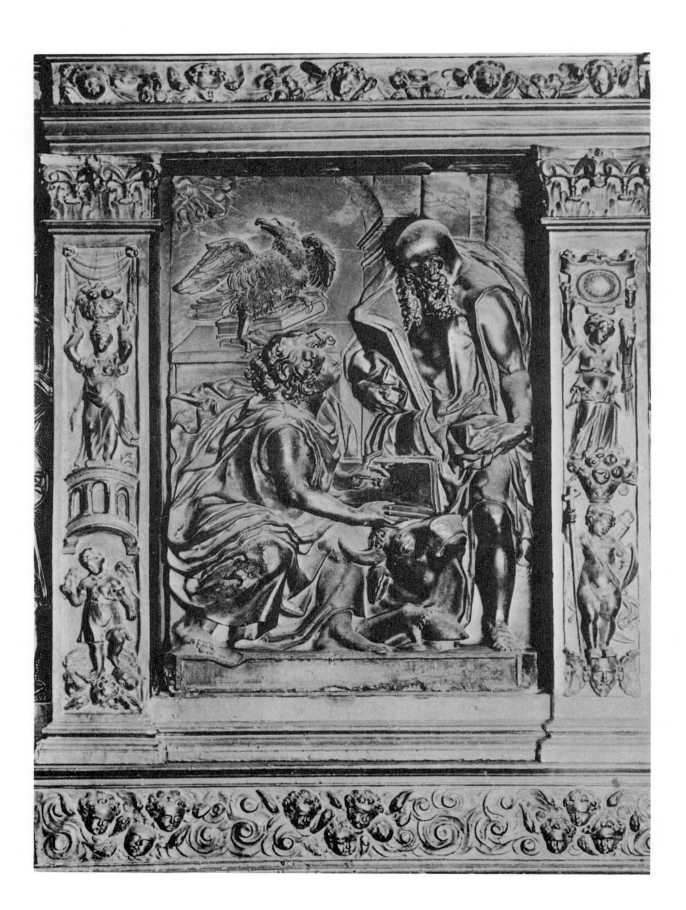

72

TAFALLA, PARISH CHURCH
High Altar.
JUAN DE ANCHETA
Photo Orueta

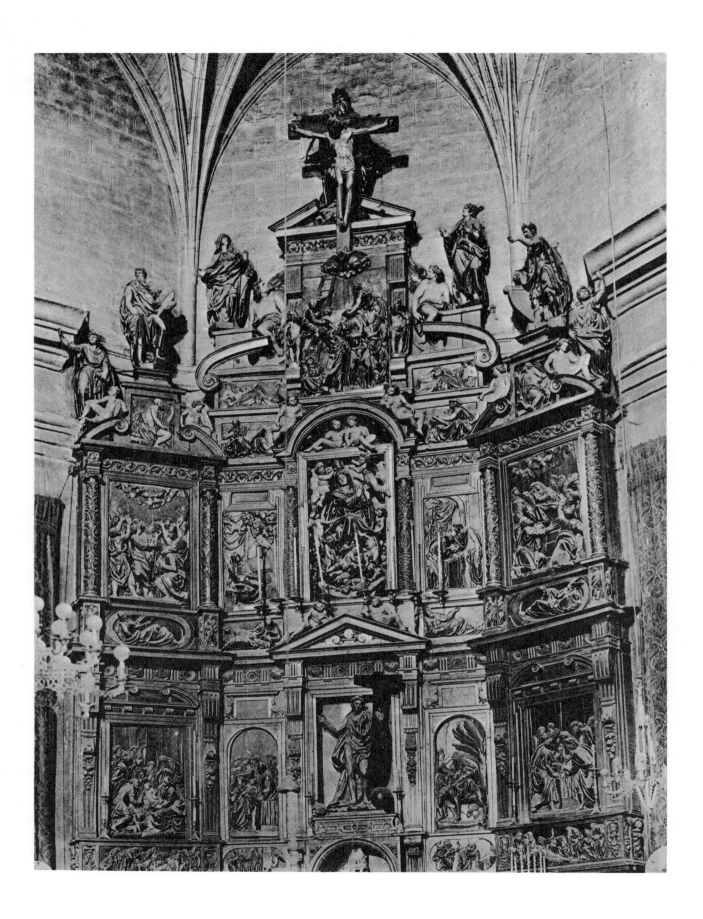

73

TAFALLA, PARISH CHURCH
Detail of the High Altar: The Annunciation.
JUAN DE ANCHETA
Photo Arxiu Mas

74

GRANADA, CATHEDRAL
Doorway of the Chapter-hall.
DIEGO DE PESQUERA
Photo Gómez Moreno

75

COLOMERA, PARISH CHURCH
The Adoration of the Magi.
ATTRIBUTED TO DIEGO DE PESQUERA
Photo Gómez Moreno

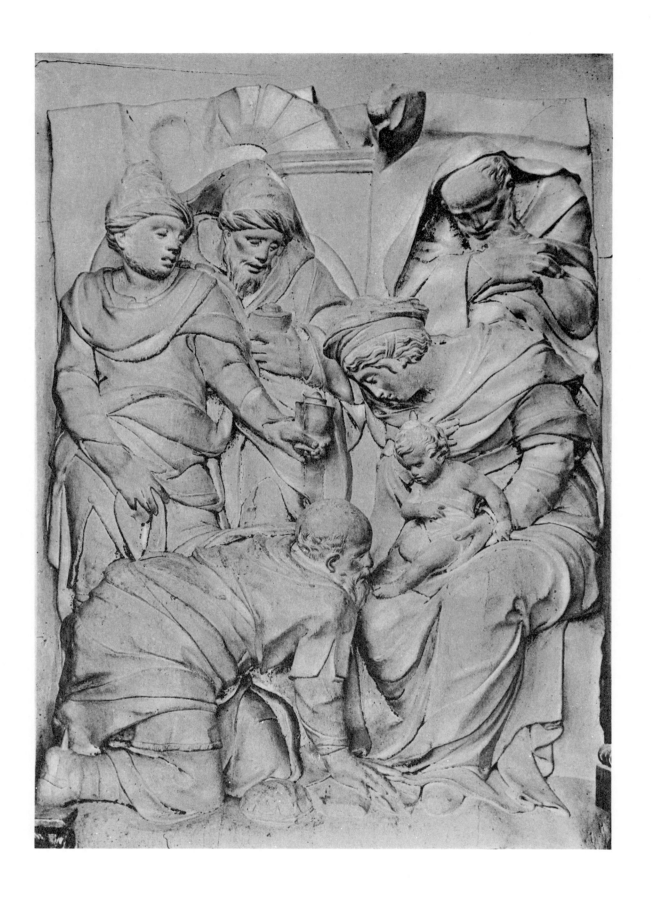

76

LUCENA, SAN MATEO
The Visitation.
BAUTISTA VÁZQUEZ
Photo Arxiu Mas

77

GRANADA, SAN JERÓNIMO
Detail from the retablo: The Adoration of the Magi.
ATTRIBUTED TO JUAN BAUTISTA VÁZQUEZ THE YOUNGER
Photo Gómez Moreno

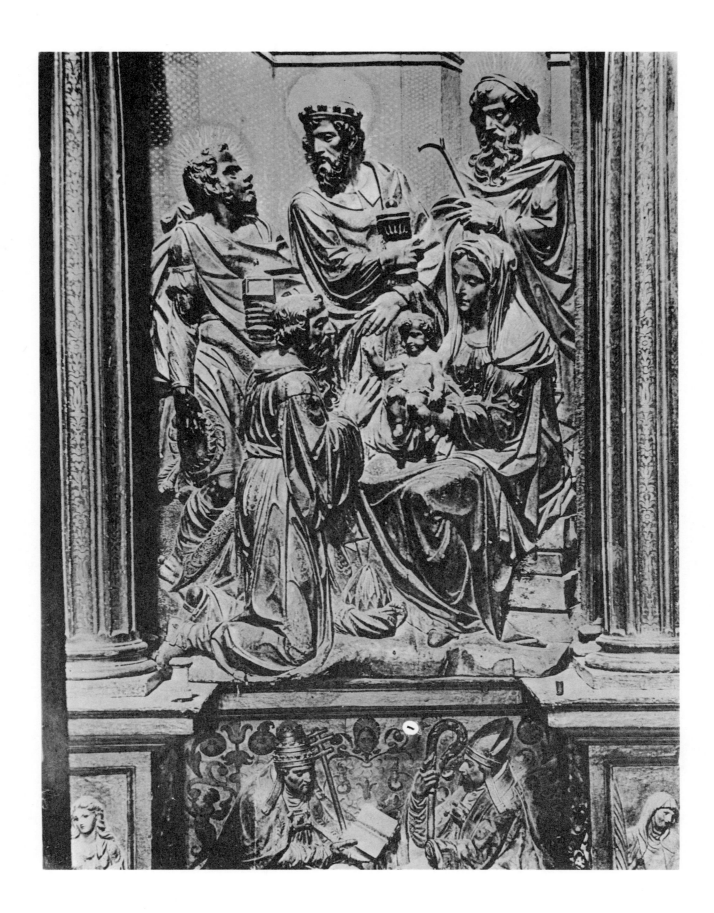

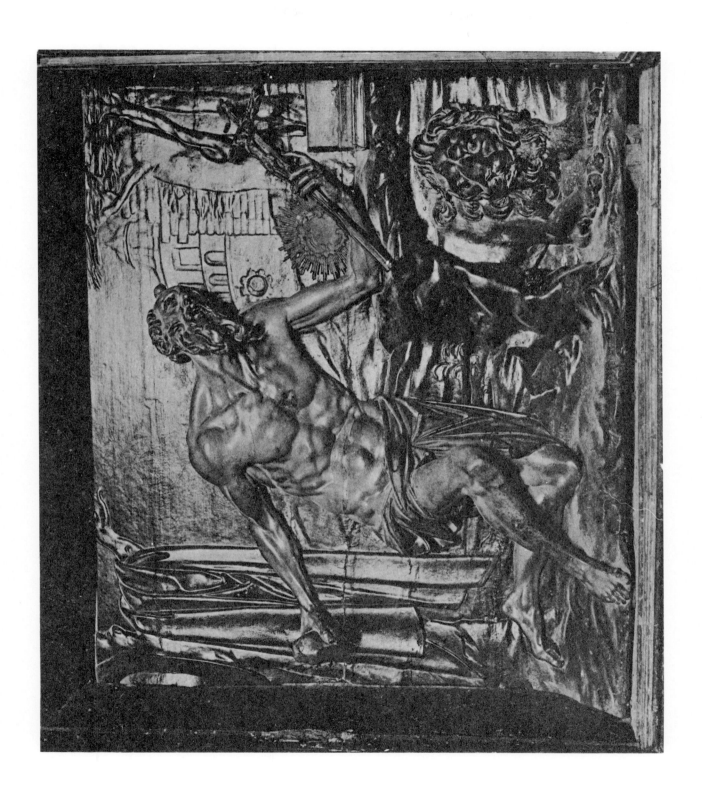

79

SEVILLE, SAN CLEMENTE
St John the Baptist.
GASPAR NÚÑEZ DELGADO
Photo Seville University

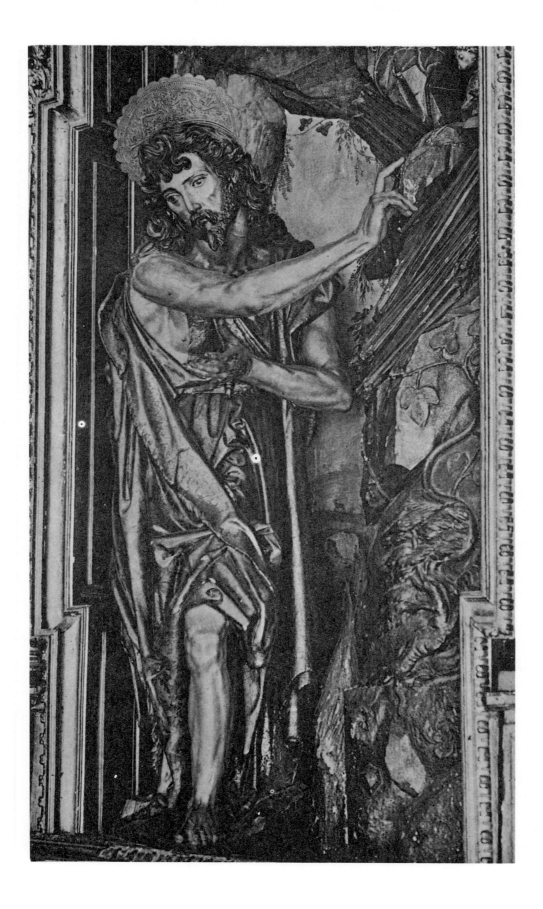

80

GRANADA, CATHEDRAL
A. & B. Two Apostles.

ATTRIBUTED TO BERNABÉ DE GAVIRIA
Photos Gómez Moreno